Selections from
THE ART MUSEUM
PRINCETON UNIVERSITY

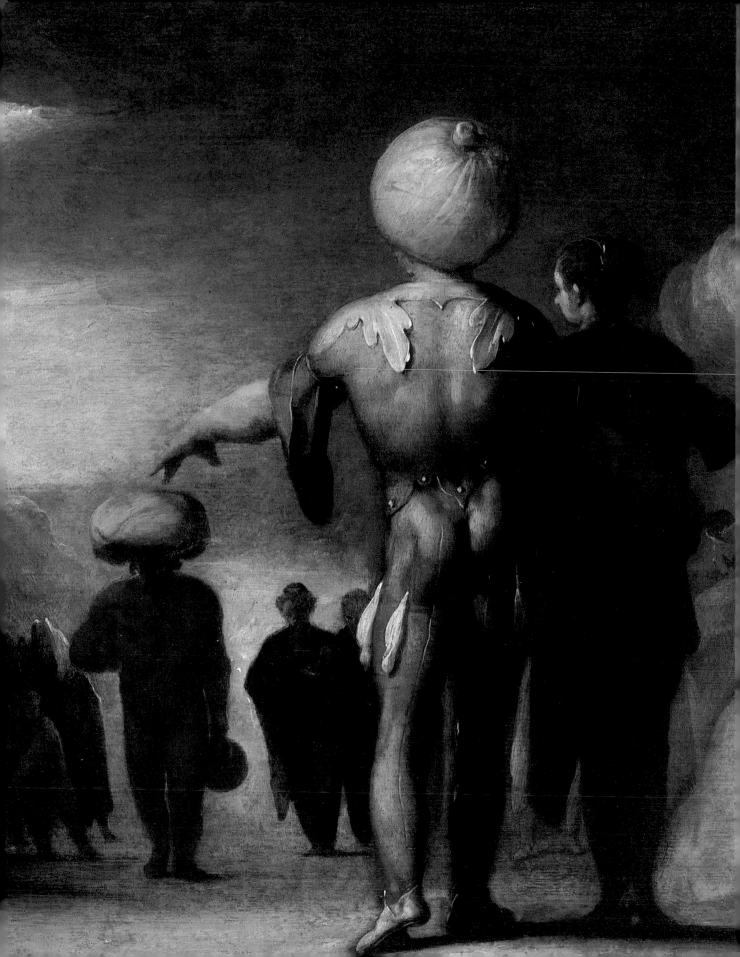

Selections from

THE ART MUSEUM
PRINCETON UNIVERSITY

PRINCETON, NEW JERSEY 1986

Copyright ©1986 by the Trustees of Princeton University.
All rights reserved. No part of this book may be reproduced
in any form or by any electronic or mechanical means, in-
cluding information storage and retrieval systems, without
permission in writing from The Art Museum, Princeton
University, except by a reviewer, who may quote brief pas-
sages in a review.

ISBN: 0-943012-08-2

Library of Congress Catalog Card Number: 86-70782

The Art Museum, Princeton University
Princeton, New Jersey 08544

Designed by Bruce Campbell
Set in type by Columbia Publishing Company, Inc.
Printed by Schneidereith & Sons
Manufactured in the United States of America

Cover: **Peter Paul Rubens** (Flemish, 1577–1640)
The Forbes Rubens: *Cupid Supplicating Jupiter*
Oil on canvas, 2.5 × 1.9 m.
Promised gift of The *Forbes* Magazine Collection: Malcolm
S. Forbes, Class of 1941, Malcolm S. Forbes, Jr., Class of
1970, and Christopher Forbes, Class of 1972

Frontispiece: **Cornelis van Haarlem** (Dutch, 1562–1638)
The Israelites Crossing the Red Sea, detail
Oil on panel, 0.4 × 1.0 m.
Museum purchase with funds given by George L. Craig, Jr.,
Class of 1921, and Mrs. Craig (73-74)

CONTENTS

PREFACE

"The foundation of any system of education in Historic Art must obviously be in object-teaching. A museum of art objects is so necessary to the system that without it we are of opinion it would be of small utility to introduce the proposed department. Courses of lectures, while conveying some instruction, would be of little practical benefit without objects to be seen and studied in connection with the instruction.

"Such a museum would be of priceless value not alone to this department, but also in the classical department and in many other branches of the collegiate course. Expressions of the great need of this have already been heard from members of the Faculty, and there can be but one view of the benefits to follow in the College from the establishment of a Museum of Works of Art."*

So wrote William Cowper Prime in 1882, at the moment when Allan Marquand was charged by President McCosh with the formation of a curriculum in the history of art. Marquand was as strong as Prime in his conviction that a museum be formed in conjunction with a department and it was he in fact who shepherded the museum through its earliest years and built the collection through solicitation of gifts, purchases, and his own generous donations. But it was Prime who provided the direct impetus for the building which was to house the Department of Art Instruction, The Museum of Historic Art, and the School of Architecture. He was the "graduate of the College" referred to in his tract who was "prepared to present to the Trustees a collection of pottery and porcelain, ancient and modern, if the Trustees should establish the proposed department of art instruction, and provide a proper museum for its reception as a beginning of a Museum of Art, with proper regard for the fu-

ture." Original works of art were deemed fundamental to instruction in the history of art and the natural extension of other fields of study.

The beginnings of the collection were modest, and of necessity the lines between original and reproduction were not always clearly drawn. The Art Museum is now the preserve of only original works of art, with the occasional exception of collateral didactic material. One small index of the evolution of the Museum is that the original of an ivory represented in a group of casts acquired by Marquand for teaching is now in the collection.

The faith of Marquand and Prime in the object has been vindicated and it is the function of the Museum, if obviously not to represent the full history of art, to provide a direct, intimate, and sustained encounter with a work of art. One must never underestimate its power to inform, to stimulate, indeed to awaken the imagination of the young. The patina of a bronze, the mellowed surface of an ivory, the intelligence and vitality of a brushstroke—the physical presence of an object and the effects of time—are all but lost and possibly distorted in even the most sophisticated and seductive reproductions. A relished bit of Princeton lore is Thomas P. F. Hoving's "loss of innocence" to a small, German thirteenth-century ivory Madonna and Child which Professor Kurt Weitzmann pulled out of his pocket in class one day. Hoving's undergraduate and graduate experience with art objects, under such impressive and knowing guidance, was crucial to his formation and decisive in his direction as a museum professional. The rest is history.

In slightly less than one hundred years since the Museum came into being, it has grown into one of the outstanding university museums in the country and one of the richest cultural resources of the State of New Jersey. Prime repeatedly referred in his argument to provision for the future expansion of the Museum in response to the growth of the collections,

* William Cowper Prime, LL.D., and Hon. George B. McClelland, *Suggestions of the Establishment of a Department of Art Instruction in the College of New Jersey* (Trenton: W. S. Sharp Printing Company), 1882.

about which he was optimistic. One regrets the loss of the fine Romanesque revival building, which was sufficiently complete in 1890 to receive Prime's collection. Although the building was inadequate, even with additions completed in 1921, it is a pity that it was razed rather than incorporated, with at least the facade preserved, in the much-needed larger modern building which displaced it in 1966. But if the old building is remembered with affection, as it should be, the Museum was badly served there and insufficiently visible. Many returning alumni have been surprised that there is, or was, a museum on campus, and all take pride in the collections, exhibitions, publications, and services which they now find. At the time of this writing a new wing of the Museum, designed by Mitchell/Giurgola, is nearing completion, to be followed by extensive renovation of the existing building. If the Museum has increased in size several times since its inception, it still retains its essentially intimate character. The present building program will not change this quality, but will allow the Museum to meet its obligations more professionally and effectively, to students, scholars and the public, and to the preservation, exhibition, and interpretation of the collections. Increased space will make it possible to exhibit the permanent collection more extensively and also more meaningfully and harmoniously through the reorganization and reapportionment of space. If some will lament "the good old days," when a member of the faculty could put a small object in his pocket and take it to class, we will now have adequate seminar and study-storage rooms within the Museum adjacent to the relevant galleries in all areas of the collection. The conservator will be able to work with the faculty and students in a fine, well-equipped studio, where works of art can be technically examined to better understand their physical properties and the changes they have undergone or suffered over time, all of which affect their interpretation. Temporary exhibitions will no longer interrupt the flow of the permanent collection and will be presented in handsome galleries in the new wing. And work, service, and storage areas will be improved. Certainly all our problems will not be solved and no doubt we shall

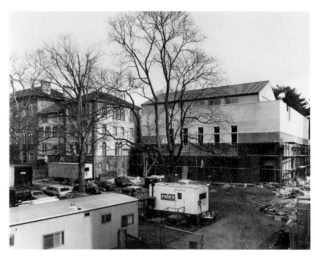

McCormick Hall and the new wing of The Art Museum from the west, Mitchell/Giurgola, architects, completed 1986.

sow seeds of discontent for future custodians of the Museum. Change will have its detractors and some things will be missed, but we trust the balance will be favorable.

But finally, a museum is not a building; it is defined by its collection and programs. Happily, The Art Museum at Princeton boasts a superb collection with great strengths, if still some conspicuous weaknesses. While we are as ambitious for the great work of art as any museum, The Art Museum is also a place where the idiosyncratic work, if instructive and of quality, is welcome. A case in point is a copy of a famous painting in The Metropolitan Museum of Art, the *Death of Socrates*, by Jacques-Louis David. Apart from the great quality of the copy, surely the work of one of David's closest followers, it is a copy with a difference. It is unfinished, but here again, with a difference: it proceeds systematically from right to left in vertical sections of increasing completion, from the broadest brushing in to the finish of the completed original. The painting pragmatically demonstrates how a work by the master was painted. Possibly an exercise or didactic model for assistants in the studio, it is invaluable for the insights it provides for students and scholars, and it is satisfying to watch visitors stop, perhaps in surprised if confused recognition of the original, and then draw closer to explore the

painting. Certainly we would be happy to have the David, but such a work as we have takes its appropriate and distinctive place here. The rubric "teaching piece," however, under which works of art are sometimes offered to the Museum, whether for purchase or as a gift, is sometimes abused. Quality is the best teacher.

Our exhibition policy also reflects our sense of special place and mission. We feel that a university museum is charged with originating exhibitions, with accompanying scholarly catalogues, which focus on neglected or little-understood aspects of the history of art, exhibitions which larger, municipal museums might not be willing to undertake. The present interest in the American arts and crafts movement is due in great measure to a ground breaking exhibition at Princeton. And, it was not the so-called Golden Age of Spanish painting, the first half of the seventeenth century, but painting of the largely uncharted second half of that century which was the subject of another exhibition and which brought to light many gifted artists and a greater understanding of that period. Drawings of the sixteenth and seventeenth centuries were examined for the first time in the context of the political and geographical definition of the Holy Roman Empire. An exhibition of an important group of drawings by Gianlorenzo Bernini from the collection of the Museum der Bildenden Künste in Leipzig, shown for the first time in this country, presented not the highly finished drawings by the artist but his working drawings, often first *concetti*, which allow the viewer to follow his creative process. It is not that we shun the popular exhibition, no more than we close our eyes to great works of art. These exhibitions were, in fact, popular, and some circulated to other museums. It is just that popularity need not be a consideration.

In addition, we organize numerous exhibitions throughout the academic year in conjunction with the curriculum of the Department of Art and Archaeology. Drawn from our own collections, these exhibitions range from regroupings of paintings in the galleries for instructive comparison to enviable groups of seventeenth- or eighteenth-century Italian drawings, Chinese painting and calligraphy, or photographs. And they are all open to the public. The primary responsibility of the Museum is to the Department of Art and Archaeology, but William Cowper Prime spoke of the value of an art museum not only for the study of art history but also for "many other branches of the collegiate course." We have indeed had rewarding collaborations with other departments, particularly Civil Engineering and the School of Architecture; and in these instances it was perhaps the horizons of the Museum which were expanded, with exhibitions demonstrating the structure of Gothic cathedrals and more modern feats of engineering, ranging from bridges to gas stations of great beauty. It was particularly satisfying one evening to see the Museum filled with engineering students (there are many more than in art history) for a reception following a lecture given by an engineer whose work, represented by models and photographs, was rightly considered in the context of a museum. For the interested student, not formally enrolled in a course of art history, the Museum offers the opportunity for discovery, even if only of a single work of art in which he or she might take a special interest or pleasure. Students so motivated may, by appointment, individually view superb collections of prints, drawings, and photographs, which only occasionally are on view because they are sensitive to light. For benignly selfish reasons we also hope to inculcate the desire to collect among future alumni.

Prime was farsighted in his projections for the Museum in all respects but one: "There would seem to be no large annual expense entailed on the College by the custody, exhibition and use of the Museum." This was perhaps a wily calculation, *mutatis mutandis*, to allay the fears of the administration. It would have held true had the Museum remained a study collection with limited access, as the rest of his sentence implies. But he was clearly ambitious for the Museum, and one feels this was simply a device to get a foot in the door, for he continues, "unless it should in time be found useful to keep it at all times open to the visits of students and others." The Museum is open to the visits of all students and of many others. If the costs of

9

maintaining a museum have increased, the return is commensurate and cannot be measured. And the University has been supportive, most notably in its efforts in The Campaign for Princeton for the present building program. The gates of the University are open, and visitors are free to enjoy what is still one of the most beautiful campuses in the country, as well as the John B. Putnam, Jr., Memorial Collection of twentieth-century sculpture placed throughout the campus. And the doors of the Museum are open with but one entrance requirement, that of considerate behavior. The Museum has a responsibility to share the treasures entrusted to it with as large a community as possible and represents one of the most generous extensions of the University to the community. That generosity is returned. The recognition of the stature which the Museum has achieved and the value in which it is held can, in part, be measured by the broad support which the Museum enjoys from the Friends of The Art Museum, the National Endowments for the Arts and for the Humanities, the Institute for Museum Services, the New Jersey Council for the Arts, and other agencies, foundations, corporations, and individual donors, alumni or not. Our volunteer Docent Association makes the Museum a welcoming and lively place, through helpful ministrations at the reception and sales desk, guided tours, "Museum Break Talks," and wonderful programs for children both in the Museum and in schools.

"The immediate neighborhood of Princeton, the State of New Jersey, the homes of graduates and friends of the College are more or less rich in works which should, from time to time, find their places in the College Museum of Art." Prime's optimism was justified and, as this publication amply testifies, works of art have, indeed, "from time to time" found their place in the Museum as gifts from a great many alumni, neighbors, and friends.

Following this preface is an article by Frances Follin Jones, who retired in 1984 as Curator of Collections and Curator of Classical Art after forty-one years of service to the Museum. In her article, which originally appeared in *University* magazine in 1979 and is reprinted here with minor revisions, Miss Jones

can give only an all-too-brief account of the history of the Museum and mention of its principal donors. Many more, of course, will be acknowledged by the inclusion in this publication of objects which were acquired through their generosity. The list will, perforce, still be sadly incomplete, but our gratitude to all who have supported the Museum is implicit and we hope that they will take satisfaction in the collections which they have helped to build. We trust that Allan Marquand and William Cowper Prime would also draw some satisfaction from the success of their original enterprise.

This publication has required the concerted effort of the staff of the Museum at a time when all were under other considerable pressures. It has been very gratifying to me to see how well and caringly they worked together. I wish to thank them all, but Maureen McCormick, Assistant Registrar, a relatively new and very fortunate addition to the staff, must be singled out, since she more than any of us made it possible, with characteristic professionalism and good cheer, to realize this project. I also wish to thank Clem Fiori, photographer; Bruce Campbell, designer; Bernard Rabb, Columbia Publishing Company; and Thomas Phillips of Schneidereith & Sons, for the quality of their work and for making it possible for us to meet a very demanding deadline.

This publication has been supported in part by a grant from the National Endowment for the Arts and by a gift from the Friends of The Art Museum. It is appropriate that is appears at a time when the Museum can look forward to exhibiting more of its permanent collection. We hope that it will make the collections at Princeton better known and that it will engender sufficient pride so that we can look forward to even more impressive editions in the future.

Allen Rosenbaum
Director

THE MAKING OF A MUSEUM

Princeton's Art Museum takes its structure from the curriculum of the university's Department of Art and Archaeology, but its substance has come largely from the gifts of alumni and other benefactors. Accordingly, its collections reflect the personalities and interests of the many donors who have contributed to its growth over the years. To a considerable extent, then, the history of the Museum can be told by recounting, even briefly, the generosity of some of those who have helped to make it one of the nation's leading university collections.

The Museum, of course, is dedicated to the university's teaching needs. Fittingly, it was conceived, in the 1880s, as part of a plan to establish a program of instruction in the history of art. The impetus came from William Cowper Prime, Class of 1843, who suggested to the trustees that they create a professorship in the then new discipline, and offered, if funds were raised for a fireproof building, to donate the considerable collection of pottery and porcelain that he and his wife had accumulated.

The trustees, in turn, suggested that Prime himself fill the new position. Though a lawyer and journalist by profession, he had served as a trustee of The Metropolitan Museum of Art and had written a book on ceramics. In those days art and archaeology were only just beginning to emerge as fields of academic study, and the leading scholars of the subject were patrons and collectors. Prime held the professorship until his death in 1905, but seems to have given intermittent series of lectures rather than steady course instruction.

Allan Marquand, Class of 1874, who had been teaching Latin and logic at Princeton, was made a lecturer in the fledgling department. One biographer has suggested that he was chosen because President McCosh detected "an unorthodox, unCalvinistic bent in Marquand's teaching of philosophy." Whatever the case, his background was an obvious qualifica-

tion: his father, Henry G. Marquand, was a collector, one of the founders of The Metropolitan Museum of Art, and later its president; for the son, close association with original works of art had always been a daily experience. In addition, he was trained in theological and classical studies, which then included archaeology.

Marquand's first course, however, given in the autumn of 1882, must have been an unexpected and demanding assignment: "The History of Christian Architecture." As he later confessed, "It was a new field for me, but I put up a good bluff and stumbled along lecturing on early Christian and Byzantine architecture as if I understood it well, and as if I knew beforehand all there was to follow in the unexplored fields of Romanesque and Gothic." Some forty-five seniors, close to half the Class of 1883, were enrolled in his elective course. Evidently he did well, for he was appointed professor the following spring.

Meanwhile, the trustees, mindful of their commitment to Prime, began soliciting funds for a building. Marquand's notebook lists for 1886–87 a dozen names of donors, whose combined contributions amounted to somewhat more than $40,000. Though the architect's plans showed two projecting wings and a lecture hall in the back, only the central section could be put up with the money at hand. (The final price-tag of $49,061 for a three-story building with 18-inch brick walls on a stone foundation, about 75 by 25 feet, seems incredible today.)

Views of the campus at the turn of the century show the building as an isolated block that cried for weight at both sides. Dean West described it as "wingless, tail-less." Nevertheless, it managed to accommodate the department, its museum and library, and the incipient School of Architecture for years to come. Those who remember the old structure still marvel at the amount of activity it contained as the program developed.

11

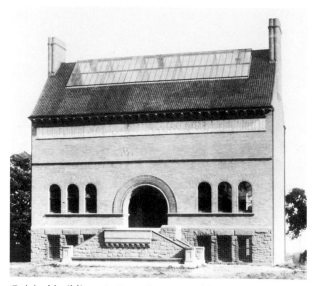

Original building, A. Page Brown, architect, completed 1889/90, demolished 1963.

Arrival of the Trumbull-Prime Collection in 1890-91 concluded the first phase of museum development. (Because of his wife's active participation in assembling the hundreds of examples of European and American pottery and porcelain, Mr. Prime wished her maiden name to be associated with the gift.) Three years earlier, in somewhat premature anticipation, he wrote Marquand from Vermont, referring to the ground-breaking in June and urging speed: "No one can attend to the package and transfer [of the collection] but myself. If you could have the building sufficiently advanced to receive them in the spring, I might do something in the way of packing this winter. . . ." The letterhead shows Brooks House in Brattleboro, a five-story building with turrets, mansard roof, flags flying, and carriages dashing about in the foreground. Prime concluded, "I am on my usual autumn journey behind my horses, stopping here over night, & going I don't know where tomorrow."

In 1889, in an otherwise undated letter that accompanied a draft of the deed of gift to be approved by the trustees, he wrote President Patton of his satisfaction in learning of the "substantial completion of the Art Building at Princeton." Prime went on to say that, while he had expected to turn over the works in New York, "It seems to me more fitting that I should as-

sume the care of their transfer to Princeton, and also the expense, if the college can arrange on reasonable terms with the railroad company for one or two freight cars to be placed where I can have a few days to load them carefully." (Those were the days!—briefly recalled when Mitchell Wolfson, Jr., Class of 1963, arrived for the Museum's Advisory Council meetings in 1985 in his private railroad car, "Hampton Roads.")

There seems to have been further delay, however, for on his autumnal gyro of 1890, Prime wrote Marquand from Franconia, New Hampshire, that he would be getting at the barrels and boxes in New York in November. "In the meantime I suggest that you have in mind the needful arrangements. Will it be practicable to have anywhere near the basement door (outside of course) a furnace and large kettle, wherewith we can heat water for washing purposes? Many objects must be washed—for the last time before consigning them to permanent places, and warm water is essential for cleanliness of glazes." Marquand notes receipt of the collection that winter, but there is no record of the washing.

The first page of Marquand's notebook records gifts of works of art and promises of gifts, jotted down with entries about subscriptions to journals, acquisitions of photographs and slides, and class lists. Instruction, museum, and library were three strands braided together from the start. Most early gifts were single items, but there were some sizeable groups. He bought a large and representative selection of Cypriote pottery from The Metropolitan Museum of Art in 1890, when it was selling from the enormous Cesnola Collection. Shortly after, with the assistance of Arthur L. Frothingham, Jr., another of the department's first faculty members, he acquired a good group of Etruscan, early Italic, and South Italian red-figured pottery.

The first gifts tended to concentrate on Mediterranean antiquity, an area familiar to Marquand and Frothingham and one in which they were teaching. Nevertheless, objects of later periods and other geographical regions were making their way into the collection. To provide control over the direction of development, in 1905 Marquand began an endowment

that would provide income for acquisitions. Later it was substantially increased by a gift from Edward Harkness, which was matched by the trustees, and it has been doing yeoman's service ever since.

Carl Otto von Kienbusch, Class of 1906, one of Marquand's students, began his steady support of the Museum two years after graduation with the gift of three Egyptian amulets—reminders that Egyptology had been among the donor's great interests, one he might have pursued professionally if not committed to his family's tobacco business in New York. Henceforth he made annual contributions to assemble a diversified group of objects, which he named the Carl Otto von Kienbusch, Jr., Memorial Collection in honor of a child who died in infancy. These selections he left to the Museum, almost always concurring enthusiastically with the choice. On the rare occasion when an object was not to his own taste, his only protest was: "If the curator wants it, so be it." As time went on, his annual stipends became more flexible. "Is there anything you feel you cannot live without?" he would sometimes ask.

Finally, Kienbusch began to turn over his own holdings. Regarding one such gift, he wrote: "I am also handing you a drawing by Modigliani which I bought many years ago at the sale of the Lord Leverhulme collection. I like it as well as any Modigliani drawing I ever saw. It is quite precious and I feel a slight tug as I part with it but, after all, it needs a good permanent home." The magnificent collection of arms and armor that he had assembled over the years was loyally offered to Princeton, but all concerned agreed that it was more suitable for a large, city museum (it is now handsomely installed in the Philadelphia Museum of Art).

The culmination of Kienbusch's generosity was his gift of $250,000 for the new building in 1963, an endowment to provide for the publication of the Museum's semi-annual bulletin (which he had sponsored from its inception), and a bequest to ensure maintenance and continuation of his Memorial Collection. Once, in a letter to President Dodds, he summed up his sense of indebtedness, which he had already repaid many times over: "What the value of an educa-tion in art may be to the modern undergraduate I am not prepared to say. In my own case (a lowly business man) what I got out of the department (1903–1906) gave much of what I have valued most through the years."

After joining the Department in 1910, Professor Frank Jewett Mather, Jr., made a practice of presenting objects to the Museum from time to time. Eventually, he and his brother and two sisters endowed the Caroline G. Mather Fund, named in memory of their mother, which has remained a valued source of income for acquisitions to the present day. Though he constantly asserted that he could never match Marquand's generosity, Mather brought the Museum some of its choicest pieces until his death in 1953. He was fond of browsing through shops and galleries in New York, Boston, or wherever his travels happened to take him. He watched the auction catalogues. Dealers came to his office on the Wednesdays that he set aside for looking at their offerings.

For years Mather's top price for a drawing was $25, with only something like a Carpaccio as an irresistible exception, and the rising market of the 1950s obviously took some of the edge off the excitement of the chase. Articulate and witty, he thoroughly enjoyed old-world bargaining. Beside his own specialty of Italian and other European paintings and drawings, he amassed classical and pre-Columbian antiquities, Far Eastern painting and sculpture, manuscript miniatures, and the works of American artists.

In 1921, the year after Mather succeeded Marquand as the Museum's director, McCormick Hall was completed as an addition to the west end of the old building. This welcome gift from the family of Cyrus H. McCormick, Class of 1879, designed in Italian Gothic style by Ralph Adams Cram, enabled the School of Architecture to come into its own, provided handsome space for the library that had grown steadily through Marquand's beneficence, housed the Department of Art and Archaeology, and included on the ground floor a "hall of casts." The Museum could now spread its possessions within the brick walls of the original Romanesque-style building.

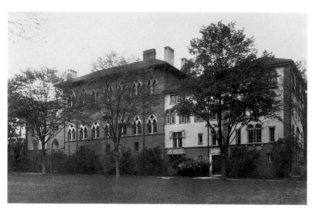

McCormick Hall from the west, Ralph Adams Cram, architect, completed 1921.

Mather oversaw the arrival of several noteworthy holdings. In 1933, the bequest of Junius S. Morgan, Class of 1888, a former student of Marquand, provided the real beginning of the Museum's print collection. Its sheer size must have made Mather feel relieved that he no longer had teaching duties. With the aid of a grant from the Carnegie Corporation he was able to engage help in inventorying the several thousand prints, including a nearly complete series of the prolific work of the seventeenth-century artist Jacques Callot. In addition, the university's collection of antiquities was enhanced by Morgan's Greek vases, one of which was destined to become the "name piece" of the Princeton Class, an assemblage of products from the same Athenian workshop.

Two years later, Henry White Cannon, Jr., Class of 1910, presented a collection of more than forty Italian paintings gathered by his father for his villa in Fiesole. Then came a bequest of more than five hundred Chinese snuff bottles, willed by Colonel James A. Blair, Class of 1903. Made of semi-precious stones, porcelain, glass, enamel, and other materials, the bottles are magnets that draw collectors from all over for admiring scrutiny.

Just before World War II, shipments of Roman mosaic pavements and other antiquities were received from the excavations of Antioch-on-the-Orontes, in which Princeton had a leading part. The liberal laws of the Syrian Department of Antiquities permitted division of finds from several seasons of field-work in the 1930s. Most of the mosaics had to remain in their crates for lack of display space, but a few of the smaller ones were mounted in the old building and, a bit later, in Firestone Library. The Museum already had a group of volcanic stone sculptures of the Roman period from turn-of-the-century explorations in Syria by Howard Crosby Butler, Class of 1892, as well as some pieces of sculpture, architectural fragments, and pottery from the excavations at Sardis that were aborted by World War I and Butler's death.

In 1942 the will of Gertrude Magie, widow of John Maclean Magie, Class of 1893, provided the third endowment for purchasing.

Dan Fellows Platt, Class of 1895, was a man of many parts—including lawyer and one-time mayor of Englewood, New Jersey, where he lived—whose interest in art had been encouraged by Marquand. In the days of less reliable automobiles and roads, he chugged up and down the hills of Italy searching out obscure churches and museums. Mather once described him as "perhaps the most enthusiastic, learned, various, and unexpected collector I have ever known." He collected paintings—mostly Italian—drawings of many schools and periods, Roman glass, Greek and Roman coins, Renaissance coins and medallions, and even some pre-Columbian antiquities. All were kept in organized groups, each item with neat notations of source, date, price paid, and, where pertinent (as in the case of coins), reference to a published *locus classicus* for the type.

Although the bequest of these objects to the Museum gave Mrs. Platt life tenure and the right to sell, when she moved out of the large house in Englewood in 1944, she waived her right to all but some of the paintings. A large van, delayed by the uncertainties of wartime transportation, arrived late one evening to unload pieces of antique Italian furniture as well as the large albums of drawings and barrels containing the other objects. It was literally years before the thousands of items could be absorbed into the inventory, but the Platt Collections from the moment of arrival became constellations in the Museum's firmament.

History professor Clifton R. ("Beppo") Hall left to Princeton his collection of more than three hundred prints and drawings in 1946. He also provided an endowment to ensure income for the purchase of additions so that the Laura P. Hall Memorial Collection, named in honor of his mother, is now twice the size of the original nucleus and includes sheets that otherwise would have been beyond the Museum's reach.

The university's bicentennial celebration in 1946–47 featured a series of conferences, including "Far Eastern Culture and Society," which involved the Museum in a complete refurbishing of its galleries. Fortunately, the basement storeroom had been slowly and thoroughly reorganized during the previous three or four years so that it could be crammed all over again as the top gallery was stripped. Freshly painted walls and temporary light fixtures to cover bare, hanging bulbs were the setting for a display of scrolls from the large collection of Chinese paintings given on the occasion by Dr. Dubois Schanck Morris, Class of 1893. On the main floor the cases containing the Trumbull-Prime Collection and classical antiquities were masked to make a background for a display of prehistoric Chinese vessels (borrowed) and books from the university's Gest Oriental Library.

The exhibition marked a turning point for the Museum. Directly and indirectly, it stimulated interest in and brought attention to the building and its collections. The effort to rotate material and to bring in special exhibitions enlivened the program, even though physical limitations were severe and there was only a skeleton crew to keep the operation going. A further boost came three years later with the formation of the Friends of The Art Museum.

Completely new territory opened for the Museum in 1947, when Mrs. Donald B. Doyle presented, in memory of her husband, Class of 1905, the collection of African textiles, masks, weapons, and other artifacts the couple had assembled while living in what was then the Belgian Congo. Another special area resulted from the gift of family portraits and eighteenth-century furnishings gathered by Mrs. Landon K. Thorne—a collateral descendant of Elias Boudinot IV, who served as president of the Continental Congress and as a trustee of the college for thirty years. Boudinot had lived in Princeton, where his daughter Annis became a member of the Stockton family by marrying "Richard the Signer," Class of 1748.

J. Lionberger Davis, Class of 1900, a collector of catholic taste and discerning eye, came to Princeton in the early 1950s after retiring from his law practice in St. Louis. Upon his arrival here he presented the Museum with a number of bronze sculptures by Bourdelle and other objects, to which for the remainder of his long life he continually added a variety of Mediterranean, Far Eastern, and Central and South American antiquities; Chinese paintings; and Persian and Mogul miniatures, among the finest objects in the collection.

In 1958 Edward Duff Balken, Class of 1897, one of the farsighted people who had taken early cognizance of nineteenth-century American folk paintings, gave a collection of sixty-five portraits and landscapes, which he had acquired over many years in the New York–Massachusetts border area of his summer home.

In 1962 Miss Margaret Mower began a succession of gifts from the collection of seventeenth- and eighteenth-century French and Italian drawings that she has designated as a memorial to her mother, the Elsa Durand Mower Memorial Collection.

Not long after his appointment in 1946 as the Museum's third director, Ernest T. DeWald had begun making urgent appeals to the administration about the need for a new building. By the 1950s the walls of the old building were fairly bulging, exhibition space was limited, and storage space was overflowing in flagrant violation of codes, written and unwritten. Part of a basement on University Place took care of objects and equipment used only periodically, and even the basement of Nassau Hall had to be pressed into service to receive a gift of Gothic architectural stonework and Egyptian reliefs.

With the organization of the university's $53-million capital campaign, hope was at last in sight. A

prospectus was published in 1959 for a new building that would house the Department, the Museum, and Marquand Library (with the School of Architecture to have its own building a short distance away). The Museum was assured by specified individual gifts and by the fact that the Class of 1929 decided to make the Museum its concerted objective in the drive. The planning went through several phases in discussion with Steinman and Cain of New York, at one time considering complete demolition of the existing complex, but in the end choosing to retain the main body of the 1921 McCormick Hall. Extending from it would be a wing to the west for the Department, one to the north for the library, and one to the east for the Museum. This is the building one sees today.

While funds were being raised and plans reviewed, the obligatory age of retirement caught up with DeWald; Patrick Joseph Kelleher, Graduate School Class of 1947, took over in time to see the Museum through its last three years in the old building. In 1962 packing began; the collections went into warehouse storage or were sent to institutions that offered hospitality for "the duration." By the summer of 1963 the exhausting job was completed and the Museum's staff joined the Department for a two-year exile in Green Hall Annex (Marquand Library found shelter in Firestone). The demolition crew took over, dumping its debris in an area between Stony Brook and the Delaware-Raritan Canal just south of Alexander Street (future archaeologists should note that the firehouse on Witherspoon Street was being deposited there at the same time).

Construction eventually reached the point where, in hard hats, the director and his assistant made visits to oversee the installation of the Roman mosaics from Princeton's excavations at Antioch, French Gothic windows and doors, a sixteenth-century Spanish stairway and loggia, and a Venetian doorway. The Department and library were settled in their wings in time for the opening of college in September 1965, with a flurry of improvisation because seats had not yet arrived for the auditorium. Offices for the Museum had been readied for occupancy, but work on the galleries continued through the winter and spring.

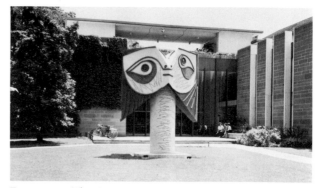

Entrance to The Art Museum, McCormick Hall, Steinman and Cain, architects, completed 1966, with Pablo Picasso, *Head of a Woman*, The John B. Putnam, Jr., Memorial Collection.

Installation of the collection in time for the formal dedication in June of 1966 was a breathless rush, but a gratifying one. Unpacking the familiar works of art, checking them against storage lists, and putting them in their appropriate places provided a review of the thousands of acquisitions made over three quarters of a century.

Just as the new building was being readied for occupancy, Clement K. Corbin, Class of 1902, donated his collection of Chinese export ware. The arrival of these porcelains on the threshold of a new building echoed 1890 and was considered an omen of good fortune. During the same year an opportunity to acquire by subscription the C. D. Carter Collection of Chinese bronze vessels was acted upon by Professor Wen C. Fong, Class of 1951. Among the spectacular pieces in this impressive group of ceremonial vases of the Shang, Chou, and Han Dynasties is the *kuang*, the purchase of which was underwritten by Dr. Arthur J. Sackler. Another outstanding gift, among many from Dr. Sackler, is a group of paintings by Tao-chi. More recently, the collections of Chinese painting and calligraphy have been greatly enriched by gifts from the Edward L. Elliott Family Collection; from John B. Elliott, Class of 1951; and, not to be confused with these, the Jeanette Shambaugh Elliott Collection.

With the opening of the new building, visitors had an opportunity for the first time to see the extent of

the Museum's collections. The new building also made it possible to look ahead and to expand activities. The Friends of The Art Museum shifted into high gear and students formed their own friends organization. Openings of special exhibitions became gala events which could be catered without the anguish of blown fuses and makeshift arrangements. And the special exhibitions themselves could be exciting events of a scope far beyond anything previously possible.

The new building attracted new gifts by making it easier to see where the collections needed help and reassuring potential donors that their contributions would be cared for suitably and would be put to effective use. George L. Craig, Jr., Class of 1921, and his wife, who had given one of the galleries, continued their interest in the well-being of the Museum by setting aside a sum of money to be used for purchasing. The first acquisition was one of Lucas Cranach's beguiling paintings of Venus and Amor to strengthen the holdings in German art. Hans Widenmann, Class of 1918, through the Hans and Dorothy Widenmann Fund, began to build a collection of pre-Columbian objects, especially in gold. Through the Widenmann Fund, the Museum was also able to acquire a painted Maya vase, arguably the finest of its kind, which was the focus for an important exhibition of pots decorated with related narrative scenes. The collection of pre-Columbian art has grown to considerable stature due, also, in great measure, to the efforts, as well as the generosity, of Gillett G. Griffin. The Surdna Foundation, through Robert H. Taylor, Class of 1930, established an endowment for the purchase of English art in 1972, its first income accruing just in time to acquire a panel of stained glass designed by Burne-Jones.

One of the conspicuous weaknesses in the Princeton collection, which Kelleher made efforts to remedy during his directorship, was contemporary art. Progress in this area was given great assistance in 1976 by the William C. Seitz, Graduate School Class of 1955, Memorial Collection, consisting of works given by friends and colleagues of Bill Seitz—painter, scholar, museum curator, and former member of the Depart-

ment. It also became possible to expand into another new field when David H. McAlpin, Class of 1920, endowed a professorship in the history of photography in the Department and gave the Museum his collection of some five hundred photographs by Ansel Adams, Charles Sheeler, Edward Weston, and others.

This necessarily brief and selective account must end with mention of the Fowler McCormick, Class of 1921, Fund, bequeathed in 1974, which has enabled the Museum to acquire many works of great quality hitherto beyond its reach. The narrative comes full circle, since McCormick was an undergraduate in the last years of Marquand's memorable teaching career.

It seems reasonable to assume that if Marquand could visit the Museum today, he would be satisfied with the outcome of McCosh's invitation, nearly a century ago, to lecture in a new area of instruction. Undoubtedly he would be startled by Picasso's *Head of a Woman,* in the John B. Putnam, Jr., Memorial Collection, as he approached McCormick Hall, but upon entering he surely would be gratified that the library, which bears his name, is regarded as outstanding both for its content and convenience of use. Upon reading the directory in the lobby, he would sense the size of the organization that has evolved from the one-man operation he began. Once in the Museum, he would recognize many of the works of art he had recorded in his notebook and which he considered essential to the proper study of the history of art. He would no doubt be astounded by the growth of the collection and pleased by the weekend crowds of visitors, with the volunteers answering their questions and giving talks and tours. And, most of all, with the sight of students coming in to write papers or, with their instructors, for discussion in the presence of the works of art.

Frances F. Jones
Formerly Curator of Collections
and Curator of Classical Art

ANCIENT ART

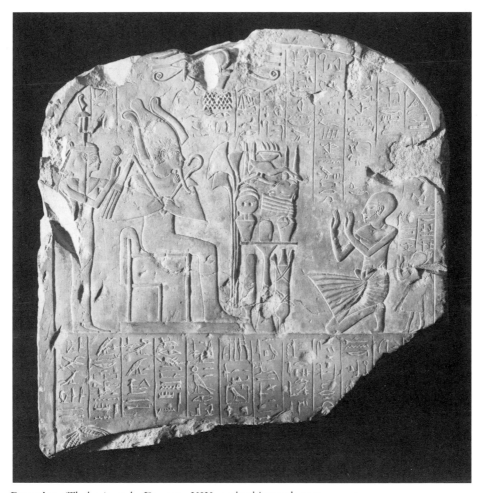

Egyptian (Thebes), early Dynasty XIX, early thirteenth century B.C.
Stela of the Official Si-Mut
Limestone, preserved height 35.0 cm.
Museum purchase, Carl Otto von Kienbusch, Jr., Memorial Collection (37-259)

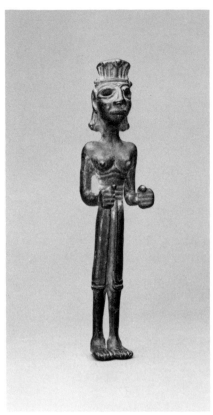

North Syrian, ca. 1600 B.C.
Female Figure
Bronze, height 13.6 cm.
Museum purchase (68-181)

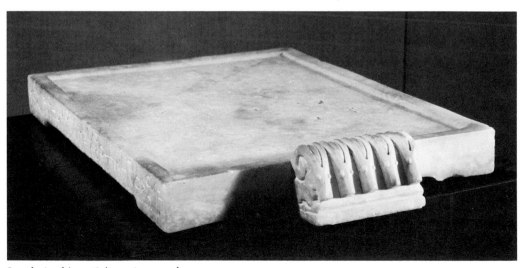

South Arabian (Sabaean), seventh century B.C.
Offering Table with Dedicatory Inscription
Alabaster, height 6.6 cm.
Museum purchase, Caroline G. Mather Fund and funds given by an anonymous donor (71-7)

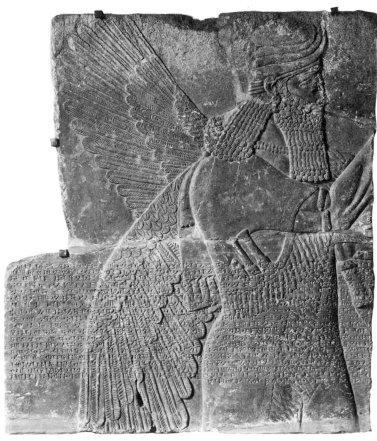

Assyrian (Nimrud), 885–860 B.C.
Winged Genius, relief from Room G, Northwest Palace
of Ashurnasirpal II
Limestone, height 1.5 m.
Gift of Robert Garrett, Class of 1897, in 1925 (207)

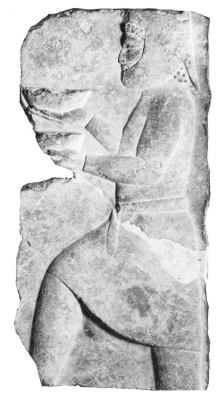

Persian (Persepolis), ca. 486–465 B.C.
Cup-Bearer, relief from the Palace of Xerxes I
Limestone, height 58.5 cm.
Museum purchase with funds given by
Gordon McCormick, Class of 1917 (49-115)

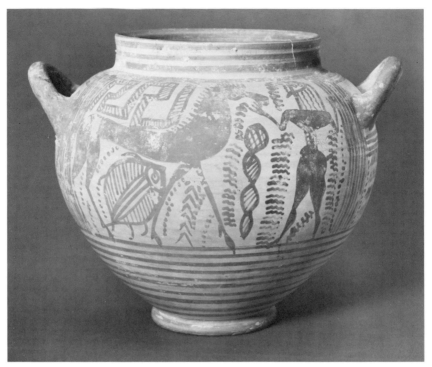

Italian Geometric, early seventh century B.C.
Mythological Scene, stamnoid jar
Terracotta, height 21.6 cm.
Museum purchase, John Maclean Magie and Gertrude Magie Fund (65-205)

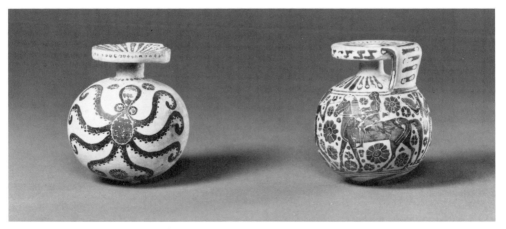

Greek (Corinthian), late seventh century B.C.
Octopus, aryballos, associated with the Workshop of the Painter of the Heraldic Lions
Terracotta, height 6.7 cm.
Gift of Miss Jessie P. Frothingham (29-189)

Greek (Corinthian), late seventh century B.C.
Hoplites in Combat, and Mounted Ephebes, aryballos, attributed to The Warrior Group
Terracotta, height 7.3 cm.
Gift of Charles T. Seltman (30-461)

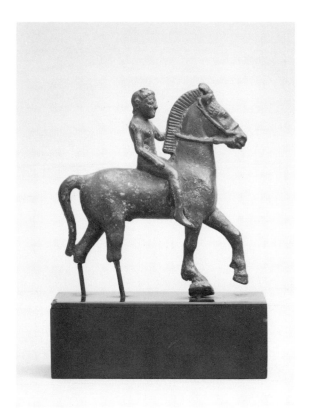

Greek, early fifth century B.C.
Horse and Rider, statuette originally attached to the
rim or shoulder of a vessel
Bronze, height 8.4 cm.
Gift of Frank Jewett Mather, Jr. (48-8)

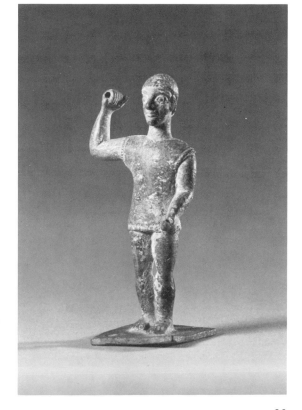

Greek (Messenian or Arcadian), ca. 550–525 B.C.
Warrior, statuette inscribed on back with a
dedication by Pythodoros to the River
Pamisos
Bronze, height 11.4 cm.
Gift of Mrs. T. Leslie Shear, Sr. (47-325)

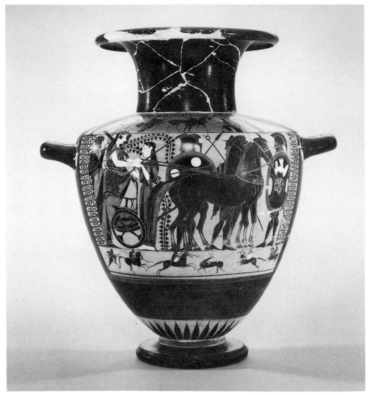

Greek (Attic), ca. 530–520 B.C.
Apotheosis of Herakles, black-figure hydria, attributed to the Manner of the Lysippides Painter
Terracotta, height 46.6 cm.
Trumbull-Prime Collection, 1889 (171)

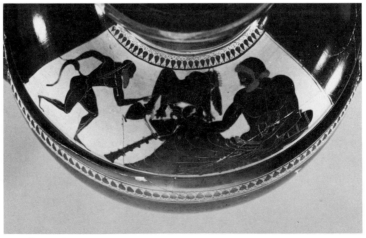

Greek (Attic), ca. 520–510 B.C.
Herakles at Rest, and Satyr, black-figure hydria (kalpis),
Near the Madrid Painter
Terracotta, height 34.6 cm.
Trumbull-Prime Collection, 1889 (170)

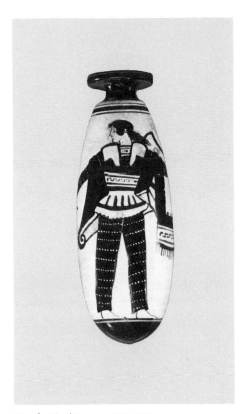

Greek (Attic), ca. 480–470 B.C.
Amazon, white-ground alabastron, attributed to
the Syriskos Painter
Terracotta, height 14.8 cm.
Museum purchase, Carl Otto von Kienbusch, Jr.,
Memorial Collection Fund (84-12)

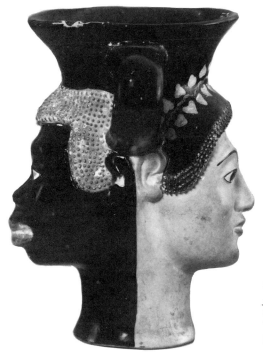

Greek (Attic), ca. 480–470 B.C.
Janiform Head-kantharos, the name-piece of
Class H of The Head Vases, The Princeton Class
Terracotta, height 14.9 cm.
Bequest of Junius S. Morgan, Class of 1888 (33-45)

25

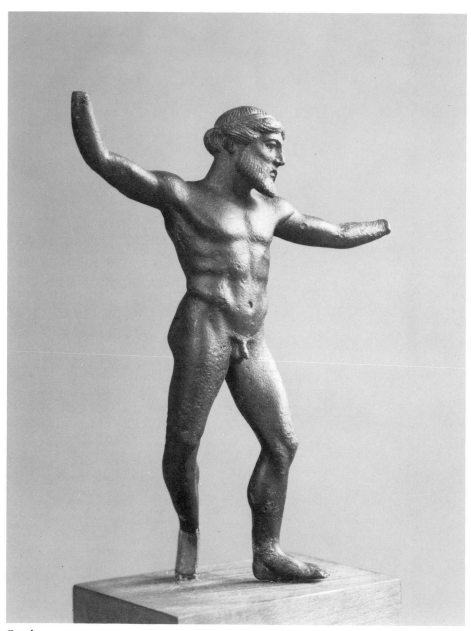

Greek, ca. 460 B.C.
Zeus
Bronze, height 15.1 cm.
Museum purchase, Caroline G. Mather Fund (37-343)

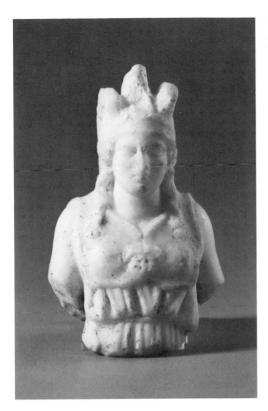

Greek, Hellenistic
Athena Parthenos, copy in miniature of the
fifth-century B.C. gold and ivory cult statue
by Pheidias
Pentelic marble, height 11.8 cm.
Gift of William F. Magie, 1923 (18)

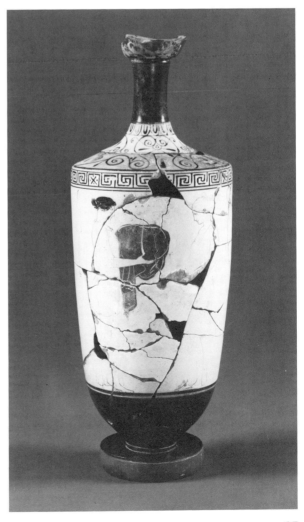

Greek (Attic), ca. 450 B.C.
Mistress and Maid, white-ground lekythos,
attributed to the Achilles Painter
Terracotta, height 32.0 cm.
Gift of Edward Sampson, Class of 1914, for
the Alden Sampson Collection (64-108)

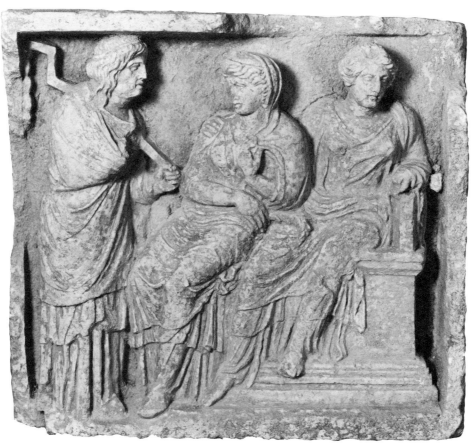

South Italian (Tarentine), late fourth century B.C.
Mythological Scene, relief from a naiskos
Limestone, height 27.5 cm.
Museum purchase with funds given by the Willard T. C. Johnson Foundation, Inc.,
and by an anonymous donor (83-34)

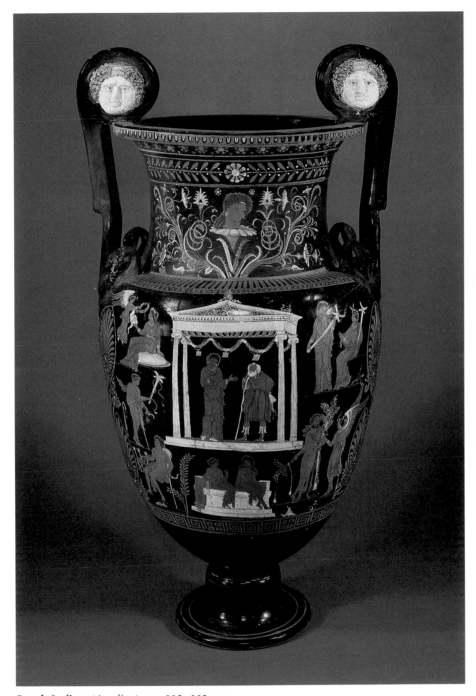

South Italian (Apulian), ca. 335–325 B.C.
Medea at Eleusis, red-figure volute-krater, attributed to the Darius Painter
Terracotta, height 1.0 m.
Museum purchase, Carl Otto von Kienbusch, Jr., Memorial Collection Fund,
in honor of the seventieth birthday of Frances Follin Jones (83-13)

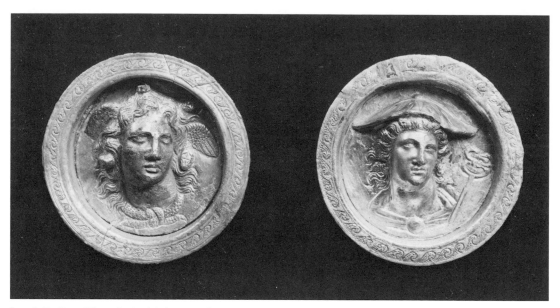

South Italian (Tarentine), third–second century B.C.
Medusa and Hermes, ornamental roundels
Silver, diameter 7.0 cm. each
Museum purchase with a fund given in memory of Allan Marquand, Class of 1874,
and Mrs. Marquand (51-5, 51-6)

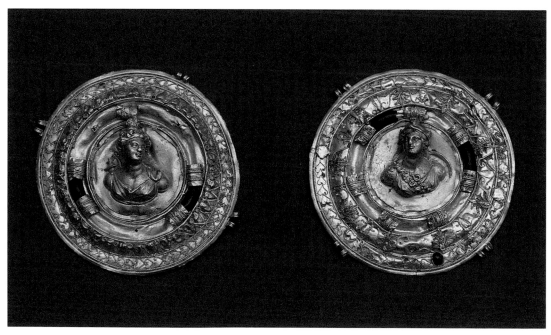

Greek, second century B.C.
Artemis and Athena, breast ornaments
Gold, garnet, and enamel, diameter 7.9 cm. each
Museum purchase (38-50, 38-49)

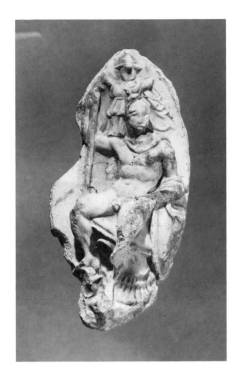

Greek (Alexandrian), Hellenistic
Warrior Seated Before a Trophy, horse's nose-piece,
cast of an original in bronze of the third–second century B.C.
Plaster, height 16.6 cm.
Museum purchase, Caroline G. Mather Fund (48-52)

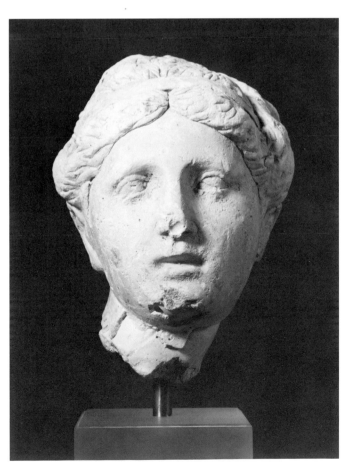

Greek (Alexandrian), Hellenistic
Head of a Goddess (?), cast of an original
in marble of the second century B.C.
Plaster, preserved height 19.0 cm.
Promised gift of Gillett G. Griffin

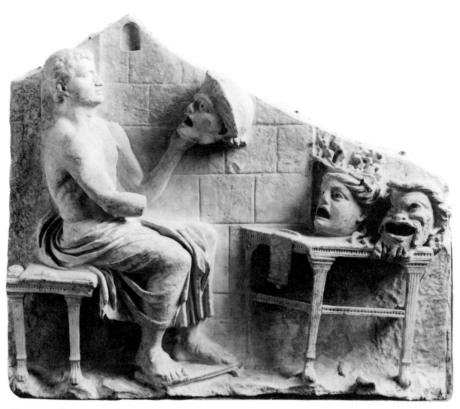

Roman, first–second century A.D.
Poet (Menander) and Theatrical Masks, copy of an original of the third century B.C.
Marble, preserved height 49.5 cm.
Museum purchase, Caroline G. Mather Fund (51-1)

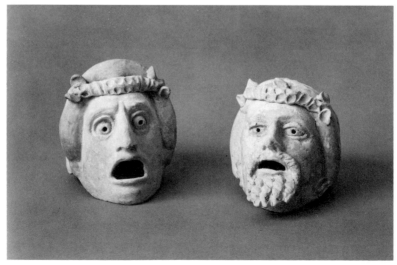

South Italian (Sicilian), third–second century B.C.
Youth; *Old Man*, dramatic masks
Terracotta, height 12.5 cm.; 11.0 cm.
Museum purchase (52-85; 52-84)

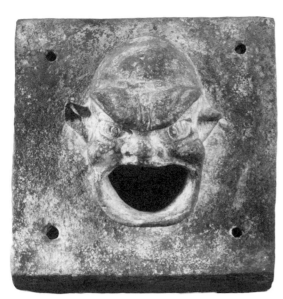

Roman, first–second century A.D.
Mask of a Satyr, attachment
Bronze, height 19.0 cm.
Promised gift of Gillett G. Griffin

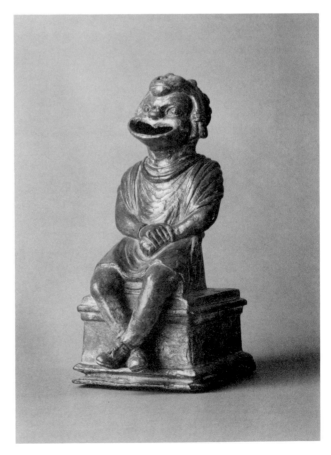

Greek (Alexandrian), second–first century B.C.
Comic Actor (as Mischievous Slave) Seated on Altar, incense burner
Bronze, height 19.3 cm.
Museum purchase, Carl Otto von Kienbusch, Jr.,
Memorial Collection (48-68)

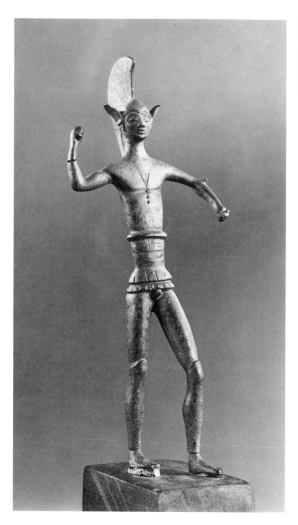

Etruscan (Umbrian), ca. 475–450 B.C.
Warrior
Bronze, height 21.3 cm.
Museum purchase, Carl Otto von Kienbusch, Jr.,
Memorial Collection (41-47)

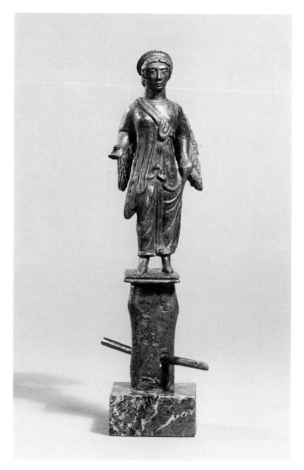

Etruscan, ca. 450–425 B.C.
Winged Female
Bronze, height 16.5 cm.
Museum purchase with funds given by
Alastair B. Martin, Class of 1938 (76-24)

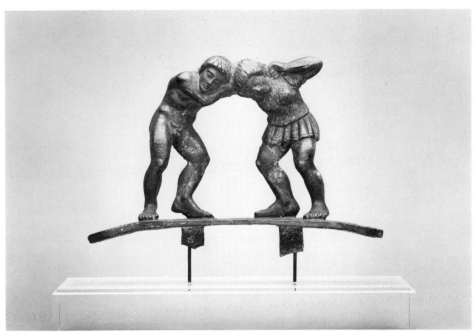

Etruscan, late fourth century B.C.
Wrestlers ("Peleus and Atalanta"), handle of a cista lid
Bronze, preserved height 9.5 cm.
Museum purchase (85-2)

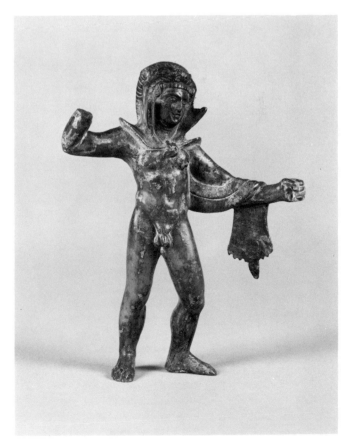

Etruscan, late fourth century B.C.
Herakles
Bronze, height 16.5 cm.
Gift of the Friends of The Art Museum in honor
of Frances Follin Jones's thirtieth year at
The Art Museum (73-7)

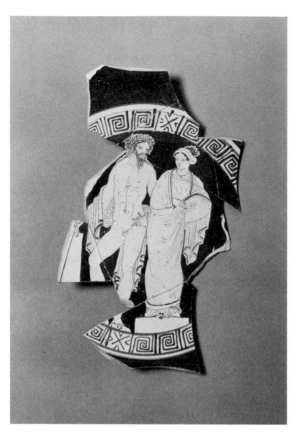

Etruscan (Faliscan), early fourth century B.C.
Nude Male, and Draped Female Standing on Base,
red-figure kylix, Near the Diespater Painter
Terracotta, preserved diameter 23.0 cm.
Gift of Allan Marquand, Class of 1874, in 1890 (50-30)

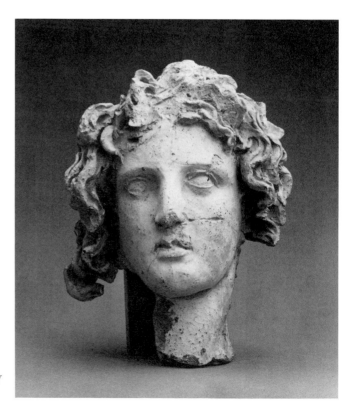

Etruscan, second century B.C.
Head of a Satyr
Terracotta, preserved height 19.5 cm.
Bequest of Miss Jessie P. Frothingham in memory
of her father and brother (49-9)

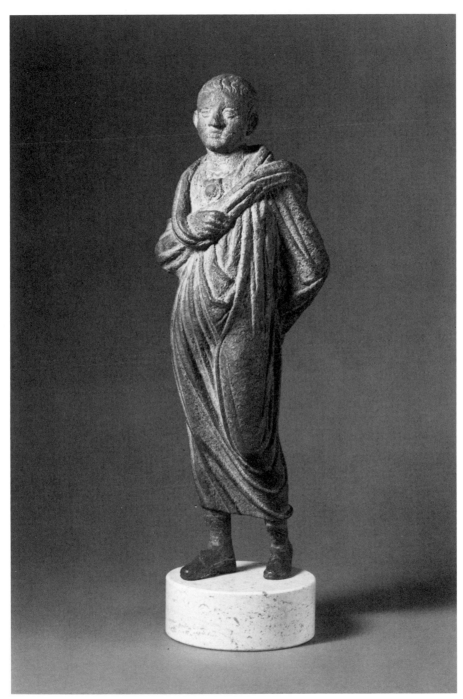

Roman, first century B.C.
Boy
Bronze, height 34.5 cm.
Given in memory of Frank Jewett Mather, Sr.,
by his children (29-188)

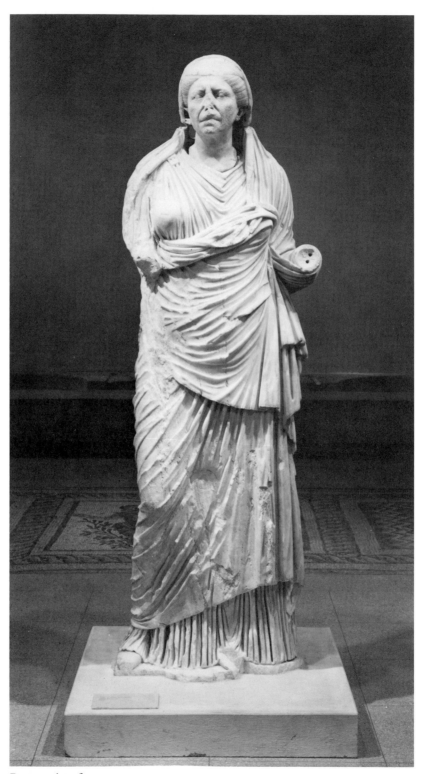

Roman, late first century B.C.
Woman (Possibly a Priestess)
Marble (body of Pentelic; head of island marble, probably Parian), height 1.9 m.
Museum purchase (80-34)

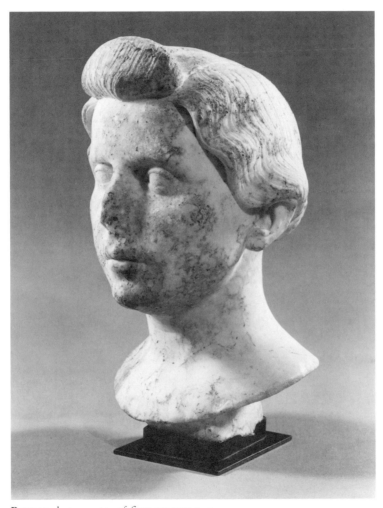

Roman, last quarter of first century B.C.
Portrait Bust of a Young Woman
Marble, height 34.0 cm.
Museum purchase, Fowler McCormick, Class of 1921, Fund (84-77)

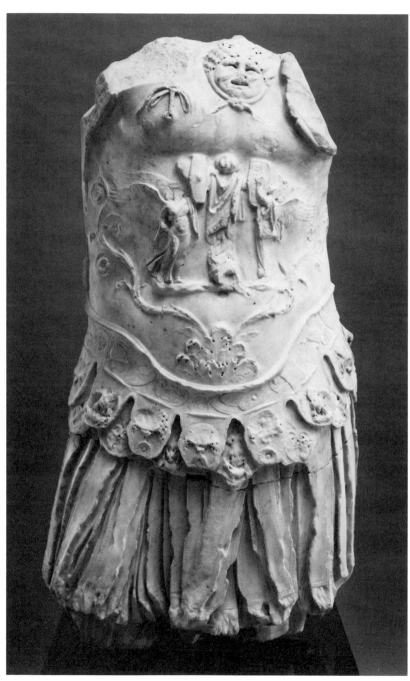

Roman, A.D. 81–96
Cuirassed Statue of an Emperor (Domitian)
Marble, preserved height 1.2 m.
Museum purchase, Caroline G. Mather Fund (84-2)

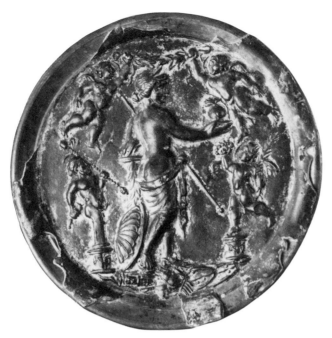

Roman, late first century A.D.
Venus Victrix, mirror
Gilt bronze, diameter 10.0 cm.
Museum purchase with funds given by
Mitchell Wolfson, Jr., Class of 1963 (85-1)

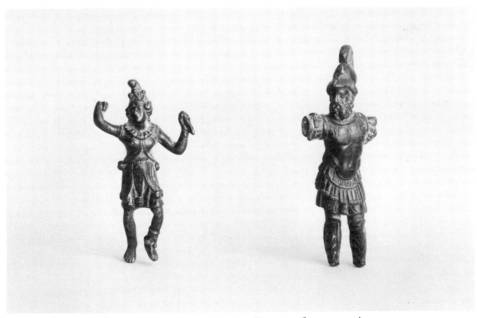

Roman, late second century A.D.
Mime Dancer
Bronze, height 7.5 cm.
Bequest of Albert Mathias Friend, Jr.,
Class of 1915 (56-101)

Roman, first–second century A.D.
Mars
Bronze, preserved height 9.1 cm.
Museum purchase with funds given by the
Guennol Charitable Foundation (71-9)

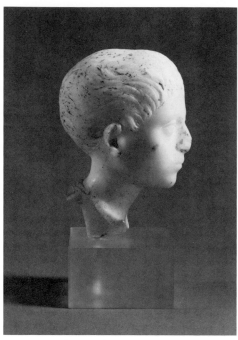

Roman, mid-second century A.D.
Portrait Bust of a Boy
Marble, preserved height 13.0 cm.
Museum purchase with funds given by family and
friends in memory of Mathias Komor (84-15)

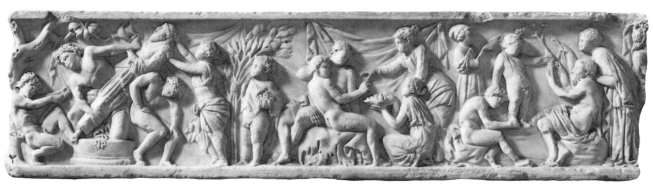

Roman, second century A.D.
Scenes from the Life of Dionysos, front panel of a sarcophagus
Marble, height 38.5 cm.
Museum purchase, John Maclean Magie and Gertrude Magie Fund (49-110)

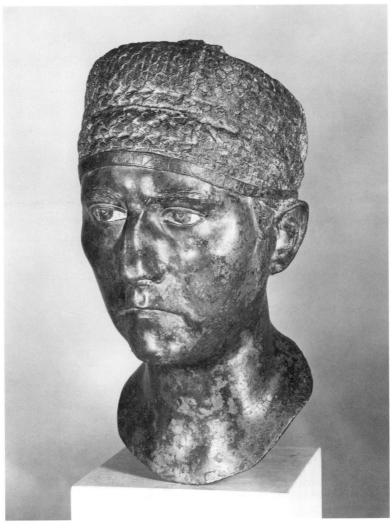

Roman, first half of the second century A.D.
Portrait of a Woman
Bronze, height 33.0 cm.
Museum purchase, Fowler McCormick, Class of 1921, Fund (80-10)

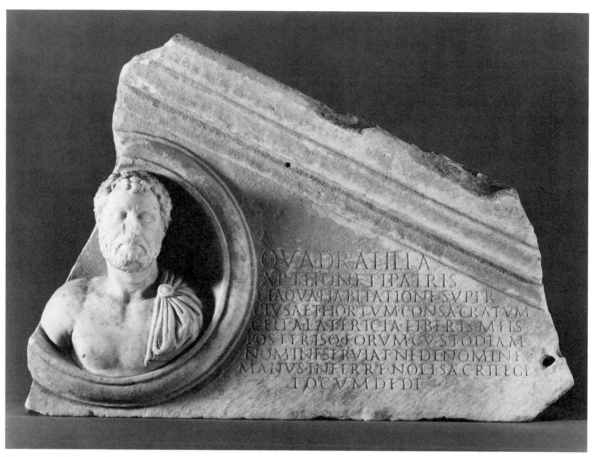

Roman, mid-second century A.D.
Pediment of a Private Sepulchral Monument
Marble, preserved height 47.0 cm.
Museum purchase, Carl Otto von Kienbusch, Jr., Memorial Collection Fund,
and funds given by Mr. and Mrs. Leon Levy (85-34)

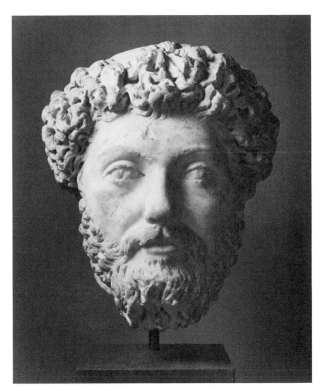

Roman, late second century A.D.
Marcus Aurelius
Marble, preserved height 34.0 cm.
Museum purchase, Carl Otto von Kienbusch, Jr.,
Memorial Collection (58-1)

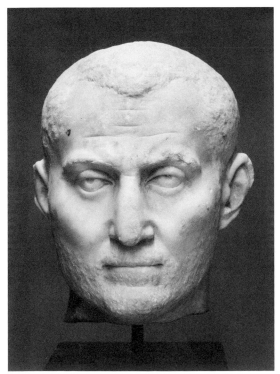

Roman, mid-third century A.D.
Portrait of a Man
Marble, preserved height 26.0 cm.
Museum purchase, Wilmer Hoffman,
Class of 1913, Fund (70-1)

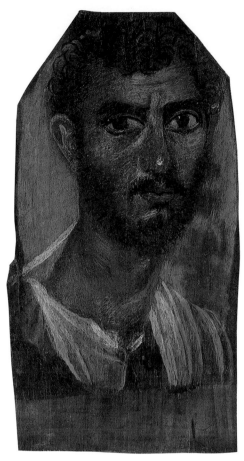

Roman (Fayum), mid-second century A.D.
Portrait of a Young Man
Encaustic on wood, height 40.0 cm.
Promised gift of Gillett G. Griffin

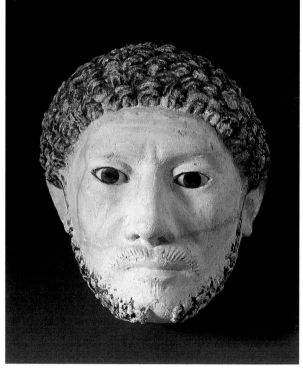

Roman, second century A.D.
Funerary Mask of a Man
Plaster, preserved height 21.5 cm.
Promised gift of Gillett G. Griffin

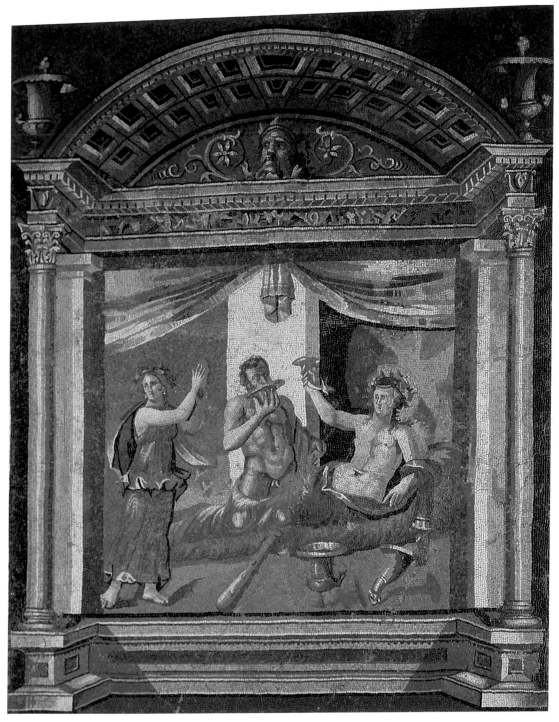

Roman, early third century A.D.
Drinking Contest Between Dionysos and Herakles, mosaic pavement from the House
of the Drinking Contest, Antioch
Stone, height 5.26 m.
Gift of The American Committee for the Excavation of Antioch and Vicinity, 1939 (65-216)

Coptic, fifth century A.D.
Orpheus and the Animals, fragment of a tunic
Textile (red wool on white linen), height 21.8 cm.
Museum purchase (52-76)

Coptic, fifth century A.D.
Muse, fragment of a tunic
Textile (red wool on white linen), height 19.5 cm.
Museum purchase (52-77)

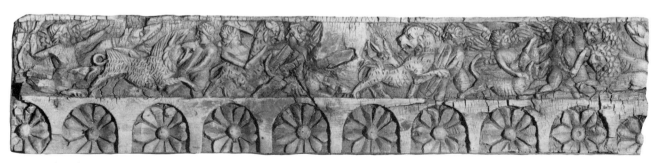

Coptic, fourth century A.D.
Erotes Struggling with Animals, decorative panel
Wood, height 36.5 cm.
Museum purchase (59-52)

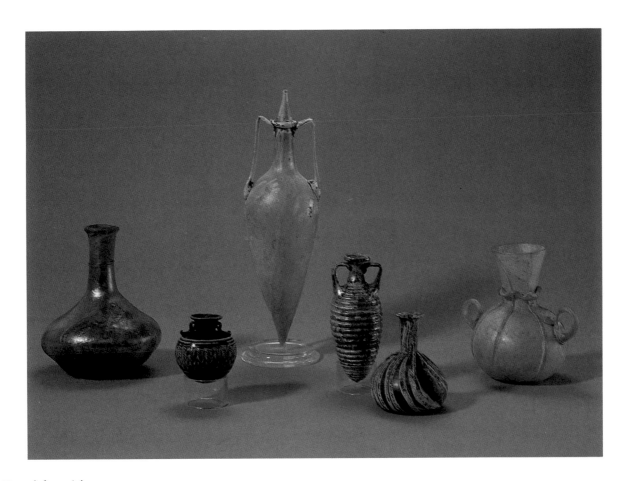

From left to right:

Roman, first century A.D.
Bottle
Blown glass, pale blue-green, height 13.7 cm.
Gift of Misses E. L. and F. B. Godwin, daughters of
Harold Godwin, Class of 1879 (67-54)

Greek (Al Mina Group), sixth–fifth century B.C.
Aryballos
Core-formed glass, translucent blue and opaque yellow,
height 5.8 cm.
Gift of Horace Mayer (59-182)

Roman, third–fourth century A.D.
Pointed Amphoriskos
Blown glass, bluish white, height 26.5 cm.
Gift of Robert D. Huxley, Class of 1964, and Mrs. Huxley
in memory of Pete and Jane Breene (83-2)

Roman, first–second century A.D.
Amphoriskos
Mold-made glass, bright blue, height 11.5 cm.
Museum purchase, in part with funds given by
Frank Jewett Mather, Jr. (46-17)

Roman, first century B.C.–first century A.D.
Unguentarium
Variegated ribbon glass, height 8.2 cm.
Given in memory of Allan Marquand, Class of 1874, and
Mrs. Marquand by their daughters (51-53)

Islamic, sixth–eighth century A.D.
Two-handled Jar
Blown glass, pale green, height 12.5 cm.
Gift of Mrs. Platt from the bequest of Dan Fellows Platt,
Class of 1895 (46-355)

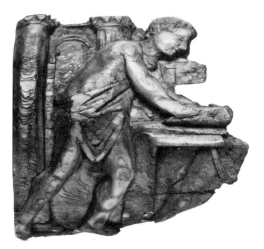

Roman (Alexandrian), third–fourth century A.D.
Carpenter at Work
Ivory, height 13.0 cm.
Bequest of Albert Mathias Friend, Jr., Class of 1915 (56-105)

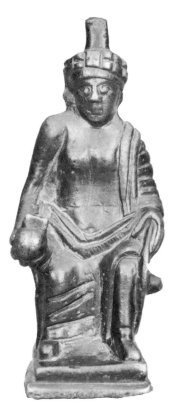

Roman, fifth–sixth century A.D.
The Emperor Constantine, steelyard
weight in form of a statuette
Bronze, height 12.5 cm.
Museum purchase (55-3257)

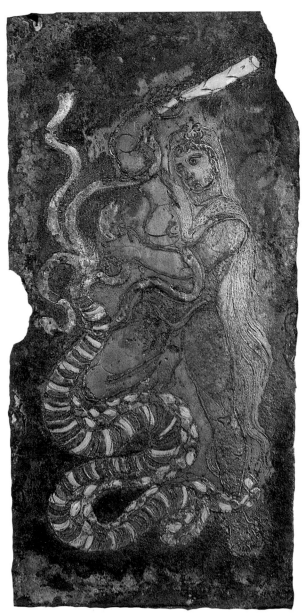

Roman, fourth century A.D.
Herakles and the Hydra
Bronze, with copper and silver inlay, height 18.8 cm.
Museum purchase, Carl Otto von Kienbusch, Jr.,
Memorial Collection (71-35)

MEDIEVAL AND BYZANTINE ART

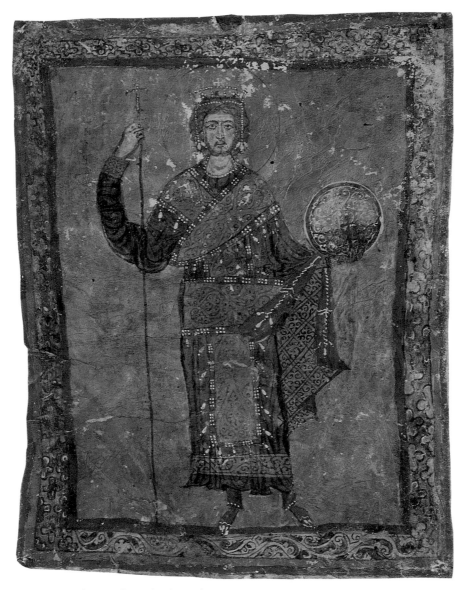

Byzantine, late tenth–early eleventh century
Constantine, leaf from a Gospel Book
Vellum, 22.6 × 17.5 cm.
Anonymous gift (32-14)

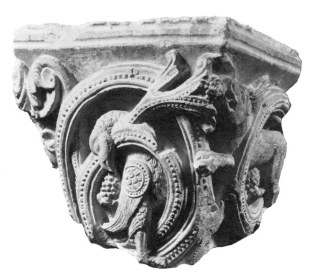

French, mid-twelfth century
Bird and Lion Entwined by Rinceaux, capital from
the Abbey Church of Sainte-Madeleine, Vézelay
Limestone, preserved height 24.5 cm.
Museum purchase with funds given by Gordon McCormick,
Class of 1917 (49-117)

Italian (Reggio Emilia), late twelfth–early
thirteenth century
The Archangel Gabriel
Marble, height 75.0 cm.
Gift of G. J. DeMotte, 1923 (4)

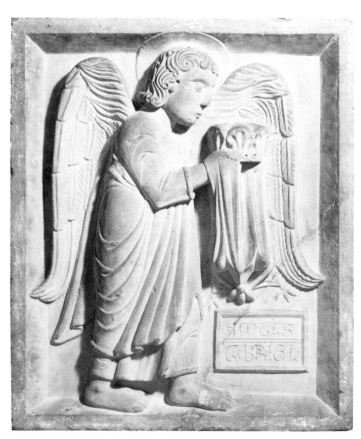

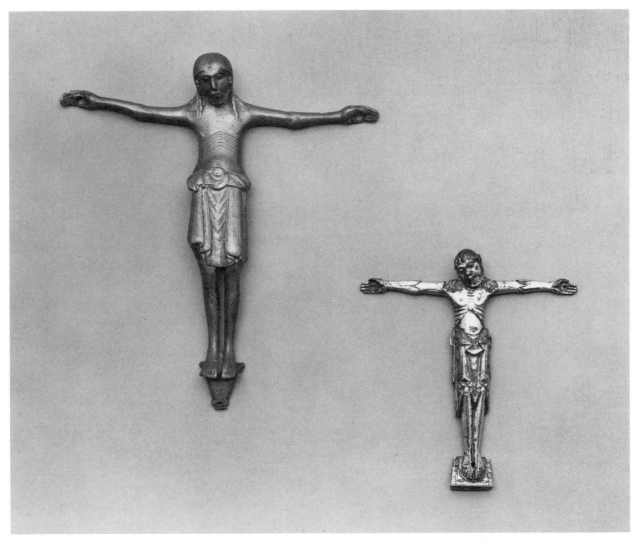

Mosan (or German?), first half of the twelfth century
Corpus for a Crucifix
Gilt bronze, height 19.0 cm.
Bequest of Albert Mathias Friend, Jr., Class of 1915 (56-107)

French (?), twelfth century
Corpus for a Crucifix
Gilt bronze, height 13.1 cm.
Museum purchase (41-24)

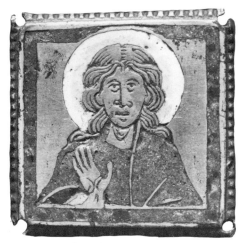

German (Rhenish), late twelfth century
Saint John
Gilt and enameled bronze, height 4.8 cm.
Bequest of Gilbert S. McClintock,
Class of 1908 (59-74)

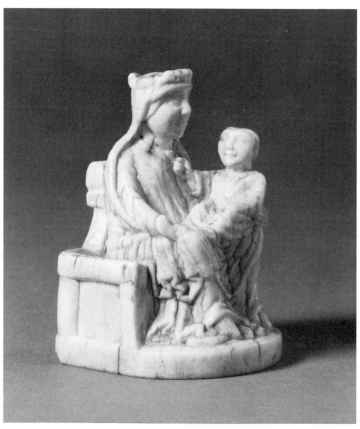

German, ca. 1220–1230
Madonna and Child Enthroned
Ivory, height 5.5 cm.
Museum purchase with funds given by Gordon McCormick,
Class of 1917 (49-120)

56

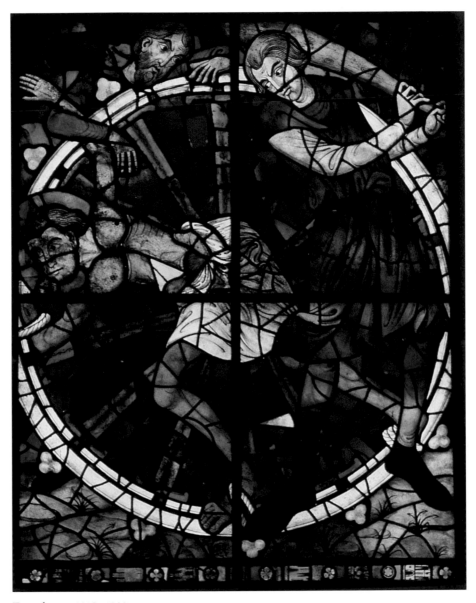

French, ca. 1215–1220
Martyrdom of Saint George, window from the choir of Chartres Cathedral. Much of the upper right quadrant original; the remainder of the window restored in the nineteenth century, probably by Viollet-le-Duc
Pot-metal glass, height as restored 1.7 m.
Museum purchase, Trumbull-Prime Fund, 1924 (71)

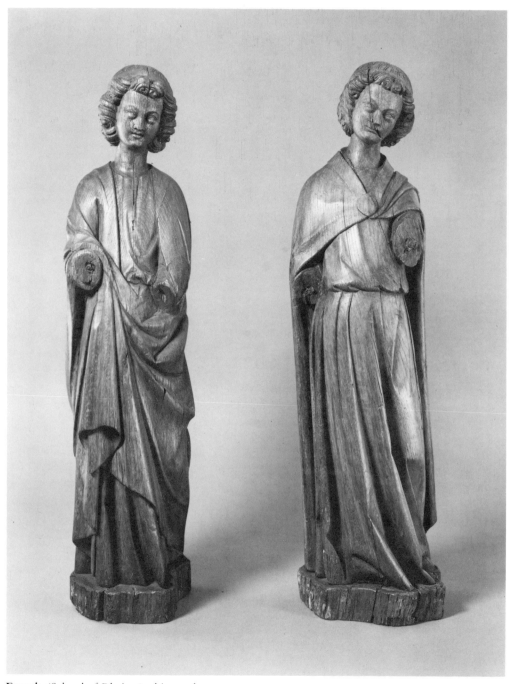

French (School of Rheims), thirteenth century
Pair of Angels
Oak, with traces of polychrome, height 67.5 cm.; 67.0 cm.
Museum purchase, Carl Otto von Kienbusch, Jr., Memorial Collection (54-46, 54-47)

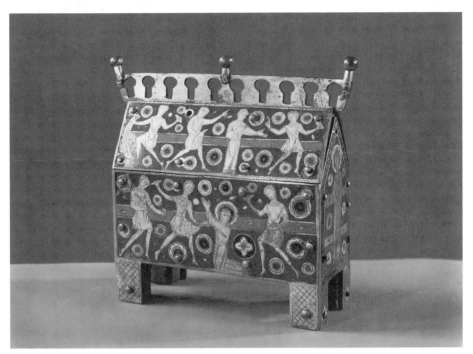

French (Limoges), thirteenth century
Martyrdom of Saint Stephen, reliquary
Gilt copper and enamel, height 16.7 cm.
Museum purchase (43-91)

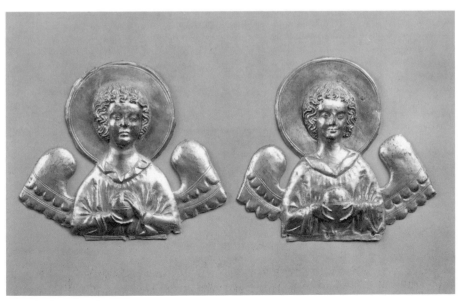

French, fourteenth century
Pair of Angels, gable figures from a reliquary of the Cathedral of Coire, Switzerland
Gilt copper, height 14.0 cm. each
Museum purchase, Carl Otto von Kienbusch, Jr., Memorial Collection (49-151, 49-152)

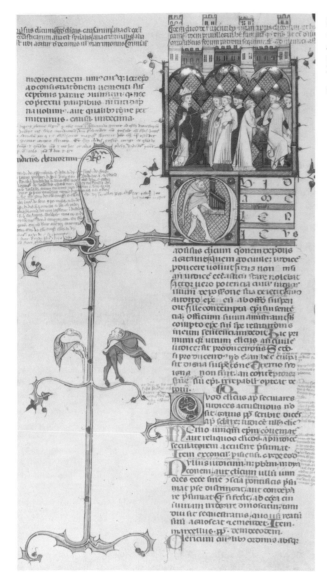

Southern France, early fourteenth century
Cleric Before a Bishop and a Civil Magistrate; Man with a Portable Organ in Initial O, and Marginal Grotesques, leaf from a *Decretum Gratiani* (causa XI)
Vellum, 34.3 × 18.2 cm.
Gift of Clinton D. Winant, Class of 1911, in 1927 (1040)

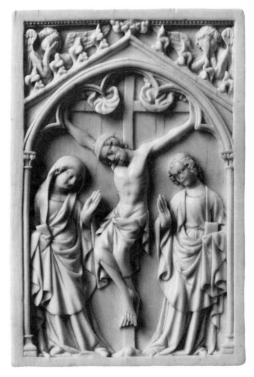

French, early fourteenth century
Crucifixion
Ivory, height 13.0 cm.
Museum purchase, Carl Otto von Kienbusch, Jr., Memorial Collection (39-33)

60

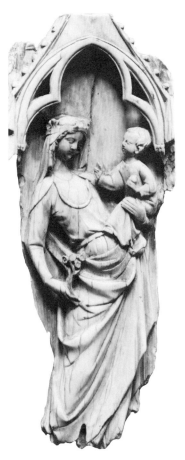

French, second quarter of the fourteenth century
Madonna and Child
Ivory, preserved height 15.7 cm.
Museum purchase, John Maclean Magie and
Gertrude Magie Fund (53-57)

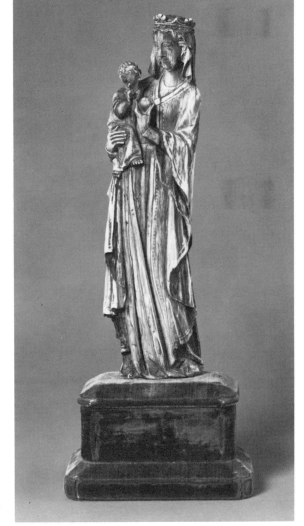

French, fourteenth century
Madonna and Child
Ivory, height 22.0 cm.
Gift of Alexander P. Morgan, Class of 1922, and his nieces
and nephew, Sarah Gardner Tiers, Mary Josephine Fenton,
and Alfred Gardner, Class of 1952 (63-37)

61

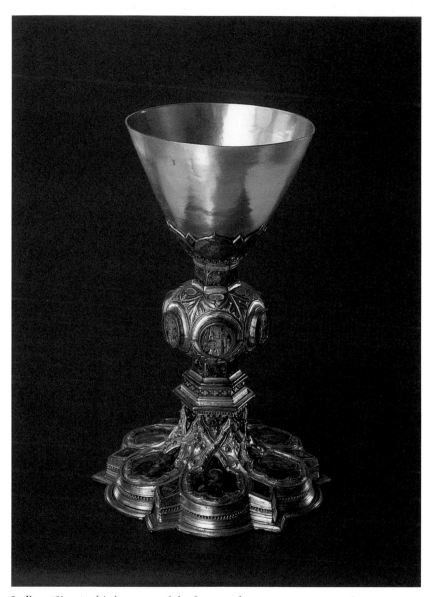

Italian (Siena), third quarter of the fourteenth century
Chalice
Gilt copper, silver, and enamel, height 21.0 cm.
Museum purchase with funds given by Gordon McCormick,
Class of 1917 (49-125)

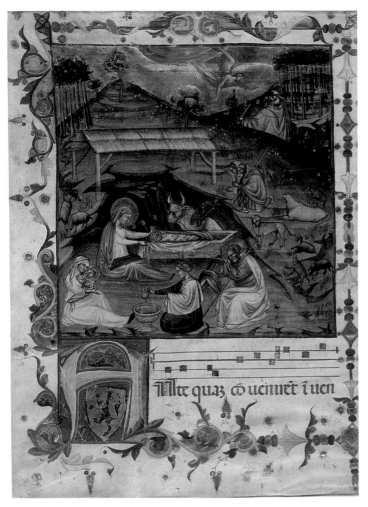

Italian (Abruzzi), late fourteenth–early
fifteenth century
Nativity, and Annunciation to the Shepherds,
leaf from an Antiphonary, attributed to the Master
of the Beffi Triptych
Vellum, 55.0 × 40.3 cm.
Gift of Alastair B. Martin, Class of 1938 (58-17)

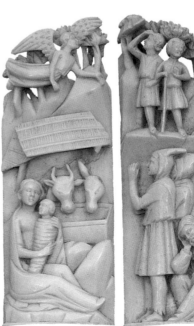

Italian, ca. 1400
Nativity, and Annunciation to the Shepherds, diptych
Ivory, height 11.0 cm.; 11.2 cm.
Museum purchase, Caroline G. Mather Fund (59-41; 59-42)

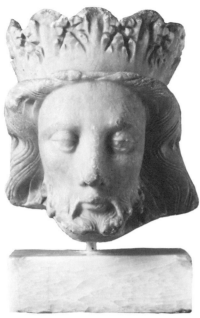

English (Nottingham School), ca. 1400
Head of God the Father
Alabaster, preserved height 20.5 cm.
Museum purchase, Carl Otto von Kienbusch, Jr.,
Memorial Collection (55-3262)

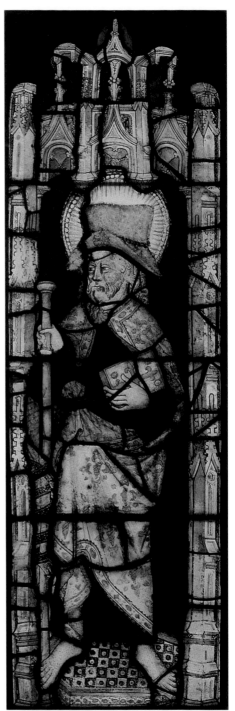

English, second half of the fifteenth century
Saint James
Pot-metal glass and white glass with silver stain,
height 1.3 m.
Bequest of Carl Otto von Kienbusch, Class of 1906,
for the Carl Otto von Kienbusch, Jr.,
Memorial Collection (77-43)

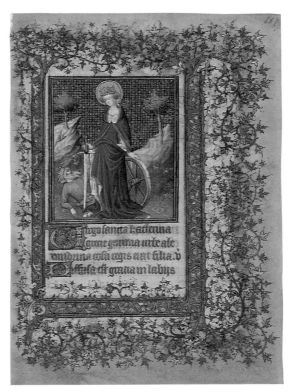

French (Paris), 1407
Saint Catherine of Alexandria Transfixing the Emperor Maxentius, leaf from a Book of Hours, attributed to the Workshop of the Boucicaut Master
Vellum, 17.5 × 13.0 cm.
Gift of Harold K. Hochschild (79-43)

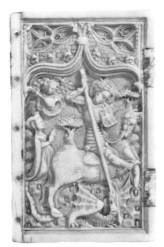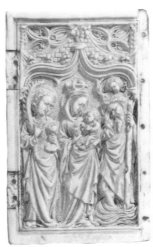

Dutch, ca. 1450–1470
Saint George; *Madonna and Child, with Saints John and Christopher*, diptych
Ivory, height 7.7 cm. each
Museum purchase, Carl Otto von Kienbusch, Jr., Memorial Collection (56-136)

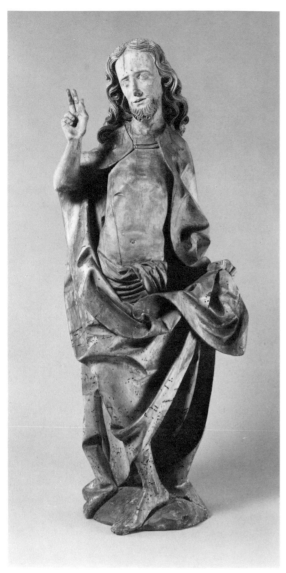

German (Upper Rhine), ca. 1480–1490
Risen Christ
Lindenwood, height 89.0 cm.
Gift of Harry M. Vale, 1927 (1036)

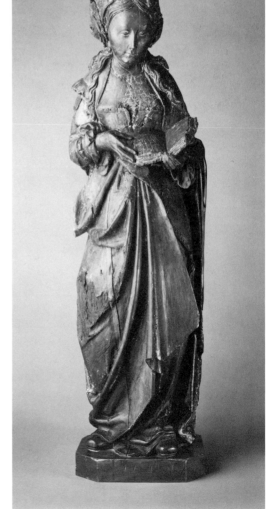

Flemish (Brabant), early sixteenth century
Saint Catherine of Alexandria
Walnut, height 1.1 m.
Museum purchase, Carl Otto von Kienbusch, Jr.,
Memorial Collection (53-77)

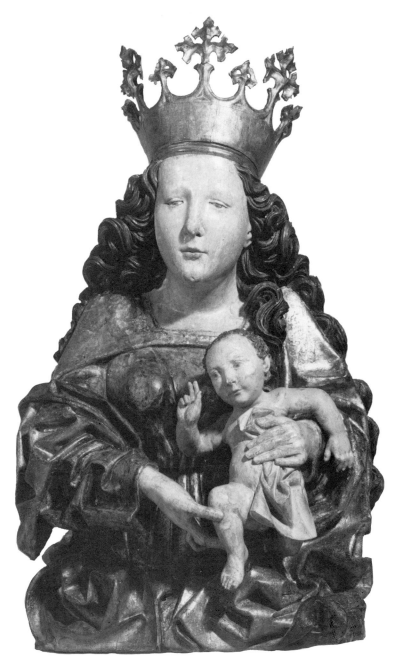

German, late fifteenth century
Madonna and Child, attributed to the Master of the Dangolsheimer Madonna
Polychrome wood, height 86.5 cm.
Museum purchase, Carl Otto von Kienbusch, Jr., Memorial Collection (54-73)

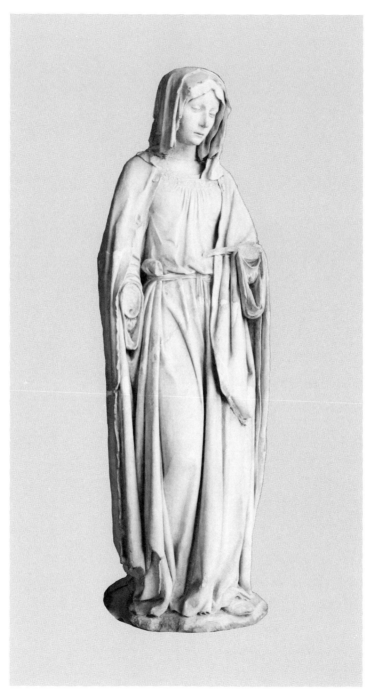

French (Champagne School), ca. 1515–1525
Saint Martha (?)
Limestone, height 1.2 m.
Gift of Allan Marquand, Class of 1874, in 1908 (47)

French, ca. 1465–1475
Saint Louis of France Fighting the Saracens,
from the Chapel of the Palais de Justice, Riom
Pot-metal glass and white glass with silver
stain, height 1.0 m.
Gift of Miss Susan D. Bliss in 1949 (50-26)

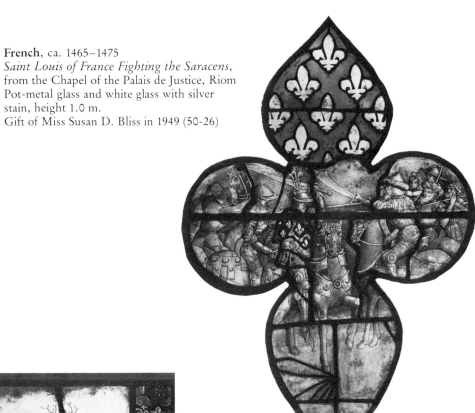

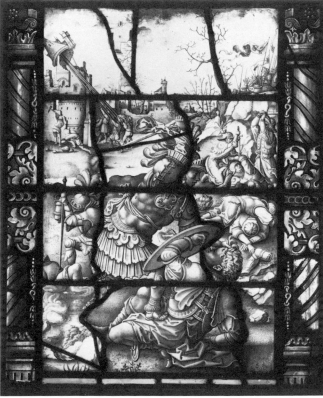

Flemish, sixteenth century
Gideon and the Tower of Penuel (Judges 8:17)
White glass with silver stain, height 68.0 cm.
Gift of Stanley Mortimer, Class of 1919 (60-48)

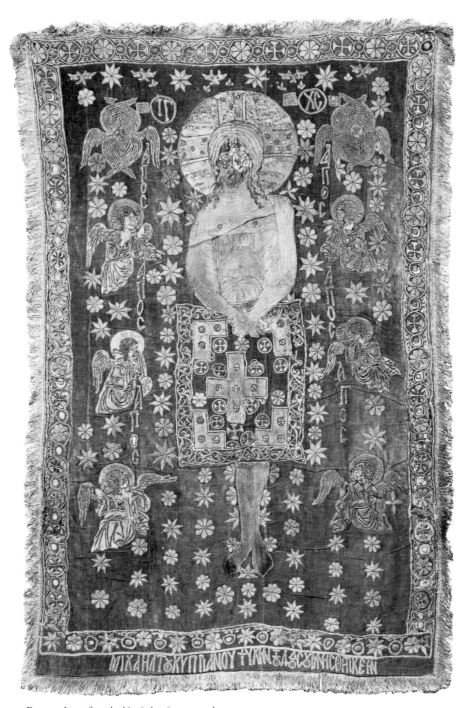

Byzantine, first half of the fourteenth century
Epitaphios, from the Sumela Monastery, Trebizond
Textile (silver thread appliqué on red silk ground; velvet backing and
gold fringe modern), length 1.5 m.
Gift of Mr. and Mrs. Sherley W. Morgan (66-218)

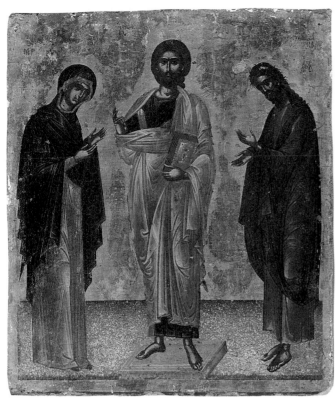

Byzantine (Cretan School), early sixteenth century
Deesis, icon
Tempera and gold leaf on panel, 25.0 × 21.0 cm.
Museum purchase (51-4)

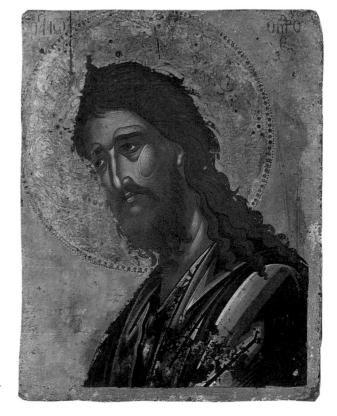

Byzantine, seventeenth century
John the Baptist
Tempera and gold leaf on panel, 35.0 × 27.2 cm.
Museum purchase (51-81)

EUROPEAN PAINTING AND SCULPTURE

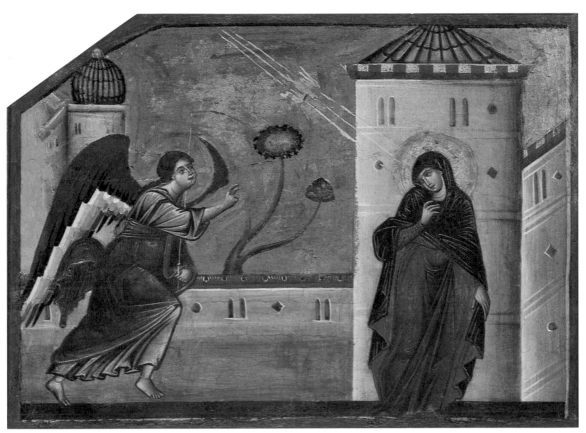

Guido da Siena (Italian, active ca. 1250–ca. 1300)
Annunciation
Tempera on panel, 35.1 × 48.8 cm.
Museum purchase, Caroline G. Mather Fund, in 1924 (144)

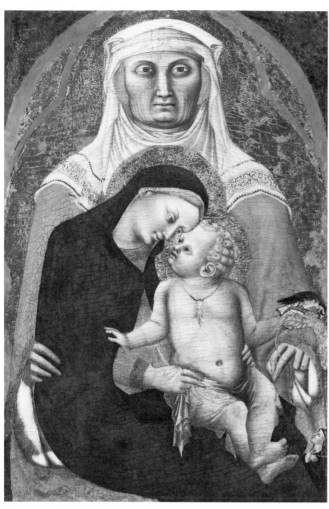

Francesco Traini (Italian, active ca. 1321–1363)
Saint Anne, Virgin, and Child
Tempera on panel, 84.9 × 56.0 cm.
Bequest of Frank Jewett Mather, Jr. (63-2)

Workshop of Nardo (Italian, active third quarter
of the fourteenth century)
Saint Peter
Tempera on panel, 47.3 × 22.9 cm.
Promised gift, anonymous donor

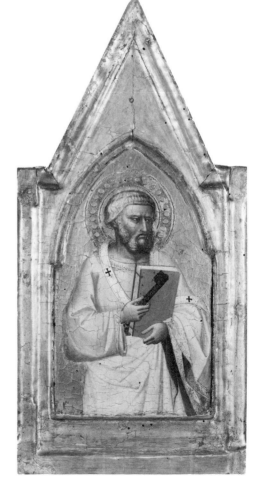

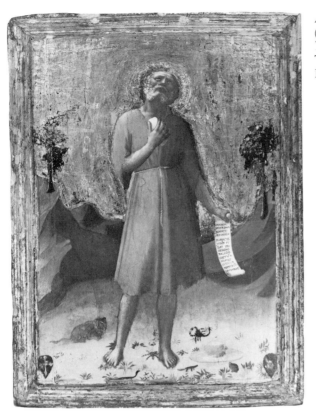

Attributed to Giovanni di Francesco Toscani
(Italian, 1370/80–1430)
The Penitent Saint Jerome
Tempera on panel, 50.0 × 35.0 cm.
Bequest of Frank Jewett Mather, Jr. (63-1)

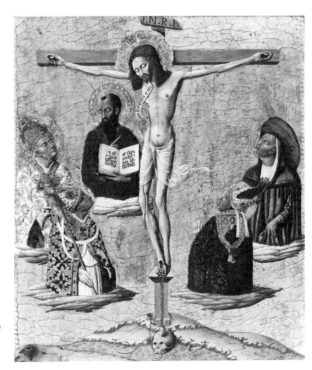

Matteo di Giovanni (Italian, ca. 1430–1495)
Doctors of the Church Contemplating the Crucifixion
Tempera on panel, 51.7 × 44.0 cm.
Bequest of Dan Fellows Platt, Class of 1895 (62-64)

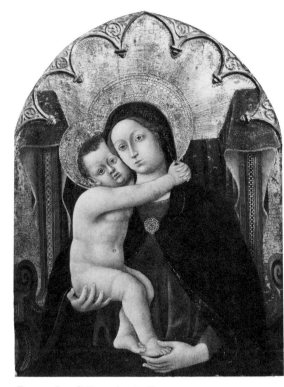

Domenico di Bartolo (Italian, ca. 1400–1447)
Madonna and Child
Tempera on panel, 91.0 × 66.0 cm.
Bequest of Dan Fellows Platt, Class of 1895 (62-58)

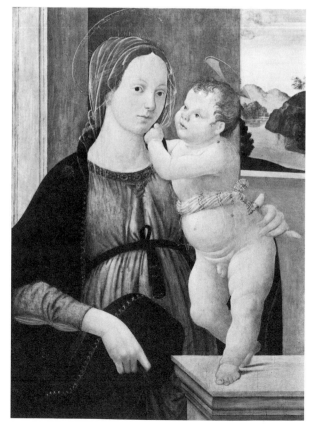

Sebastiano di Bartolo Mainardi (Italian, ca. 1450/55–1513)
Madonna and Child
Tempera and oil on panel, 91.0 × 63.2 cm.
Gift of H. Kelley Rollings, Class of 1948,
and Mrs. Rollings, in memory of Mr. Rollings's
parents, Harry and Elizabeth Rollings (83-38)

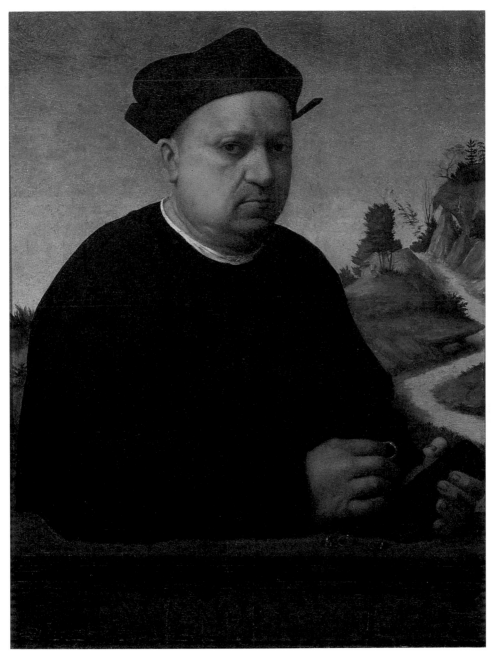

Francesco di Cristofano, called **Franciabigio** (Italian, 1482/3–1525)
Portrait of a Jeweler, 1516
Oil on panel, 69.5 × 51.6 cm.
Museum purchase, Fowler McCormick, Class of 1921, Fund (83-4)

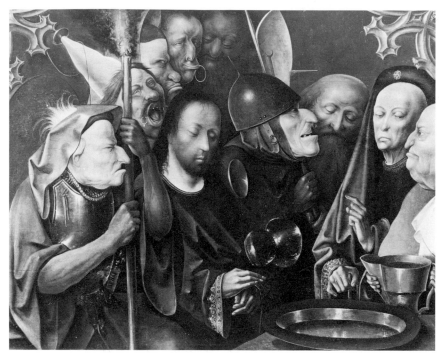

Attributed to Hieronymus Bosch (Dutch, ca. 1450–1516)
Christ Before Pilate
Oil on panel, 0.8 × 1.0 m.
Gift of Allan Marquand, between 1922 and 1924 (711)

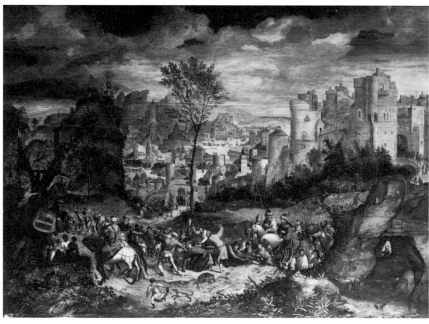

Herri met de Bles (Flemish, ca. 1510–after 1554)
Road to Calvary
Oil on panel, 0.8 × 1.1 m.
Gift of the Friends of The Art Museum (50-1)

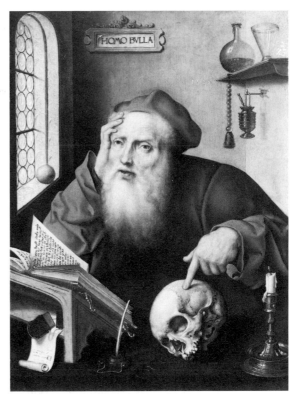

Joos van Cleve (Flemish, ca. 1485–1540/41)
Saint Jerome in His Study
Oil on panel, 39.7 × 28.8 cm.
Gift of Joseph F. McCrindle (82-76)

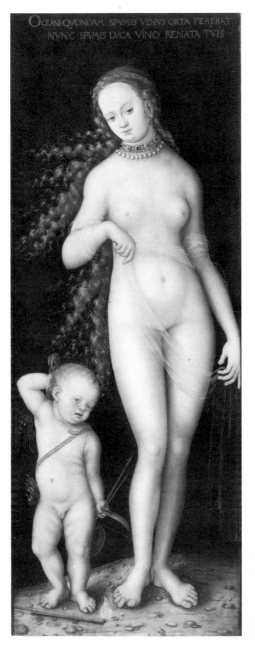

Lucas Cranach the Elder (German, 1472–1553)
Venus and Amor
Oil on panel, 1.0 × 0.4 m.
Museum purchase with funds given by George L.
Craig, Jr., Class of 1921,
and Mrs. Craig (68-111)

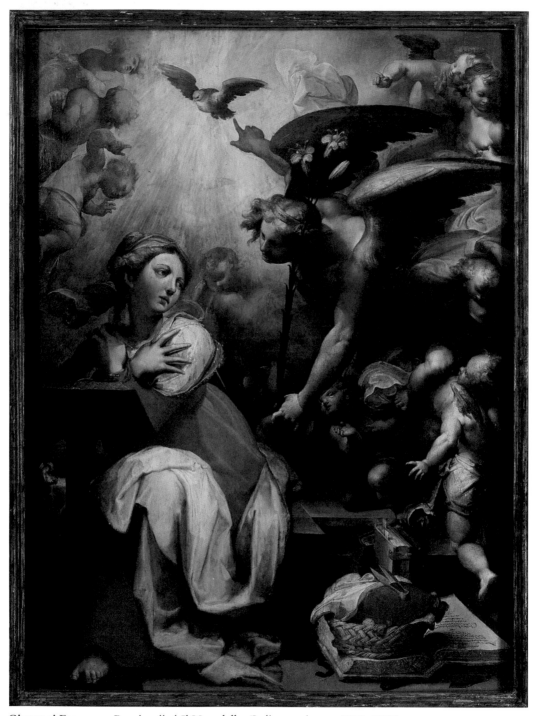

Giovanni Francesco Bezzi, called **Il Nosadella** (Italian, active ca. 1550–1571)
Annunciation
Oil on panel, 1.1 × 0.8 m.
Museum purchase, Fowler McCormick, Class of 1921, Fund (76-25)

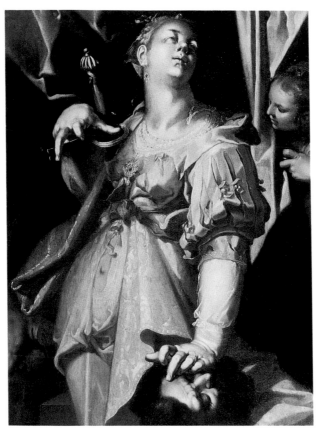

Joachim Antonisz. Wtewael (Dutch, ca. 1566–1638)
Judith with the Head of Holofernes
Oil on canvas, 1.1 × 0.8 m.
Museum purchase, with funds given by George L. Craig, Jr.,
Class of 1921, and Mrs. Craig (75-11)

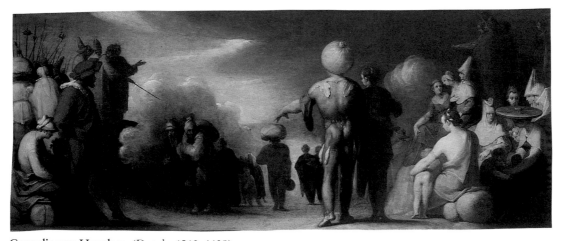

Cornelis van Haarlem (Dutch, 1562–1638)
The Israelites Crossing the Red Sea
Oil on panel, 0.4 × 1.0 m.
Museum purchase, with funds given by George L. Craig, Jr., Class of 1921, and Mrs. Craig (73-74)

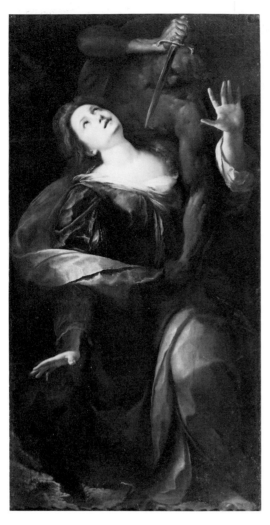

Giulio Cesare Procaccini (Italian, 1574–1625)
Martyrdom of Saint Justina
Oil on canvas, 1.7 × 0.9 m.
Museum purchase, with funds given by George
L. Craig, Jr., Class of 1921, and Mrs. Craig
(75-31)

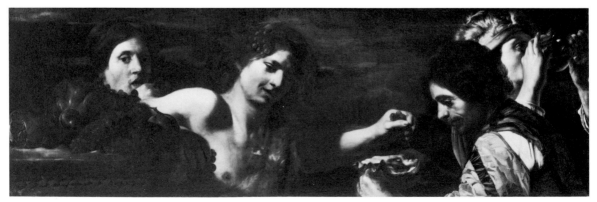

Nicolas Regnier (French, 1591–1667)
Allegory of Autumn
Oil on canvas, 0.5 × 1.7 m.
Museum purchase, with funds given by George L. Craig, Jr., Class of 1921,
and Mrs. Craig, in memory of James F. Oates, Jr., Class of 1921 (83-6)

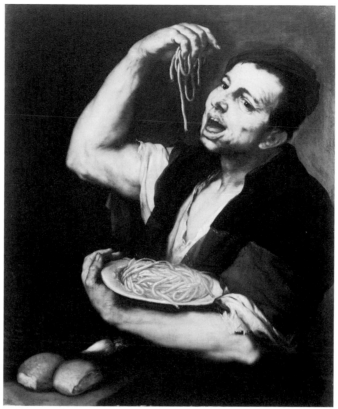

Luca Giordano (Italian, 1632–1705)
Pasta Eater: Allegory of Taste
Oil on canvas, 91.5 × 74.0 cm.
Museum purchase, John Maclean Magie
and Gertrude Magie Fund (85-35)

Nicolas Regnier (French, 1591–1667)
Allegory of Winter
Oil on canvas, 0.5 × 1.7 m.
Museum purchase, with funds given by George L. Craig, Jr., Class of 1921,
and Mrs. Craig, in memory of James F. Oates, Jr., Class of 1921 (83-7)

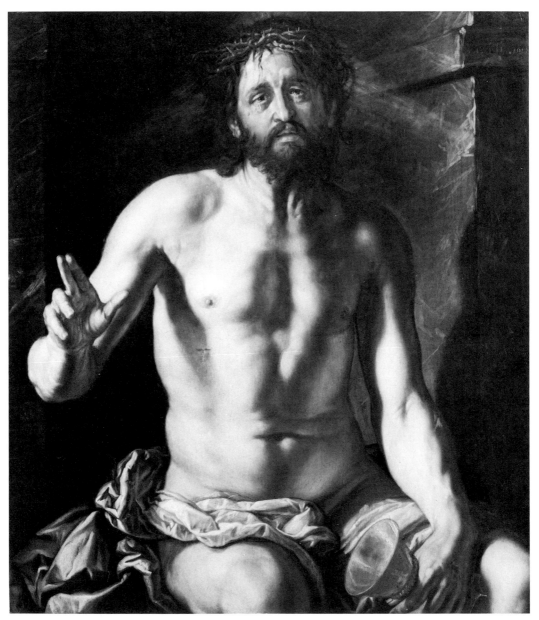

Hendrik Goltzius (Dutch, 1558–1617)
Christ as Redeemer
Oil on panel, 89.0 × 78.7 cm.
Museum purchase, Fowler McCormick, Class of 1921, Fund (85-36)

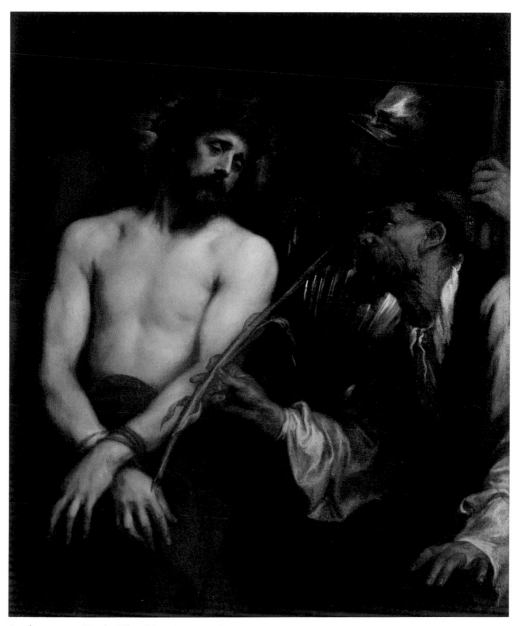

Anthony van Dyck (Flemish, 1599–1641)
The Mocking of Christ
Oil on canvas, 1.1 × 0.9 m.
Gift of the Charles Ulrick and Josephine Bay Foundation, Inc.,
through Colonel C. Michael Paul (75-12)

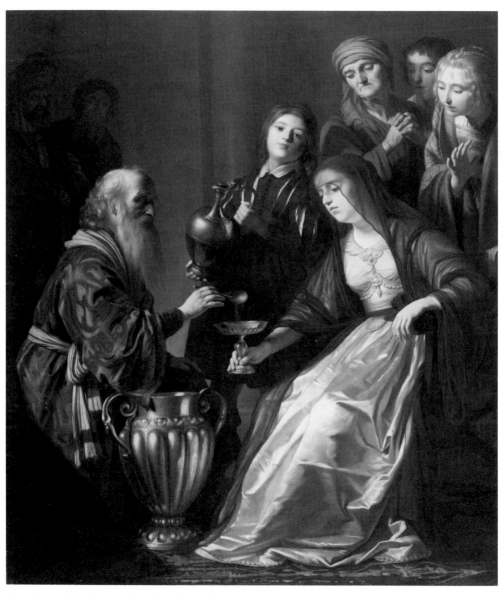

Gerrit van Honthorst (Dutch, 1590–1656)
Artemisia
Oil on canvas, 1.7 × 1.5 m.
Museum purchase, with funds given by George L. Craig, Jr., Class of 1921,
and Mrs. Craig (68-117)

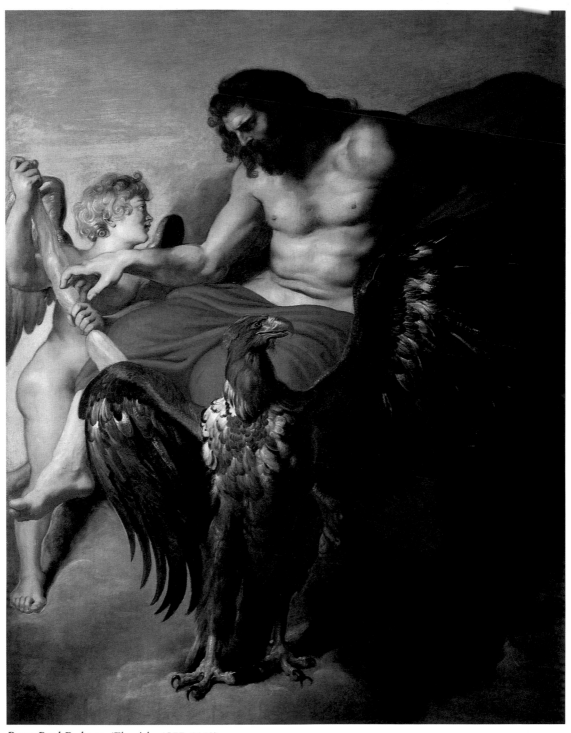

Peter Paul Rubens (Flemish, 1577–1640)
The Forbes Rubens: *Cupid Supplicating Jupiter*
Oil on canvas, 2.5 × 1.9 m.
Promised gift of The *Forbes* Magazine Collection: Malcolm S. Forbes, Class of 1941,
Malcolm S. Forbes, Jr., Class of 1970, and Christopher Forbes, Class of 1972

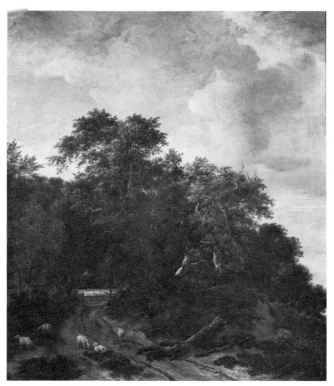

Jacob van Ruisdael (Dutch, 1628/29–1682)
Forest Landscape
Oil on canvas, 61.0 × 53.0 cm.
Gift of Elias Wolf, Class of 1920, and Mrs. Wolf (79-46)

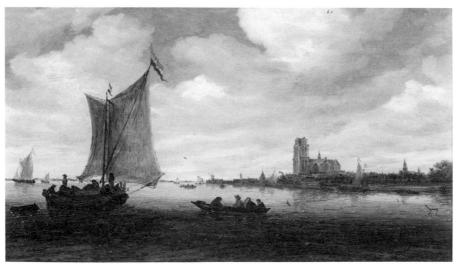

Salomon van Ruysdael (Dutch, 1600/3–1670)
Dordrecht
Oil on panel, 34.5 × 61.0 cm.
Bequest of Brooks Emeny, Class of 1924 (80-13)

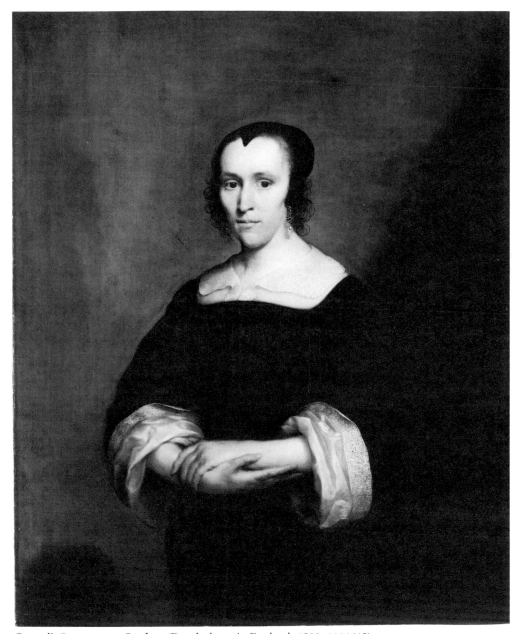

Cornelis Jonson van Ceulen (Dutch, born in England, 1593–1664/65)
Portrait of a Woman
Oil on canvas, 1.0 × 0.8 m.
Gift of Marco Grassi, Class of 1956, and Mrs. Grassi (84-67)

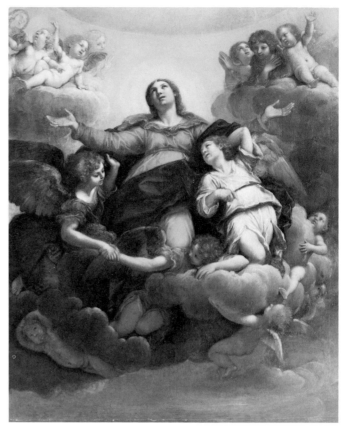

Francesco Albani (Italian, 1578–1660)
Assumption
Oil on panel, 31.8 × 26.0 cm.
Museum purchase, with funds given by George L. Craig,
Jr., Class of 1921, and Mrs. Craig (77-75)

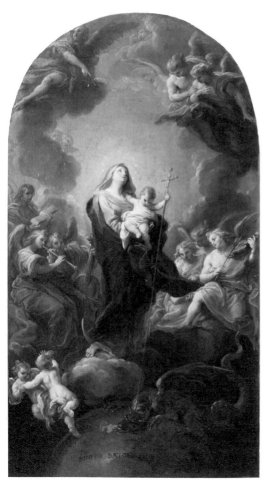

Pompeo Batoni (Italian, 1708–1787)
Madonna and Child in Glory
Oil on canvas, 41.6 × 23.0 cm.
Museum purchase, with funds given by George L.
Craig, Jr., Class of 1921, and Mrs. Craig (77-51)

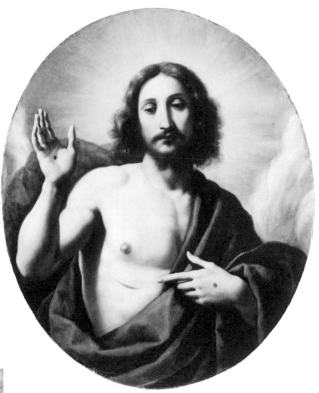

Matteo Rosselli (Italian, 1578–1650)
Christ the Redeemer
Oil on canvas, 1.0 × 0.8 m.
Gift of Joseph F. McCrindle (77-1)

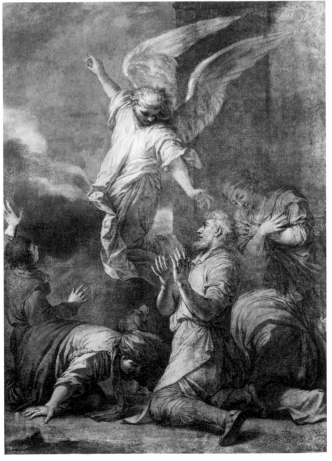

Salvator Rosa (Italian, 1615–1673)
The Angel Leaving the House of Tobias
Oil on paper, mounted on canvas, 1.4 × 1.0 m.
Promised gift of Joseph F. McCrindle

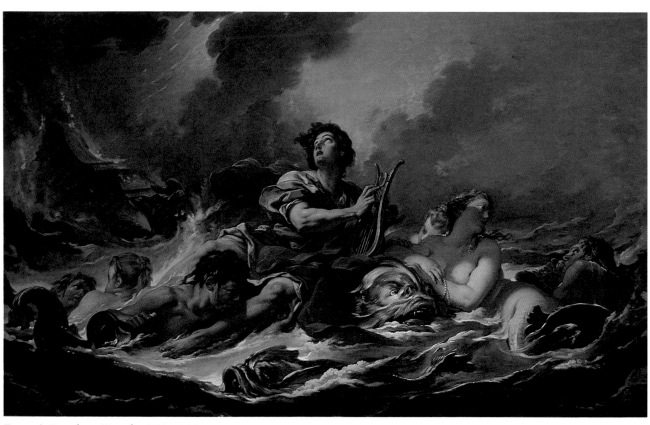

François Boucher (French, 1703–1770)
Arion on the Dolphin
Oil on canvas, 0.9 × 1.4 m.
Museum purchase, Fowler McCormick, Class of 1921, Fund (80-2)

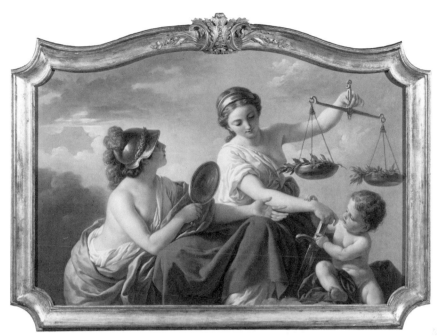

Louis-Jean-François Lagrenée (French, 1725–1805)
Justice Disarmed by Innocence and Applauded by Prudence, 1766
Oil on canvas, 1.0 × 1.5 m.
Museum purchase, John Maclean Magie and Gertrude Magie Fund (75-16)

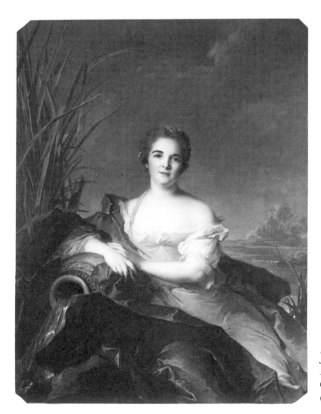

Jean-Marc Nattier (French, 1685–1766)
Mademoiselle de Flesselles, 1747
Oil on canvas, 1.4 × 1.0 m.
Gift of Mrs. H. Clinch Tate (64-5)

97

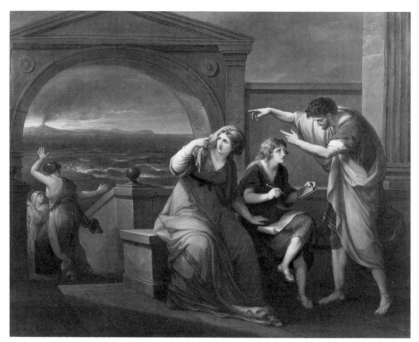

Angelica Kauffmann (British, born in Switzerland, 1741–1807)
Pliny the Younger and His Mother at Misenum, A.D. 79
Oil on canvas, 1.0 × 1.3 m.
Museum purchase, with funds given by Franklin H. Kissner (69-89)

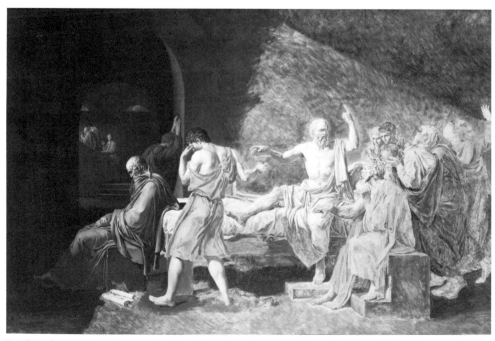

Studio of Jacques-Louis David (French, 1748–1825)
Death of Socrates
Oil on canvas, 1.3 × 2.0 m.
Museum purchase, with funds given by Carl D. Reimers (82-82)

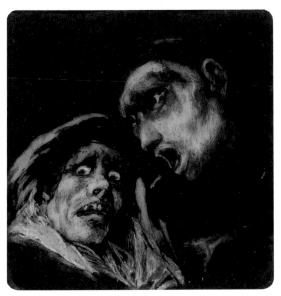

Francisco José de Goya y Lucientes
(Spanish, 1746–1828)
Monk Talking to an Old Woman
Color on ivory, 5.7 × 5.4 cm.
Museum purchase, Fowler McCormick,
Class of 1921, Fund (85-6)

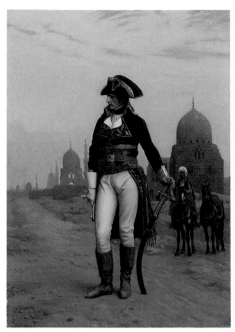

Jean-Léon Gérôme (French, 1824–1904)
Napoleon in Egypt
Oil on panel, 35.8 × 25.0 cm.
Museum purchase, John Maclean Magie
and Gertrude Magie Fund (53-78)

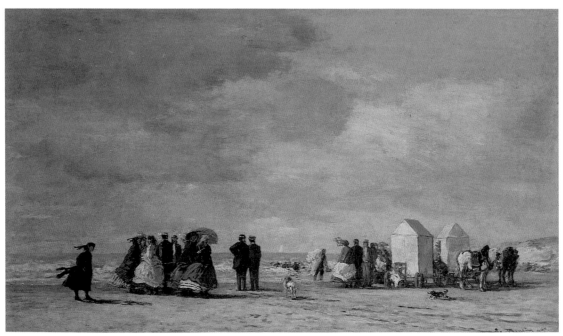

Eugène-Louis Boudin (French, 1824–1898)
The Beach at Trouville, 1865
Oil on canvas, 38.0 × 62.8 cm.
Gift of the Estate of Laurence Hutton, in 1913 (50-65)

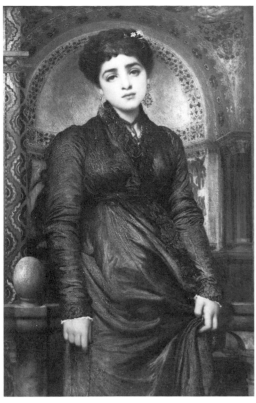

Frederic, Lord Leighton (British, 1830–1896)
After Vespers
Oil on canvas, 1.1 × 0.7 m.
Museum purchase (61-17)

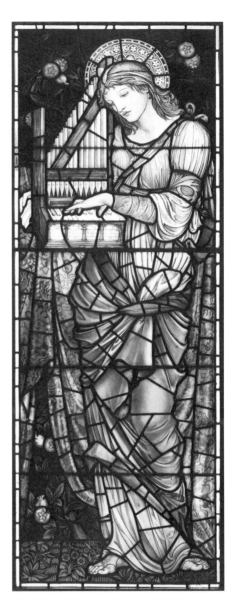

Sir Edward Burne-Jones (British, 1833–1898), designer; executed by William Morris & Co.
Saint Cecilia
Pot-metal glass and white glass with silver stain, 2.1 × 0.8 m.
Museum purchase, Surdna Fund (74-84)

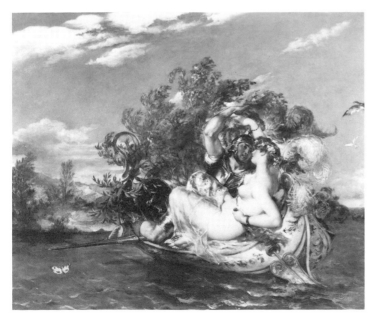

William Etty (British, 1787–1849)
Phaedria and Cymochles
(*Faerie Queen*, book II, canto vi)
Oil on panel, 62.5 × 76.0 cm.
Gift of Benjamin Sonnenberg (67-24)

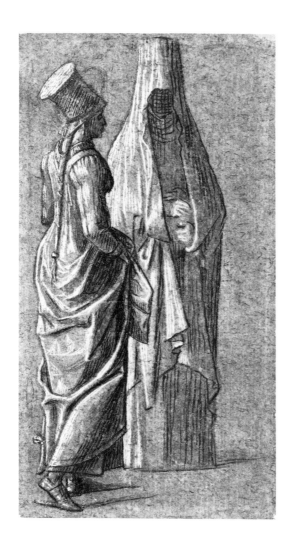

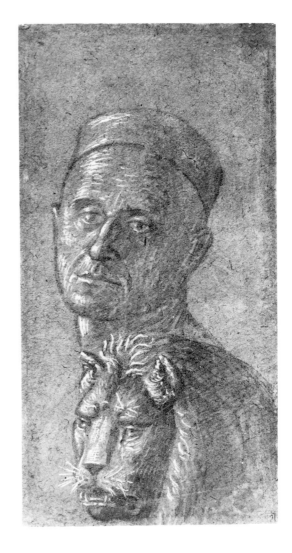

Vittore Carpaccio (Venetian, ca. 1465–1526)
Recto: *Two Standing Muslim Women*
Verso: *Head of a Man and Head of a Lion*
Pen, brown ink, gray-brown wash, heightened
with white, on tan paper, 22.9 × 11.9 cm.
Gift of Frank Jewett Mather, Jr. (44-274)

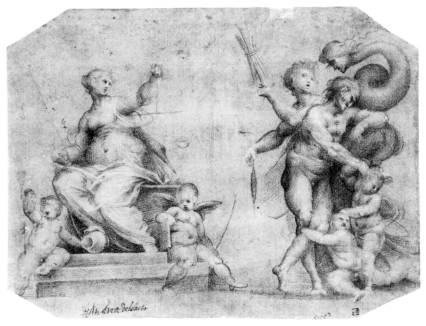

Attributed to Fra Bartolommeo, born Baccio della Porta (Florentine, 1472–1517)
Allegory of Justice
Black and white chalk on gray-brown paper, 19.8 × 26.6 cm.
Gift of Frank Jewett Mather, Jr. (46-84)

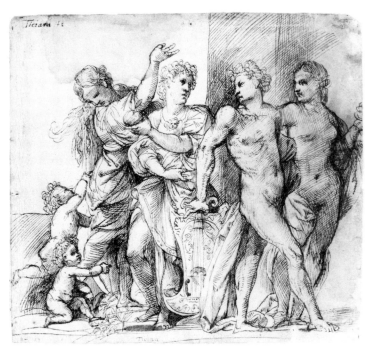

Domenico Campagnola (Paduan, 1500?–1564)
Mythological Scene
Pen and brown ink, 22.2 × 24.3 cm.
Gift of Frank Jewett Mather, Jr. (46-81)

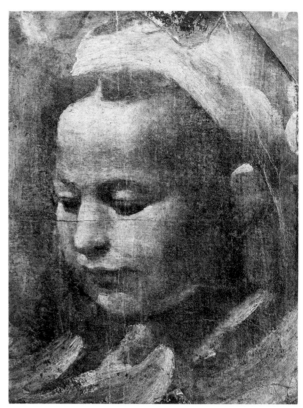

Domenico Beccafumi (Sienese, 1486–1551)
Head of a Young Woman
Tempera and emulsion, 22.7 × 16.3 cm.
Bequest of Dan Fellows Platt, Class of 1895 (48-607)

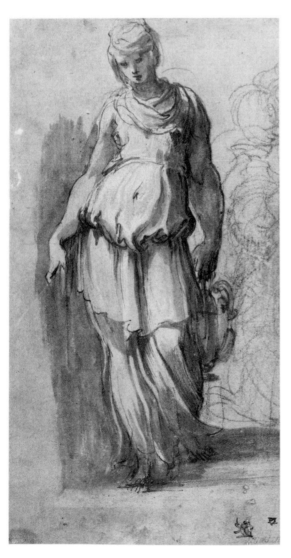

Francesco Mazzola, called **Parmigianino**
(Parmesan, 1503–1540)
Young Woman Carrying a Vessel
Pen and brown ink, brown wash, over
black chalk, 22.8 × 11.5 cm.
Gift of Margaret Mower for the Elsa Durand Mower
Collection (62-65)

114

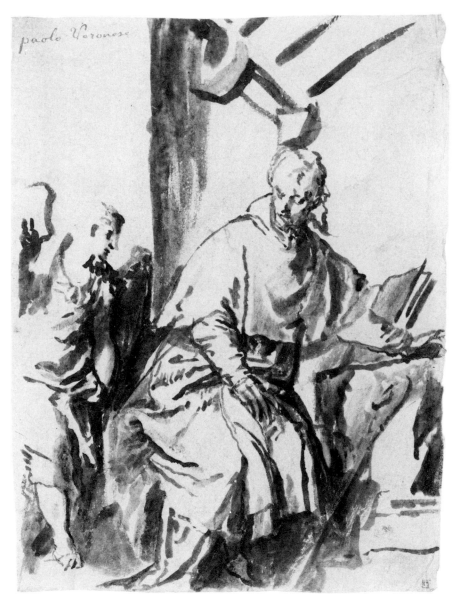

Paolo Caliari, called **Veronese** (Venetian, 1528–1588)
Saint Herculanus Visited by an Angel
Brush and iron gall ink on blue paper, 29.0 × 12.8 cm.
Gift of Frank Jewett Mather, Jr. (44-6)

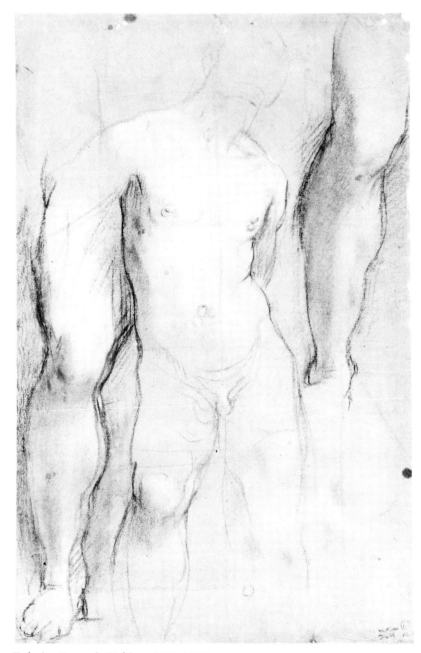

Federico Barocci (Urbino, 1526–1612)
Studies for Saint Sebastian in the Genoa *Crucifixion*
Black and white chalk, red highlights, on brown prepared paper, 42.5 × 26.3 cm.
Bequest of Dan Fellows Platt, Class of 1895 (48-598)

Luca Cambiaso (Genoese, 1527–1585)
Silenus Drinking
Pen and iron gall ink, 31.7 × 14.7 cm.
Bequest of Dan Fellows Platt, Class of 1895 (48-627)

Abraham Bloemaert (Dutch, 1564–1651)
Angel Appearing to Hagar
Pen and brown ink, brown wash, white highlights, 28.5 × 58.2 cm.
Museum purchase, Laura P. Hall Memorial Fund (65-62)

Attributed to Jacques-Louis David (French, 1748–1825)
Man Stepping to the Right
Black chalk, white highlights, on grayish-brown paper,
54.5 × 44.5 cm.
Gift of Mathias Polakovits (77-35)

Jean-Guillaume Moitte (French, 1746–1810)
Ceres and Arethusa (Ovid, *Metamorphoses*, IX, 1–97)
Pen and black ink, greenish-gray and white opaque watercolor, black wash, 27.0 × 64.5 cm.
Museum purchase, Laura P. Hall Memorial Fund (76-297)

126

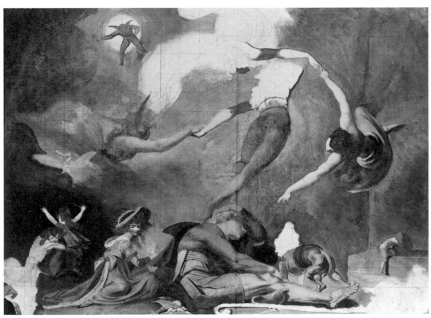

Henry Fuseli (British, born in Switzerland, 1741–1825)
The Shepherd's Dream (Milton, *Paradise Lost*, I, 781 ff.)
Opaque watercolor, pencil, oil, 36.7 × 51.8 cm.
Bequest of Dan Fellows Platt, Class of 1895 (48-991)

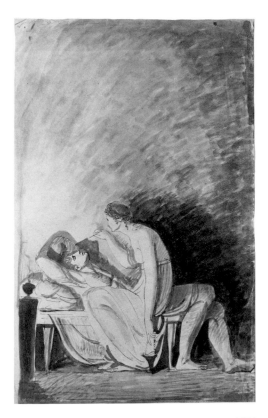

George Romney (British, 1734–1802)
The Origin of Painting
Pen and brown ink, brown and gray wash, 52.0 × 32.0 cm.
Gift of Frank Jewett Mather, Jr. (47-28)

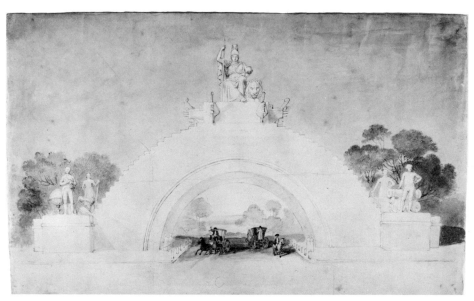

John Flaxman (British, 1755–1826)
Triumphal Arch Surmounted by Britannia
Watercolor, 30.0 × 48.2 cm.
Bequest of Dan Fellows Platt, Class of 1895 (48-1681)

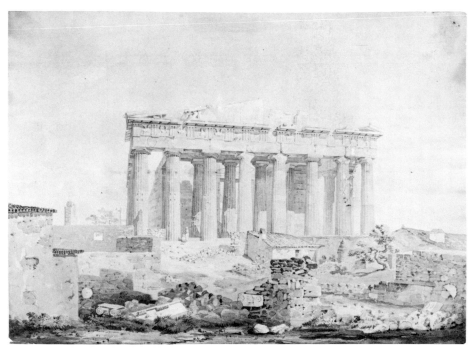

Leo von Klenze (German, 1784–1864)
The Parthenon from the West
Watercolor, 45.3 × 61.4 cm.
Museum purchase, Caroline G. Mather Fund (46-100)

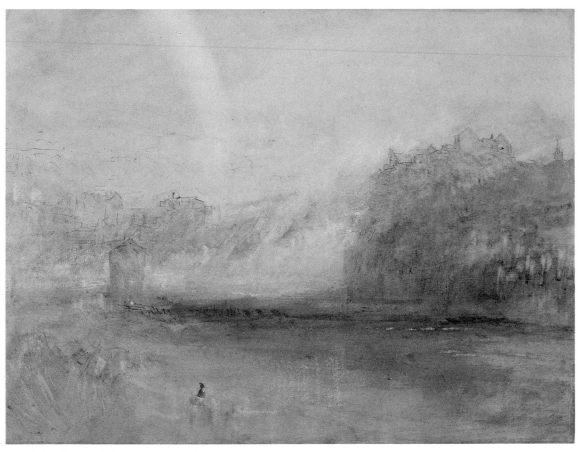

Joseph Mallord William Turner (British, 1775–1851)
Falls at Schaffhausen, ca. 1841
Watercolor, 22.6 × 28.8 cm.
Museum purchase with funds given by Mrs. Millard Meiss
and the Surdna Fund (82-48)

PRINTS

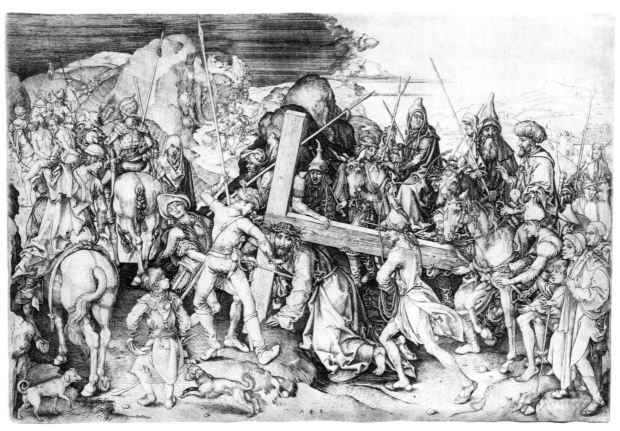

Martin Schongauer (German, ca. 1430–1491)
Christ Bearing the Cross
Engraving, 28.9 × 43.2 cm.
Museum purchase, Laura P. Hall Memorial Fund (51-120)

Albrecht Dürer (German, 1471–1528)
The Man of Sorrows, 1509; in *The Engraved Passion*, in contemporary leather binding
with arms of Frederick the Wise, and interleaved with illuminated pages of text
Engraving, on page, 20.4 × 14.4 cm.
Bequest of Junius S. Morgan, Class of 1888 (34-369)

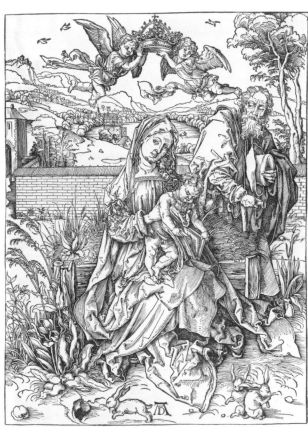

Albrecht Dürer (German, 1471–1528)
Holy Family with Three Hares, 1498
Woodcut, 38.7 × 28.1 cm.
Given in memory of Erwin Panofsky by his friends,
colleagues, and students (72-13)

Albrecht Dürer (German, 1471–1528)
Holy Family with Three Hares, ca. 1497
Fruitwood block for woodcut, 39.8 × 28.3 cm.
Gift of Alexander P. Morgan, Class of 1922 (67-111)

145

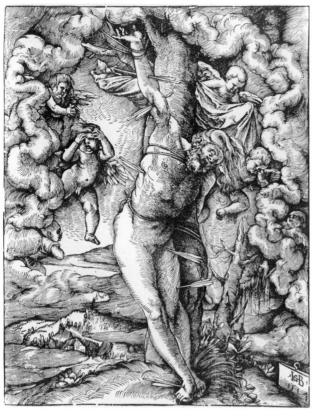

Hans Baldung Grien (German, 1484/85–1545)
Saint Sebastian, 1514
Woodcut, 31.3 × 23.4 cm.
Museum purchase, Laura P. Hall Memorial Fund (83-158)

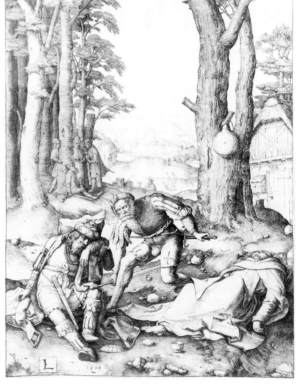

Lucas van Leyden (Dutch, 1489?–1533)
The Monk Sergius Killed by Mohamet, 1508
Engraving, 29.2 × 21.8 cm.
Gift of James H. Lockhart, Jr., Class of 1935 (60-2)

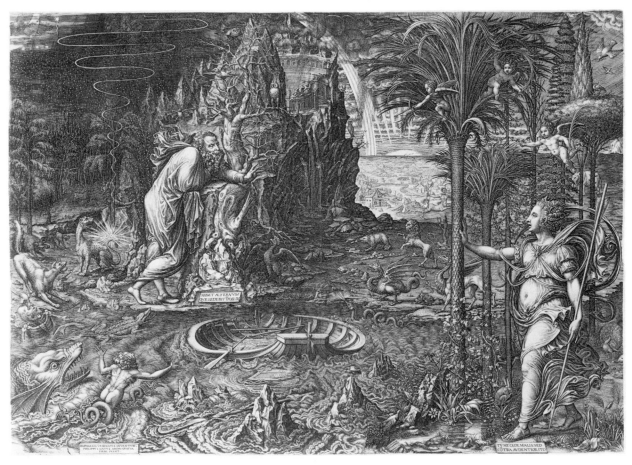

Giorgio Ghisi (Italian, 1520–1582), in part after Raphael (Italian, 1483–1520)
Allegory of Life ("The Dream of Raphael"), 1561
Engraving, 38.0 × 54.0 cm.
Museum purchase by exchange, Caroline G. Mather Fund (84-329)

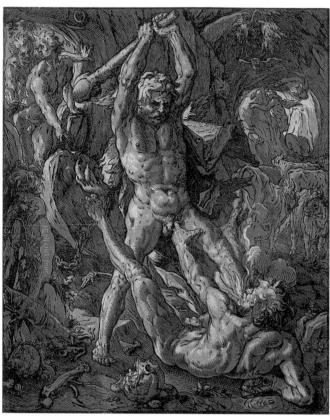

Hendrik Goltzius (Dutch, 1558–1617)
Hercules Killing Cacus, 1588
Chiaroscuro woodcut, 41.2 × 33.3 cm.
Gift of Robert M. Walker, Class of 1932 (78-4)

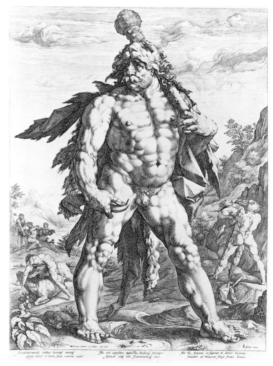

Hendrik Goltzius (Dutch, 1558–1617)
Hercules ("The Great Hercules"), 1589
Engraving, 55.8 × 40.2 cm.
Bequest of Junius S. Morgan, Class of 1888
(34-672)

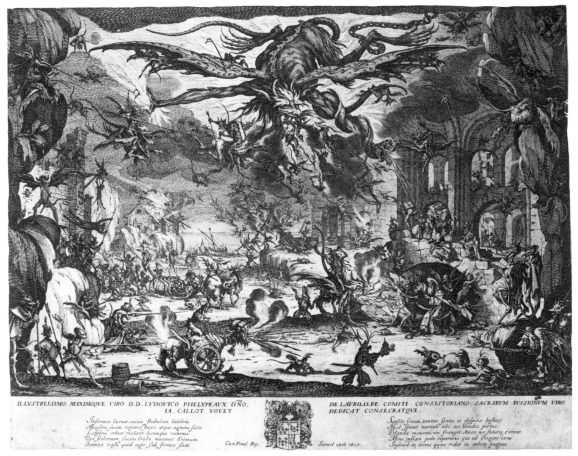

Jacques Callot (French, 1592–1635)
The Temptation of Saint Anthony, 1635
Etching, 35.3 × 45.6 cm.
Bequest of Junius S. Morgan, Class of 1888 (34-358)

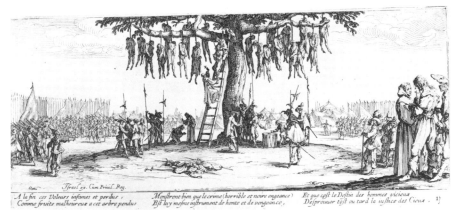

Jacques Callot (French, 1592–1635)
The Hanging, 1633; from the series *Les Grandes Misères de la Guerre*
Etching, 8.1 × 18.5 cm.
Bequest of Junius S. Morgan, Class of 1888 (34-302A)

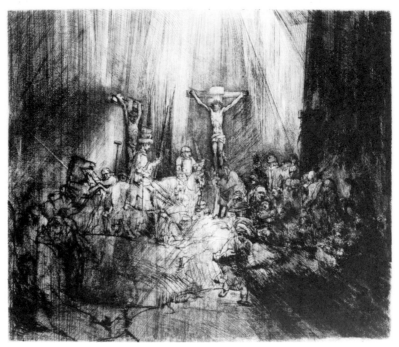

Rembrandt van Rijn (Dutch, 1606–1669)
Christ Crucified Between Two Thieves ("The Three Crosses"), 1653
Drypoint and burin, 38.5 × 45.0 cm.
Gift of David H. McAlpin, Class of 1920, and Mrs. McAlpin,
in memory of Professor Clifton R. Hall (69-310)

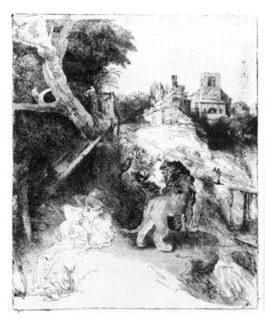

Rembrandt van Rijn (Dutch, 1606–1669)
Saint Jerome in an Italian Landscape, ca. 1653
Etching and drypoint, 26.0 × 21.1 cm.
Gift of James H. Lockhart, Jr., Class of 1935 (59-26)

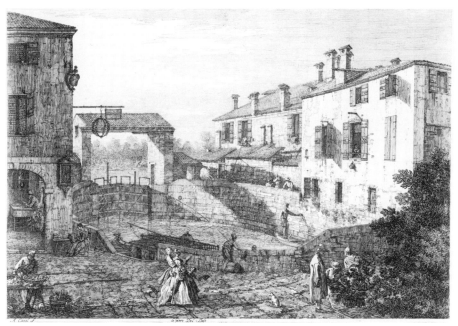

Antonio Canale, called **Canaletto** (Italian, 1697–1768)
Le Porte del Dolo
Etching, 29.8 × 42.8 cm.
Laura P. Hall Memorial Collection (46-160)

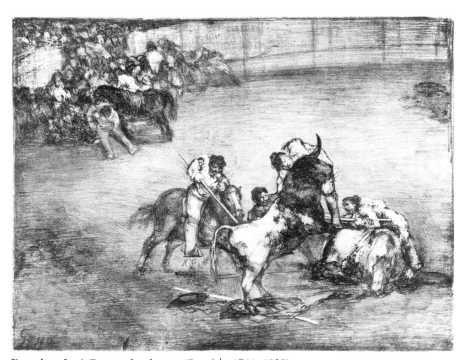

Francisco José Goya y Lucientes (Spanish, 1746–1828)
Bravo Toro, 1825; from the series *The Bulls of Bordeaux*
Lithograph, 31.3 × 41.4 cm.
Museum purchase through the bequest of Mrs. Herbert S. Langfeld (78-14)

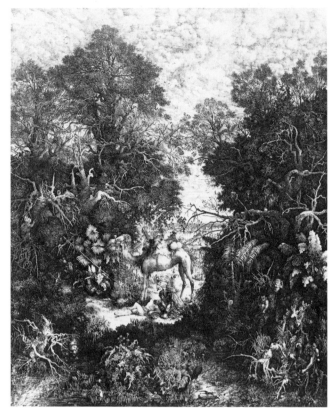

Rodolphe Bresdin (French, 1825–1885)
The Good Samaritan, 1861
Lithograph, 56.0 × 43.8 cm.
Gift of Mrs. Alfred H. Barr Jr. (78-12)

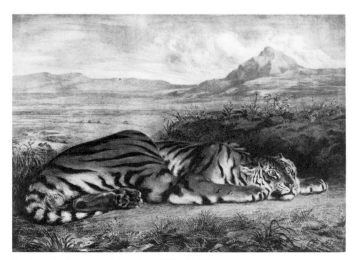

Eugène Delacroix (French, 1798–1863)
Royal Tiger, 1829
Lithograph, 32.8 × 46.7 cm.
Museum purchase, Laura P. Hall Memorial Fund (70-120)

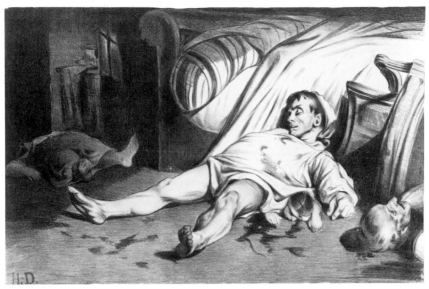

Honoré Daumier (French, 1808–1879)
Rue Transnonain, le 15 Avril 1834
Lithograph, 28.7 × 44.4 cm.
Gift of Robert M. Walker, Class of 1932 (79-91)

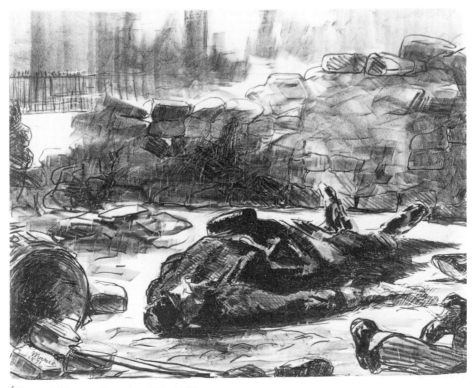

Édouard Manet (French, 1832–1883)
Civil War, 1871
Lithograph, 39.6 × 51.0 cm.
Museum purchase, Laura P. Hall Memorial Fund (62-54)

153

Henri de Toulouse-Lautrec (French, 1864–1901)
Miss Loïe Fuller, 1893
Color lithograph, embellished by the artist with gold powder,
38.0 × 28.4 cm.
Laura P. Hall Memorial Collection (46-360)

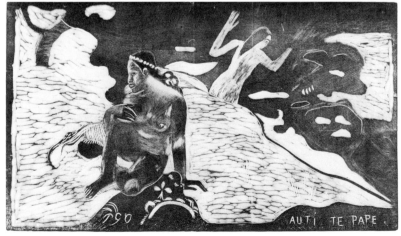

Paul Gauguin (French, 1848–1903)
Auti Te Pape, 1894
Woodcut, 20.5 × 35.5 cm.
Laura P. Hall Memorial Collection (46-235)

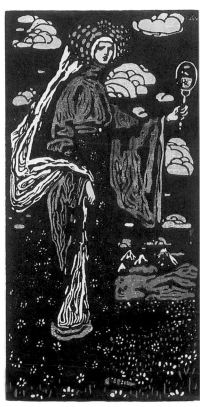

Wassily Kandinsky (German, born
in Russia, 1866–1944)
The Mirror, 1907
Color linocut, 32.1 × 15.8 cm.
Museum purchase by exchange (70-123)

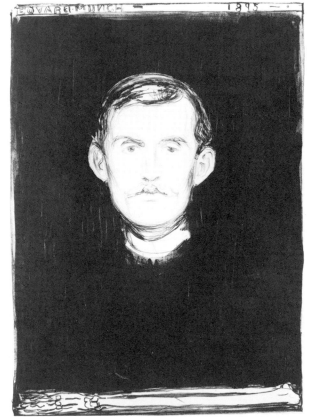

Edvard Munch (Norwegian, 1863–1944)
Self-Portrait, 1895
Lithograph, 45.1 × 31.5 cm.
Museum purchase with funds given by
James R. Epstein, Class of 1978 (82-1)

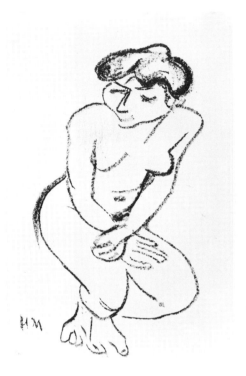

Henri Matisse (French, 1869–1954)
Crouching Nude, 1906
Lithograph, 43.5 × 28.0 cm.
Museum purchase, Laura P. Hall Memorial Fund (61-37)

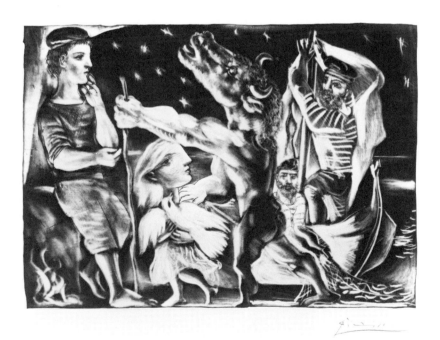

Pablo Picasso (Spanish, 1881–1973)
Blind Minotaur Led by a Girl in the Night, 1939;
from *Suite Vollard*, 97
Aquatint, 24.7 × 34.6 cm.
Gift of Wen C. Fong, Class of 1951 and Graduate School Class of 1958,
and Mrs. Fong (86-1)

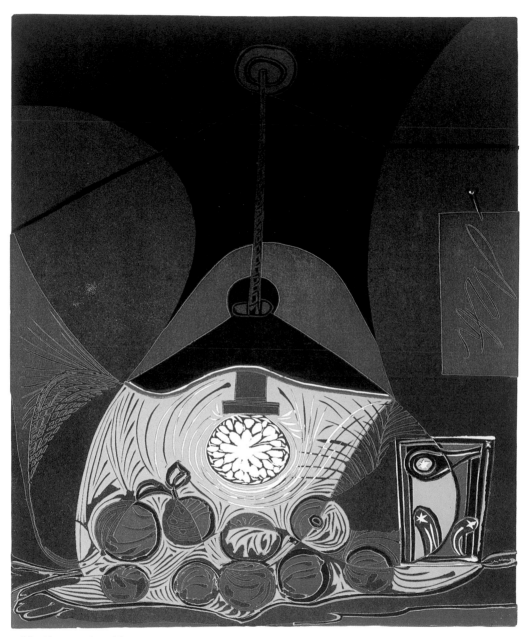

Pablo Picasso (Spanish, 1881–1973)
Still Life Under a Lamp, 1962
Color linocut, 64.0 × 53.0 cm.
Gift of Robert M. Walker, Class of 1932 (75-1)

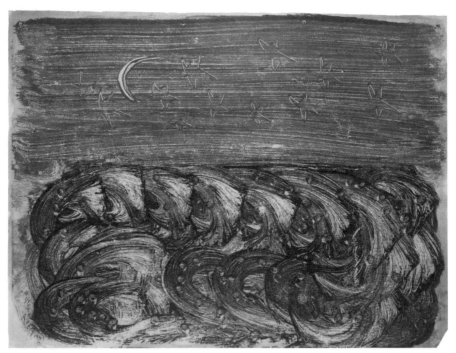

Milton Avery (American, 1885–1965)
Green Sea, 1951
Monotype, 45.9 × 61.0 cm.
Gift of Mrs. Milton Avery (82-353)

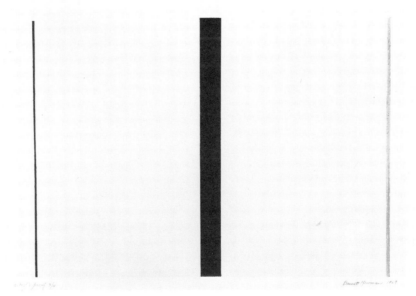

Barnett Newman (American, 1905–1970)
Untitled Etching #1, 1969
Etching and aquatint, 36.8 × 59:4 cm.
Gift of Henry Geldzahler (83-195)

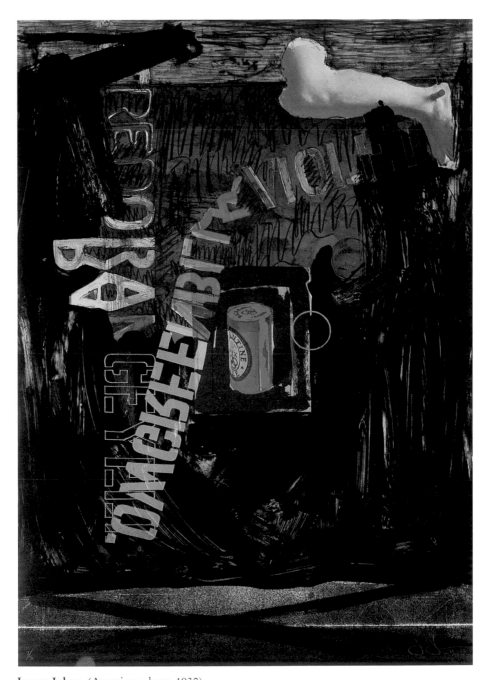

Jasper Johns (American, born 1930)
Decoy II, 1971–1973
Color lithograph, 1.1 × 0.8 m.
Given by the artist for the William C. Seitz, Graduate School Class of 1955,
Memorial Collection (76-313)

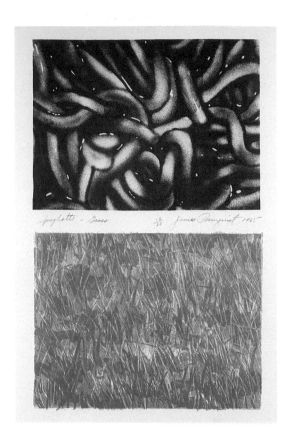

James Rosenquist (American, born 1933)
Spaghetti and Grass, 1965
Color lithograph, 79.6 × 56.9 cm.
Museum purchase, Laura P. Hall Memorial Fund (74-6)

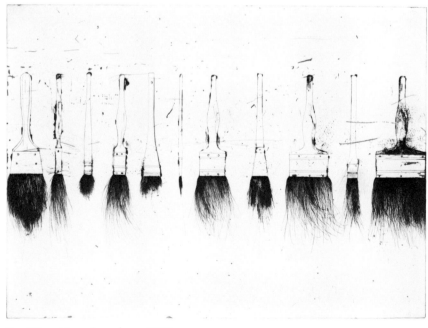

Jim Dine (American, born 1935)
Five Paintbrushes: Second State, 1973
Etching and drypoint, 59.6 × 89.2 cm.
Museum purchase, Laura P. Hall Memorial Fund (74-19)

Robert Motherwell (American, born 1915)
A La Pintura: Frontispiece, 1972
Aquatint, on sheet, 65.1 × 97.0 cm.
Anonymous gift (73-1)

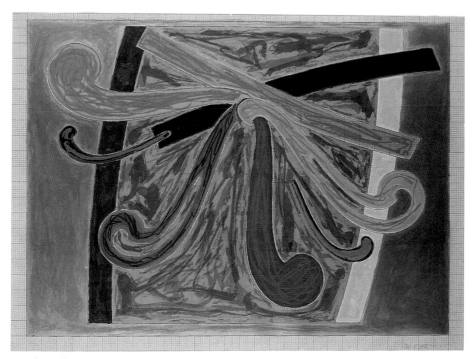

Frank Stella (American, born 1936)
Puerto Rican Blue Pigeon, 1977
52-color lithograph and screenprint, 0.9 × 1.2 m.
Gift of C. Bagley Wright, Jr., Class of 1946, and Mrs. Wright (78-3)

PHOTOGRAPHS

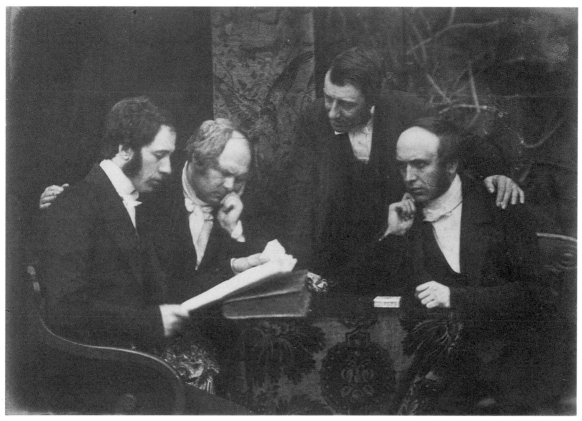

David Octavius Hill (British, born in Scotland, 1802–1870) and
Robert Adamson (British, born in Scotland, 1821–1848)
Dumbarton Presbytery, ca. 1845
Salted-paper print, 14.5 × 20.2 cm.
The Robert O. Dougan Collection, Gift of Warner Communications Inc. (82-300)

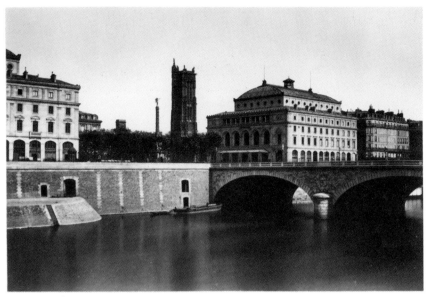

Edouard-Denis Baldus (French, born in Germany, 1815–1882)
Place du Châtelet, Paris, ca. 1855
Albumen print, 18.6 × 27.7 cm.
Museum purchase with funds given by Baldwin Maull, Class of 1922,
and Mrs. Maull (77-113)

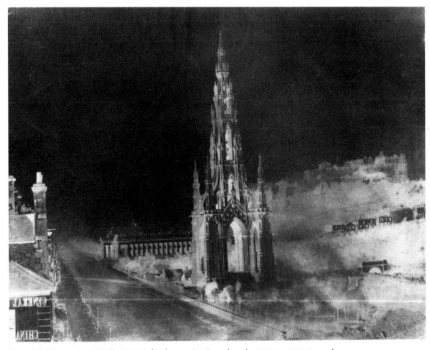

David Octavius Hill (British, born in Scotland, 1802–1870) and
Robert Adamson (British, born in Scotland, 1821–1848)
The Scott Monument, Edinburgh, Scotland, ca. 1846
Waxed-paper negative, 32.6 × 40.8 cm.
The Robert O. Dougan Collection, Gift of Warner Communications Inc. (82-312)

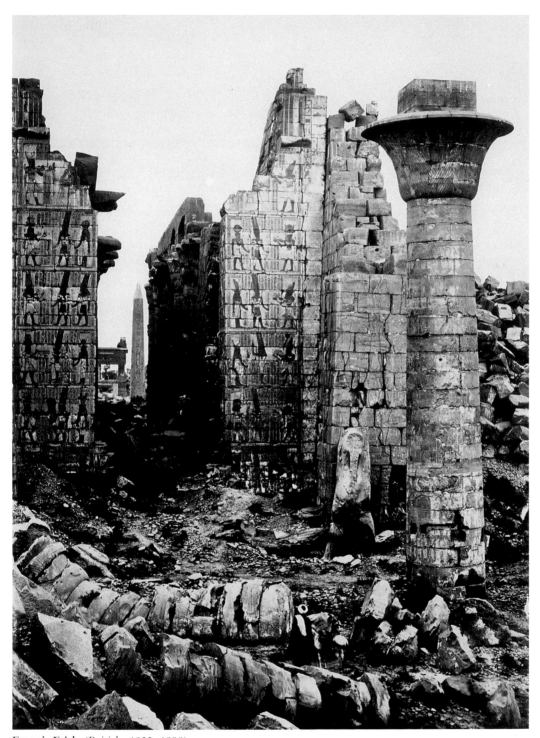

Francis Frith (British, 1822–1898)
The Court of Shishak, Karnak, 1857
Albumen print, 22.2 × 16.1 cm.
Museum purchase with funds given by David H. McAlpin, Class of 1920 (75-109)

Roger Fenton (British, 1819–1869)
Still Life, ca. 1858
Albumen print, 36.3 × 44.0 cm.
Museum purchase (76-302)

John Moffat (British, born in Scotland, 1819–1869)
Portrait of a Woman, ca. 1865
Albumen print, 14.0 × 16.6 cm.
The Robert O. Dougan Collection, Gift of Warner Communications Inc. (82-341.3)

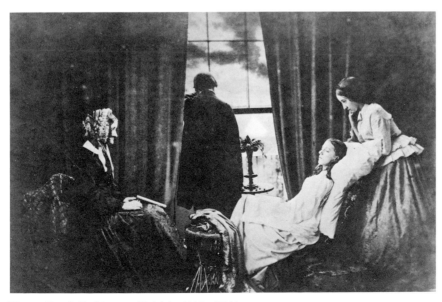

Henry Peach Robinson (British, 1830–1901)
Fading Away, 1858, printed ca. 1880
Albumen print, 14.6 × 22.3 cm.
Museum purchase with funds given by Robert Venturi, Class of 1947
and Graduate School Class of 1950 (84-1)

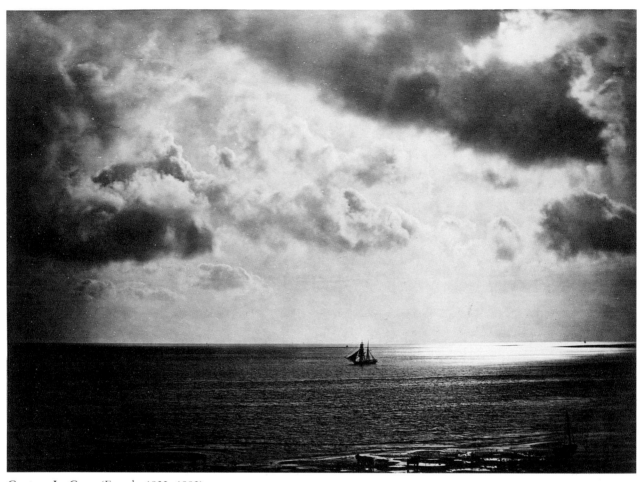

Gustave Le Gray (French, 1820–1882)
Brig upon the Water, ca. 1855–1856
Albumen print, 29.4 × 39.9 cm.
Museum purchase, John Maclean Magie and Gertrude Magie Fund (85-33)

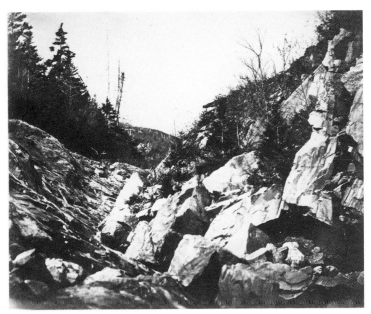

James Wallace Black (American, 1825–1896)
In the Notch, White Mountains, 1854
Calotype, 23.9 × 29.2 cm.
The Robert O. Dougan Collection, Gift of Warner Communications Inc.
(79-100)

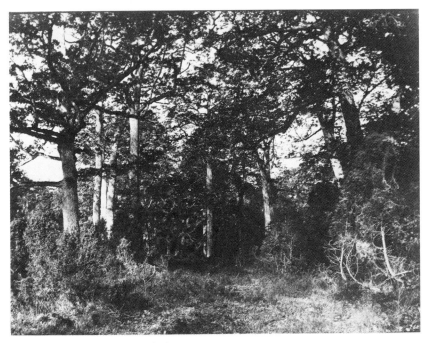

Eugène Cuvelier (French, died 1900)
Forest of Fontainebleau, ca. 1860
Albumen print, 25.8 × 34.1 cm.
Museum purchase with funds given by C. David Robinson,
Class of 1957, and Mrs. Robinson (85-38)

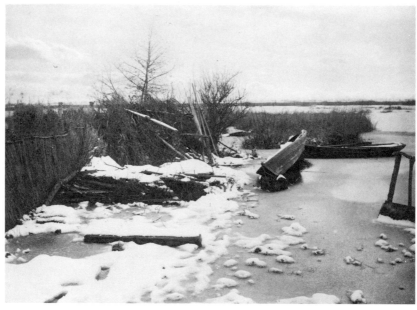

Peter Henry Emerson (British, 1856–1936)
The First Frost from *Life and Landscape on the Norfolk Broads*, 1886 (London)
Platinum print, 20.6 × 28.9 cm.
Museum purchase with funds given by David H. McAlpin, Class of 1920 (75-226)

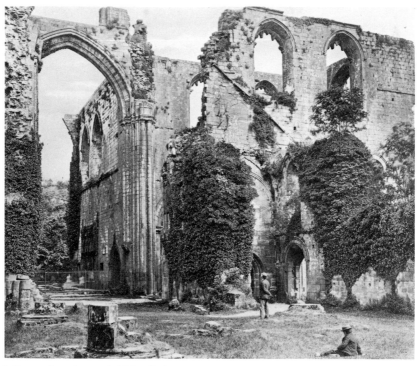

J. Payne Jennings (British, died 1927)
Furness Abbey, West View, ca. 1870
Albumen print, 24.0 × 28.7 cm.
Gift of Douglas Hahn, Class of 1934 (76-172)

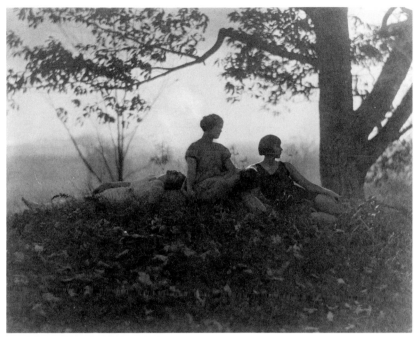

Clarence H. White (American, 1871–1925)
Members of the Larson Dancers, Canaan, Connecticut, ca. 1923
Platinum print, 19.4 × 24.6 cm.
The Clarence H. White Collection

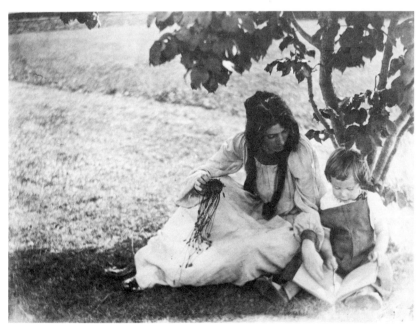

Gertrude Käsebier (American, 1852–1934)
Storybook, 1902
Platinum print, 24.5 × 32.9 cm.
Gift of Hermine M. Turner (75-127)

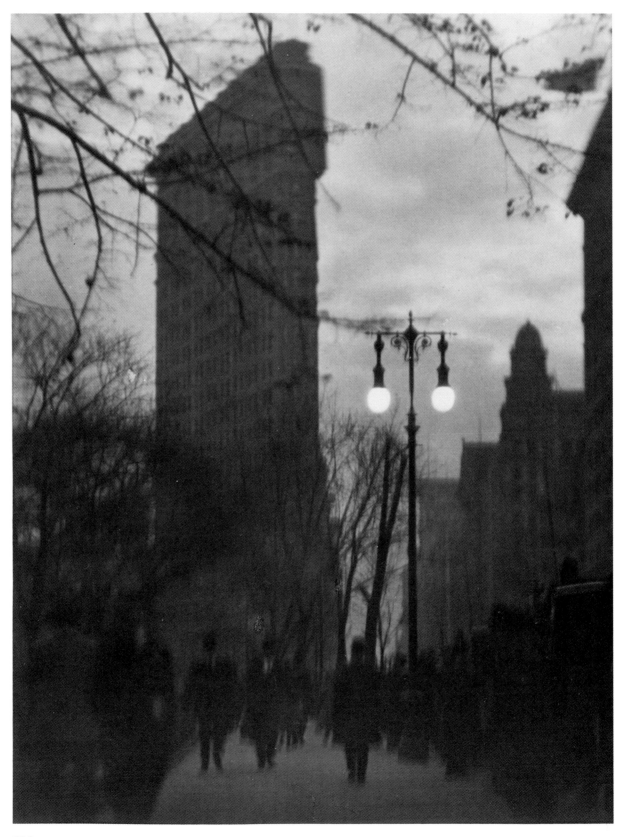

174

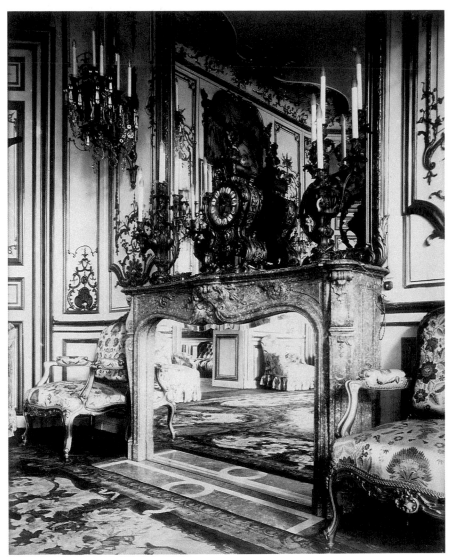

Eugène Atget (French, 1857–1927)
Ambassade d'Autriche, 57 rue de Varenne, 1905
Gelatin silver print, toned, 21.9 × 18.0 cm.
Gift of Mrs. Saul Reinfeld (83-116)

◄ **Alvin Langdon Coburn** (British, born in the United States, 1882–1966)
The Flat-Iron Building, New York, 1912
Gelatin silver print, 28.7 × 21.0 cm.
The Clarence H. White Collection

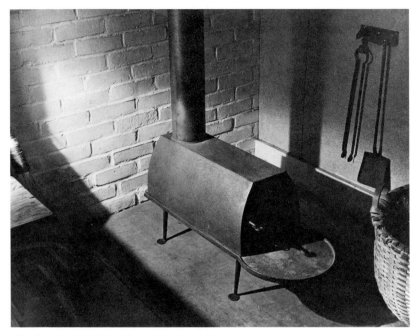

Charles Sheeler (American, 1883–1965)
American Interior, ca. 1932–1935
Gelatin silver print, 19.4 × 24.6 cm.
Museum purchase, Fowler McCormick, Class of 1921, Fund (80-13)

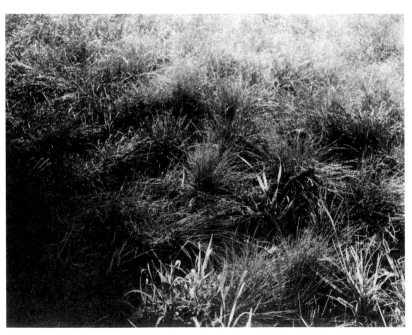

Alfred Stieglitz (American, 1864–1946)
Grasses, Lake George, 1930
Gelatin silver print, 18.2 × 23.5 cm.
Museum purchase with funds given by Baldwin Maull, Class of 1922,
Mrs. Maull, and anonymous donors (73-62)

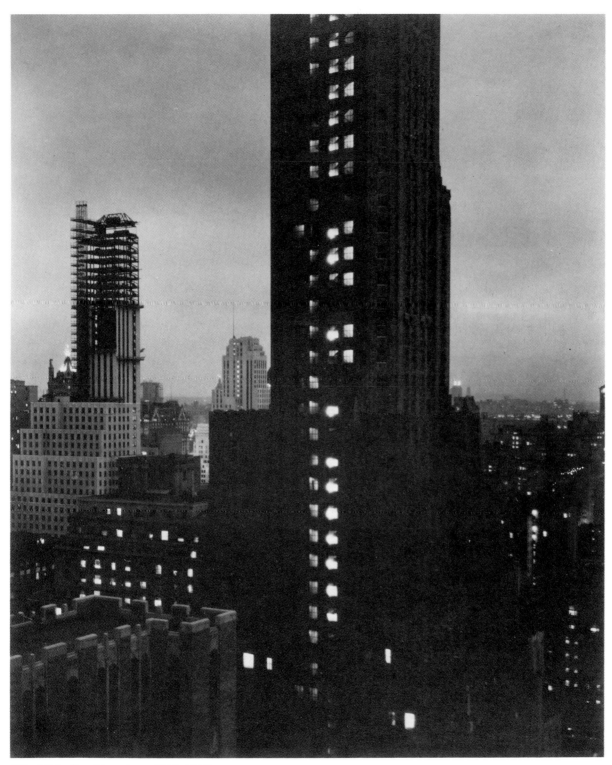

Alfred Stieglitz (American, 1864–1946)
Night—New York, 1931
Gelatin silver print, 24.3 × 19.0 cm.
Gift of Ansel Adams in honor of David H. McAlpin, Class of 1920 (74-36)

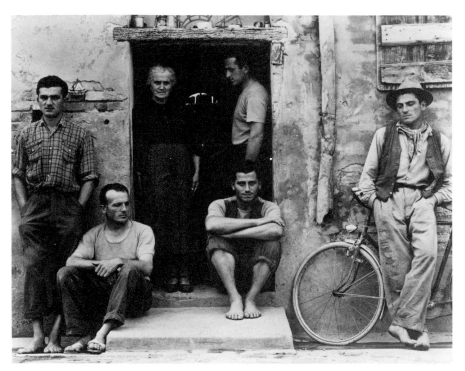

Paul Strand (American, 1890–1976)
The Family, View II, Luzzara, Italy, 1953
Gelatin silver print, 27.4 × 34.7 cm.
Museum purchase, Fowler McCormick, Class of 1921, Fund (80-14)

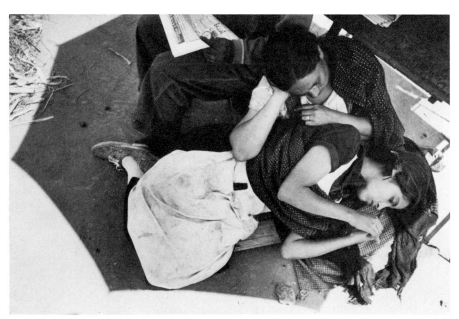

Henri Cartier-Bresson (French, born 1908)
A Family of News-Vendors, Mexico City, 1934
Gelatin silver print, 26.5 × 39.4 cm.
Gift of Elliott J. Berv (77-94)

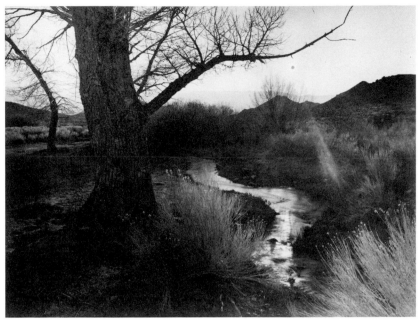

Ansel Adams (American, 1902–1984)
The Black Sun, Tungsten Hills, Owens Valley, California, 1939;
from *Portfolio V*, 1970
Gelatin silver print, 34.6 × 46.7 cm.
Gift of David H. McAlpin, Class of 1920 (71-207.7)

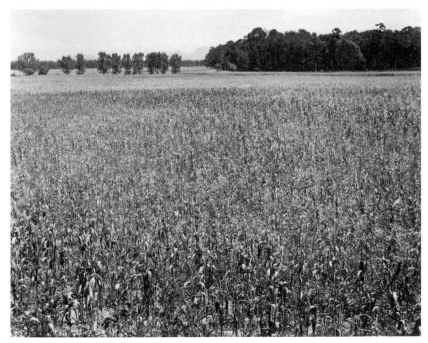

Manuel Alvarez Bravo (Mexican, born 1902)
Your Surface Is of Corn, Mexico, 1945
Gelatin silver print, 19.0 × 24.4 cm.
The Minor White Archive

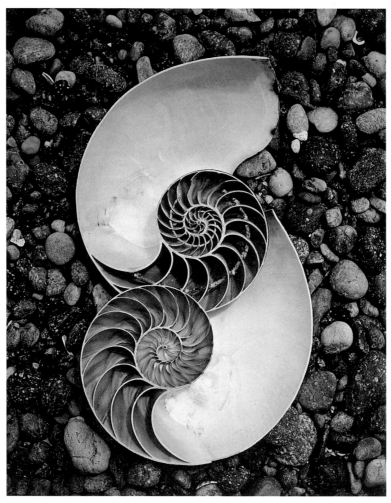

Edward Weston (American, 1886–1958)
Shells, 1947
Dye transfer print, 24.4 × 19.0 cm.
The Minor White Archive

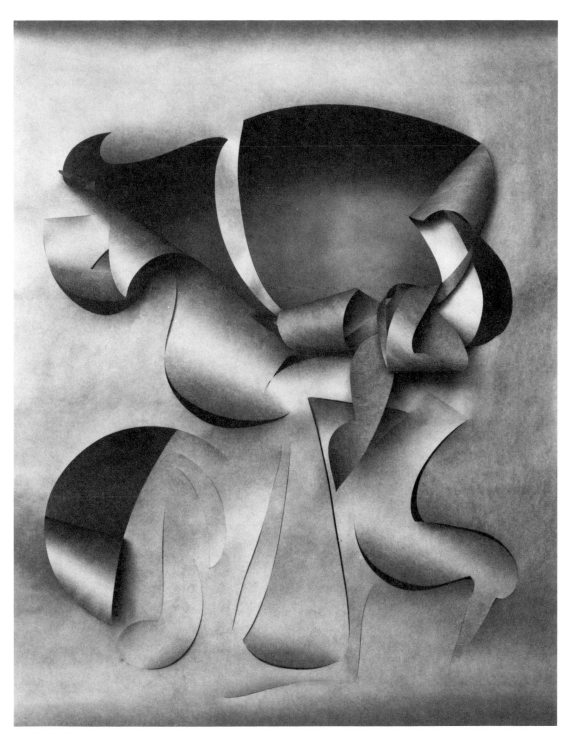

Frederick Sommer (American, born 1905)
Cut Paper, 1972
Gelatin silver print, 27.9 × 21.3 cm.
Gift of Patricia and Frank Kolodny (80-44)

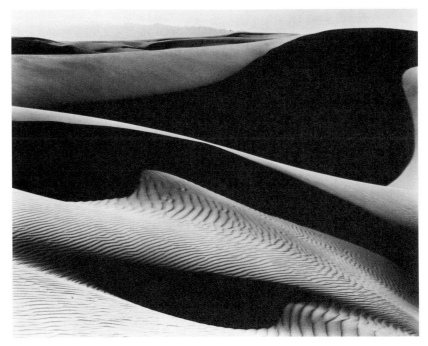

Edward Weston (American, 1886–1958)
Dunes, Oceano, 1936
Gelatin silver print, 19.2 × 24.1 cm.
Gift of David H. McAlpin, Class of 1920 (71-432)

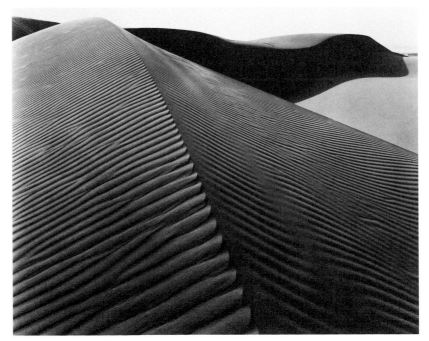

Brett Weston (American, born 1911)
Windswept Dune, Oceano, California, 1947
Gelatin silver print, 19.2 × 24.4 cm.
Gift of David H. McAlpin, Class of 1920 (71-399)

182

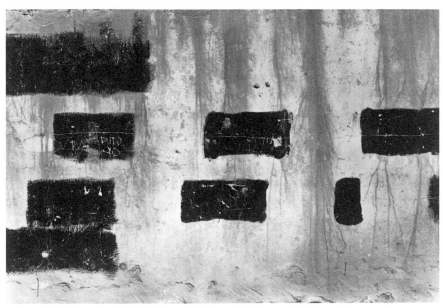

Aaron Siskind (American, born 1903)
Arizpe, Mexico 21, 1966
Gelatin silver print, 29.4 × 44.6 cm.
Museum purchase with funds from the National Endowment for the Arts
and an anonymous matching gift (75-25)

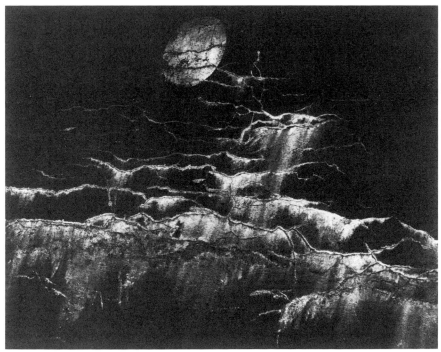

Minor White (American, 1908–1976)
Moon and Wall Encrustations, Pultneyville, New York, 1964
Gelatin silver print, 23.4 × 30.8 cm.
The Minor White Archive

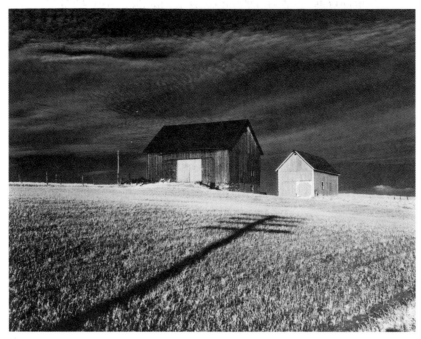

Minor White (American, 1908–1976)
Two Barns and Shadow, 1955
Gelatin silver print, 23.9 × 30.1 cm.
The Minor White Archive

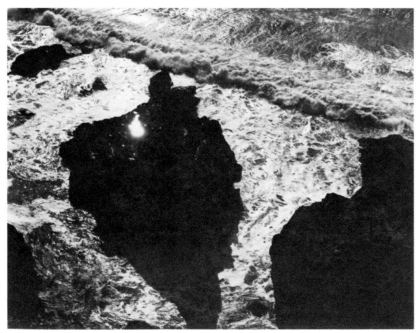

Minor White (American, 1908–1976)
Sun in Rock, Devil's Slide, California, 1947
Gelatin silver print, 9.3 × 12.0 cm.
Gift of F. Jeffris Elliott (78-78)

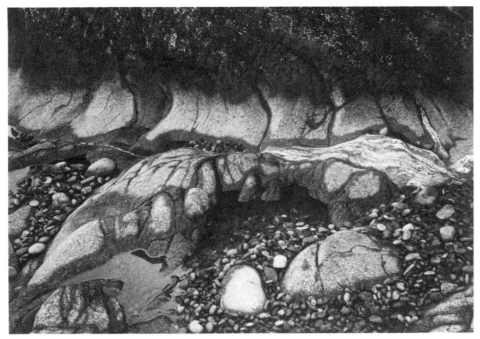

Paul Caponigro (American, born 1932)
Untitled, Nahant, Massachusetts, 1959
Gelatin silver print, 16.9 × 24.5 cm.
The Minor White Archive

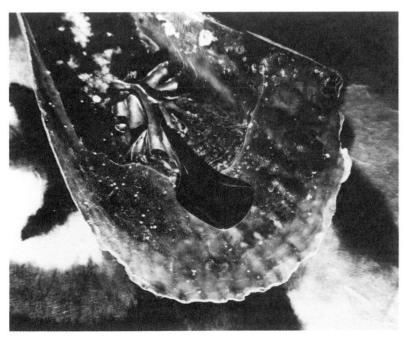

Walter Chappell (American, born 1925)
Shell with Cast Silver Sculpture on Walter Chappell Painting, 1959
Gelatin silver print, 19.3 × 24.3 cm.
The Minor White Archive

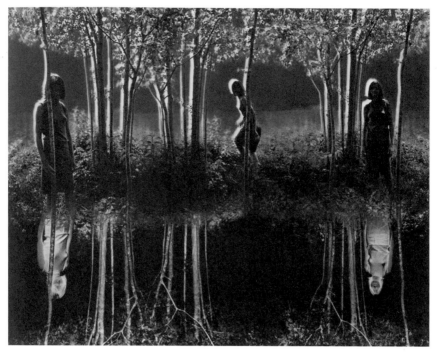

Jerry N. Uelsmann (American, born 1934)
Small Woods Where I Met Myself, 1967
Gelatin silver print, 25.5 × 32.3 cm.
Museum purchase with funds from the National Endowment for the Arts
and an anonymous matching gift (75-43)

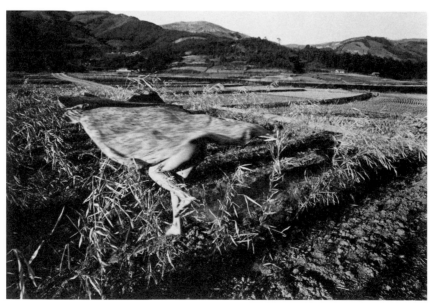

Eikoh Hosoe (Japanese, born 1933)
Untitled #27; from the series *Kamaitachi*, 1968, printed 1981–1982
Gelatin silver print, 36.8 × 54.2 cm.
Gift of Susan and Eugene Spiritus (85-10)

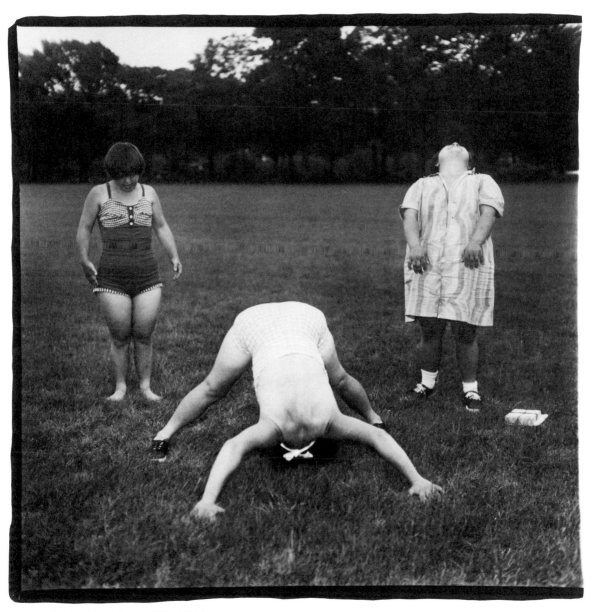

Diane Arbus (American, 1923–1971)
3 women. (School for the mentally retarded, N.J.) One watches,
the second begins a somersault, the third laughs., 1969
Gelatin silver print, 38.5 × 38.0 cm.
Gift of Henry Geldzahler (79-117)

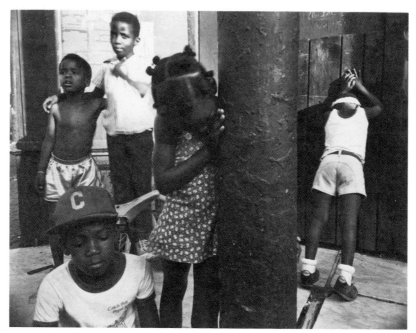

Nicholas Nixon (American, born 1947)
Cherry Street, Cambridge, 1981
Gelatin silver print, 19.6 × 24.7 cm.
Museum purchase with funds given by Norman S. Matthews, Class of 1954,
and Mrs. Matthews (81-71)

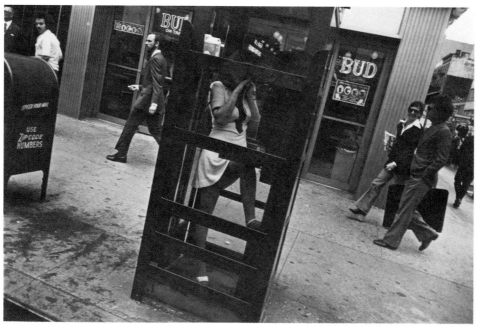

Garry Winogrand (American, 1928–1984)
New York City, 1972; from the portfolio *Garry Winogrand*, 1978
Gelatin silver print, 22.7 × 34.0 cm.
Gift of Victor S. Gettner, Class of 1927, and Mrs. Gettner (81-60.11)

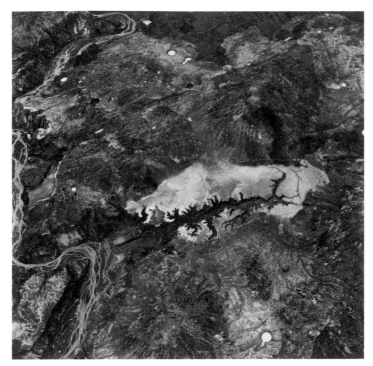

Emmet Gowin (American, born 1941)
Toutle River Valley, Mount St. Helens, 1981
Toned gelatin silver print, 23.2 × 23.3 cm.
Museum purchase with funds from the National Endowment for the
Arts and a matching gift from David H. McAlpin, Class of 1920 (84-25)

Ray K. Metzker (American, born 1931)
Pictus Interruptus, 1977, printed 1980
Gelatin silver print, 29.0 × 42.1 cm.
Museum purchase with funds given by Mr. and Mrs. Max Adler (80-18)

CHINESE ART

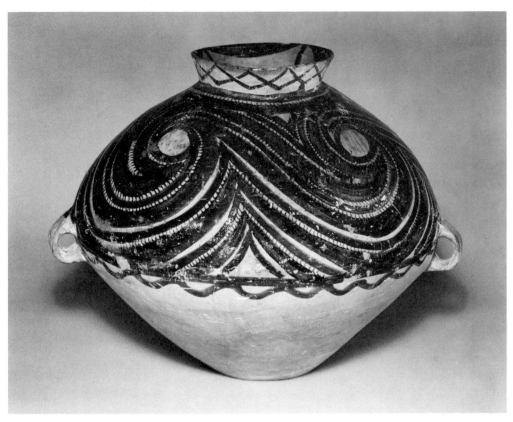

Jar with Spiral Decoration, Pan-shan style, Kansu province, Yang-shao culture,
ca. 2500–2000 B.C.
Red clay, 37.0 × 53.0 cm.
Museum purchase, Fowler McCormick, Class of 1921, Fund (79-94)

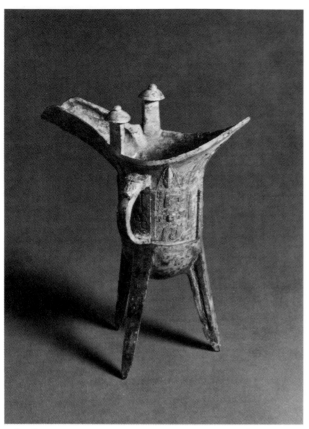

Chüeh, wine goblet, Shang Dynasty, An-yang period
(thirteenth–eleventh century B.C.)
Bronze, height 19.8 cm.
Gift of J. Lionberger Davis, Class of 1900 (52-9)

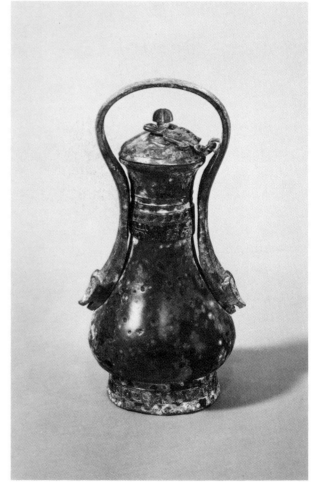

Yu, wine vessel, Shang Dynasty, An-yang period
(thirteenth–eleventh century B.C.)
Bronze, height 31.5 cm.
Museum purchase from the C. D. Carter Collection,
with funds given by the Arthur M. Sackler Foundation
(65-5)

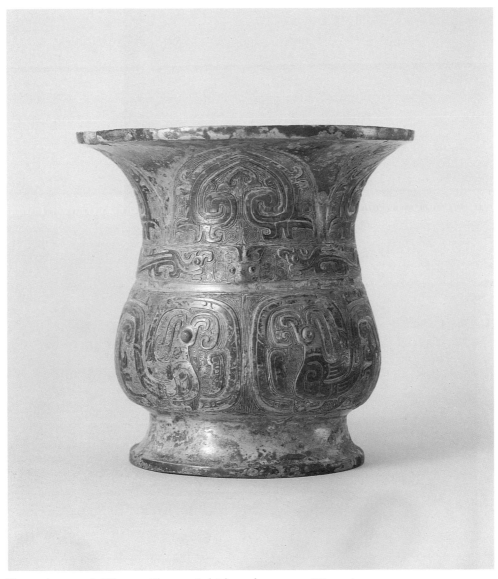

Tsun, wine vessel, Western Chou period (eleventh century–771 B.C.)
Bronze, height 16.4 cm.
Museum purchase, Carl Otto von Kienbusch, Jr., Memorial Collection (52-58)

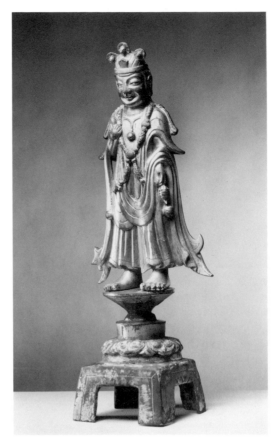

Standing Kuan-yin (Avalokiteśvara),
Six Dynasties period, ca. 540
Gilt bronze, height 31.5 cm.
Museum purchase with funds given by
Mrs. Else Sackler (67-133)

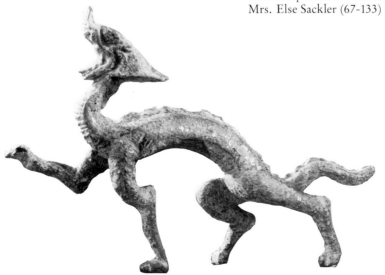

Striding Dragon, Six Dynasties period (220–589)
Gilt bronze, 11.0 × 17.0 cm.
Gift of Mrs. Albert E. McVitty (49-26)

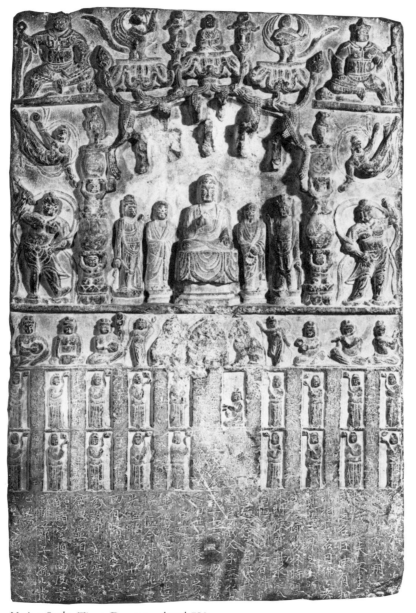

Votive Stele, T'ang Dynasty, dated 750
Stone, height 73.0 cm.
Museum purchase, Carl Otto von Kienbusch, Jr., Memorial Collection (43-134)

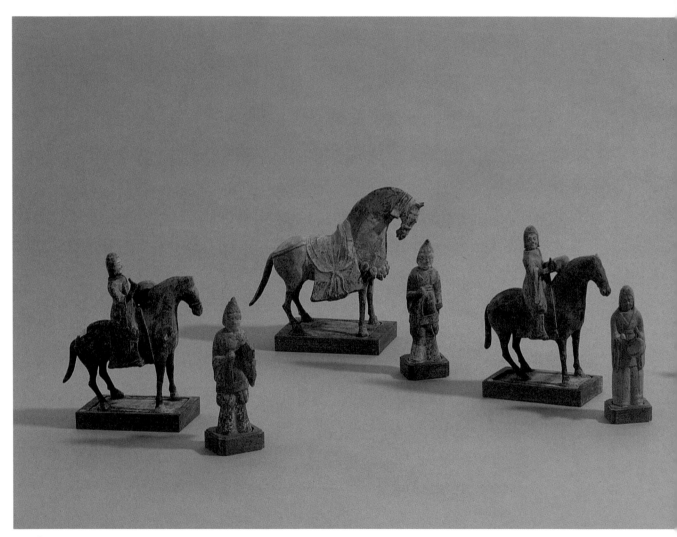

Tomb Figurines, Six Dynasties period (220–589)
Polychromed clay, height ranging from 15.2 to 25.5 cm.
Gift of J. Lionberger Davis, Class of 1900 (50-71–50-122)

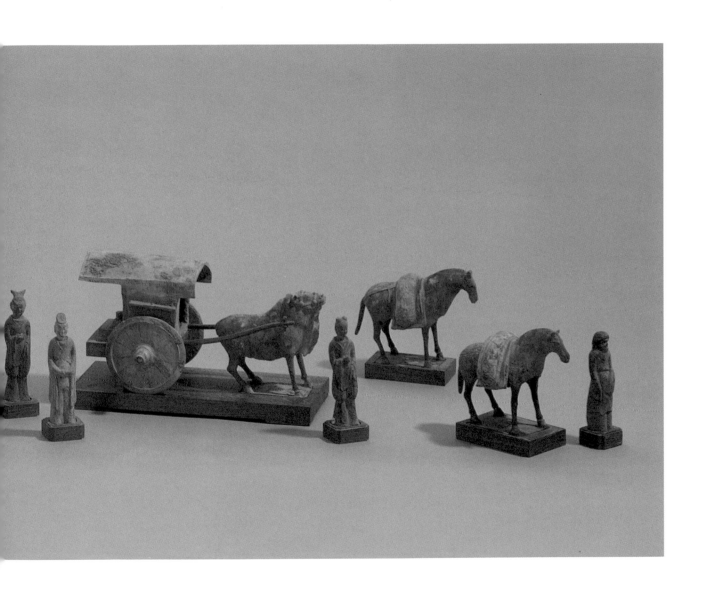

201

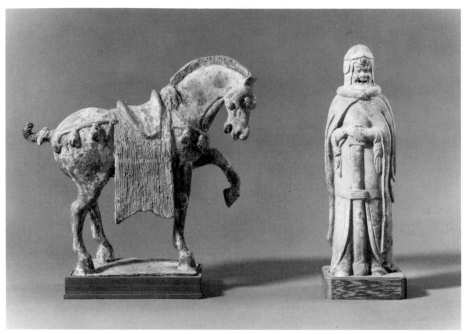

Horse, Six Dynasties period (220–589)
Polychromed clay, height 29.0 cm.
Gift of Mrs. Alan Valentine (64-208)

Tomb-guardian, Six Dynasties period
(220–589)
Polychromed clay, height 29.8 cm.
Gift of J. Lionberger Davis, Class of 1900
(50-71)

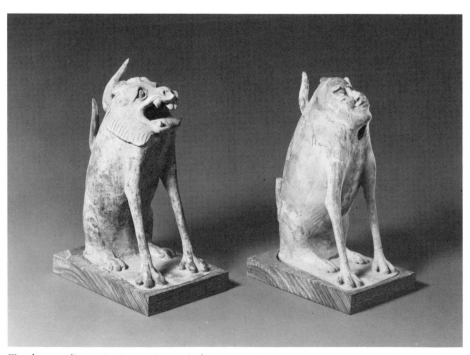

Tomb-guardians, Six Dynasties period (220–589)
Polychromed clay, height 25.5 cm.; 24.5 cm.
Gift of J. Lionberger Davis, Class of 1900 (50-83; 50-84)

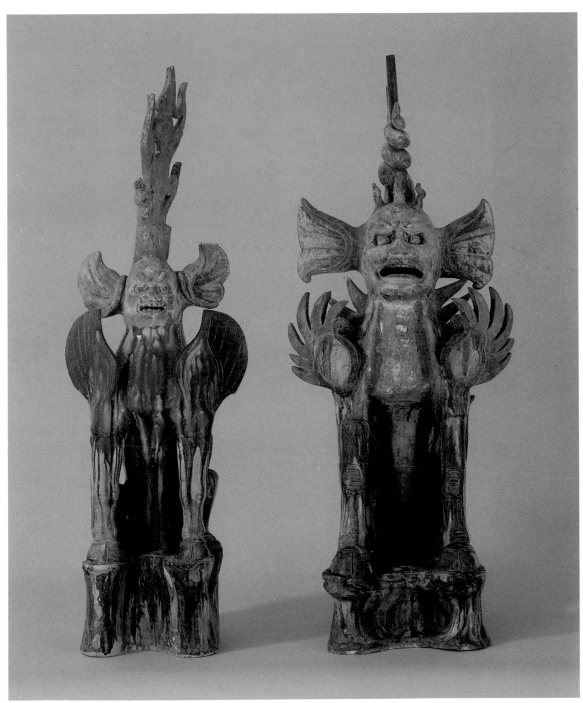

Tomb-guardian, T'ang Dynasty (618–907)
Glazed polychromed clay, height 91.0 cm.
Museum purchase with funds given by the
Arthur M. Sackler Foundation (69-121)

Tomb-guardian, T'ang Dynasty (618–907)
Glazed polychromed clay, height 93.0 cm.
Museum purchase with funds given by the
Arthur M. Sackler Foundation (69-120)

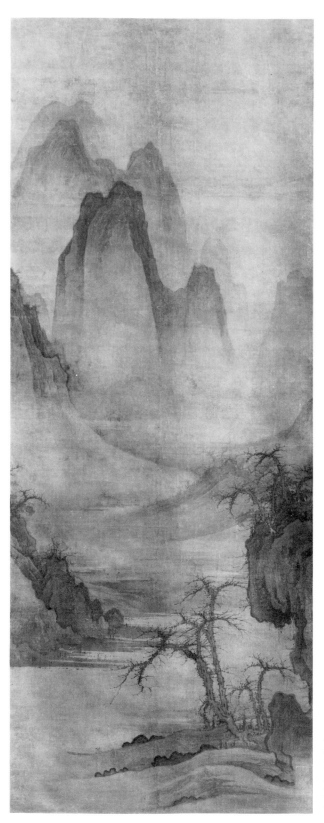

Li Kung-nien (flourished ca. 1120)
Winter Landscape (Tung ching shan-shui), Northern Sung Dynasty, ca. 1120
Hanging scroll, ink and light color on silk, 1.3 × 0.5 m.
DuBois Schanck Morris Collection (46-191)

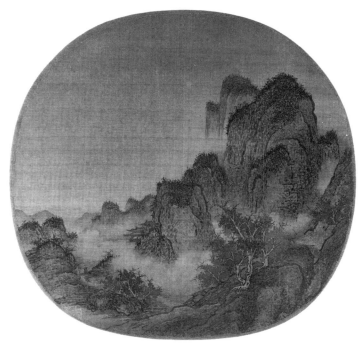

*Landscape in the Style of Fan K'uan (Fang Fan K'uan
shan-shui)*, Southern Sung Dynasty, ca. 1150
Round fan mounted as a hanging scroll, ink and light color on silk,
23.9 × 25.5 cm.
Gift of Mrs. Edward L. Elliott (84-49)

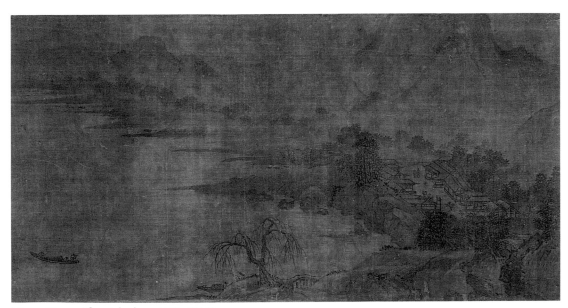

Wang Hung (flourished ca. 1131–1161)
Detail of *Mountain Market, Clear with Rising Mist (Shan-shih ch'ing-lan)*,
section of *Eight Views of Hsiao and Hsiang Rivers (Hsiao-Hsiang pa-ching)*, Southern Sung Dynasty, ca. 1150
Handscroll, ink on silk, 23.4 × 90.7 cm.
Edward L. Elliott Family Collection, Fowler McCormick, Class of 1921, Fund (84-14a)

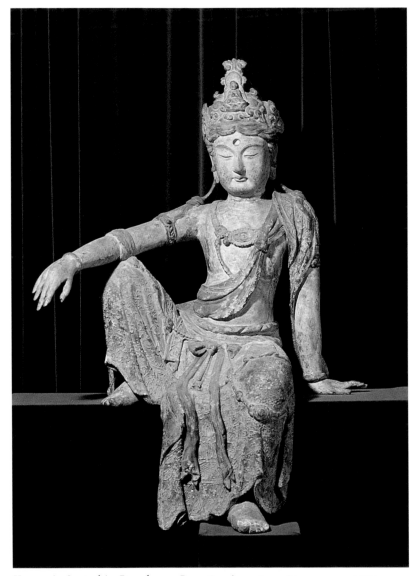

Kuan-yin Seated in Royal-ease Pose, Southern Sung Dynasty, ca. 1250
Polychromed and stuccoed wood, height 1.1 m.
Museum purchase, Carl Otto von Kienbusch, Jr., Memorial Collection (50-66)

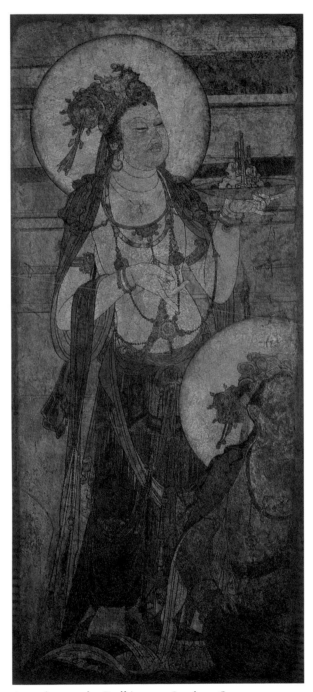

Attendant to the Bodhisattva, Southern Sung
Dynasty, ca. 1225–1250
Fresco, 1.8 × 0.8 m.
Museum purchase, Carl Otto von Kienbusch, Jr.,
Memorial Collection (52-41)

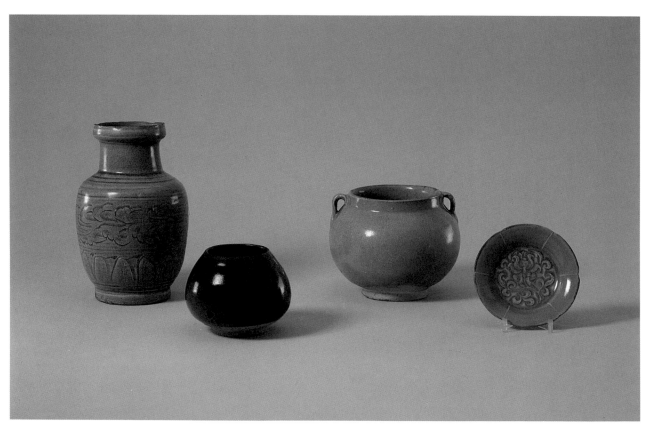

SUNG DYNASTY CERAMICS

From left:

Jar with Flower Decoration, Sung Dynasty,
ca. tenth century
Gray-green celadon glaze over reddish-brown clay,
height 19.5 cm.
Gift of Mrs. Alan Valentine (64-194)

Deep Bowl, Sung Dynasty (960–1279)
Mottled aubergine glaze over reddish-brown clay,
height 8.5 cm.
Gift of Mr. and Mrs. Nathan V. Hammer (55-3242)

Two-handled Jar, Sung Dynasty, ca. eleventh century
Light greenish-blue glaze over reddish-brown clay,
height 12.0 cm.
Gift of J. Lionberger Davis, Class of 1900 (66-64)

Saucer with Flower Decoration,
Sung Dynasty (960–1279)
Celadon glaze over granular buff clay, height 2.3 cm.
Gift of J. Lionberger Davis, Class of 1900 (66-68)

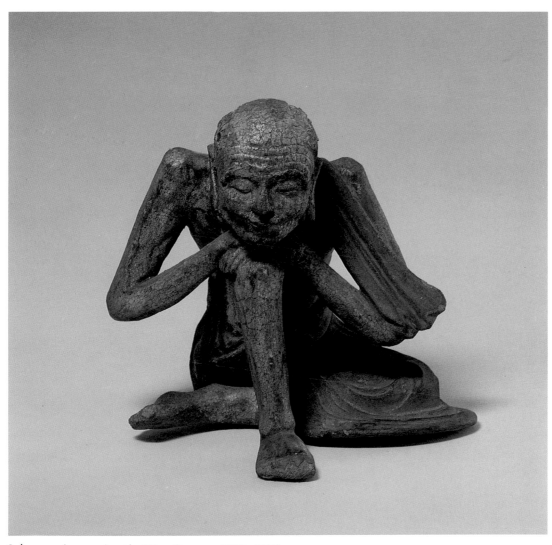

Sakyamuni as an Ascetic, Yüan Dynasty (1279–1368)
Polychromed and gilded lacquer, height 28.0 cm.
Museum purchase with funds given by David W. Steadman, Graduate School Class of 1974,
and Mrs. Steadman, in honor of Robert P. Griffing, Jr., Graduate School Class of 1940 (72-16)

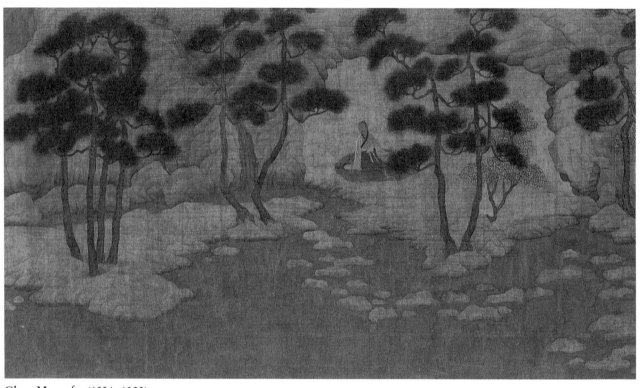

Chao Meng-fu (1254–1322)
Detail of *The Mind Landscape of Hsieh Yu-yü (Yu-yü ch'iu-ho)*, Yüan Dynasty, ca. 1287
Handscroll, ink and color on silk, 0.3 × 1.2 m.
Edward L. Elliott Family Collection, Fowler McCormick, Class of 1921, Fund (84-13)

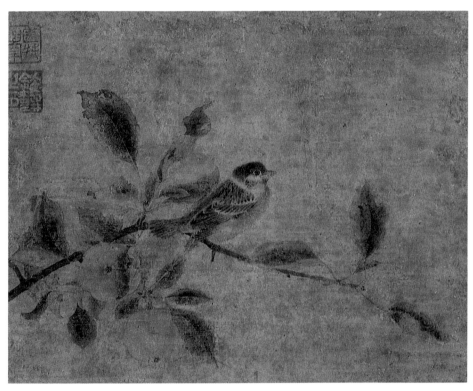

Ch'ien Hsüan (ca. 1235–1300)
Sparrow on an Apple Branch (Lin-ch'in shan-ch'üeh), Yüan Dynasty,
ca. later half of the thirteenth century
Hanging scroll, ink and light color on paper, 22.0×27.5 cm.
Museum purchase, Carl Otto von Kienbusch, Jr., Memorial Collection (59-1)

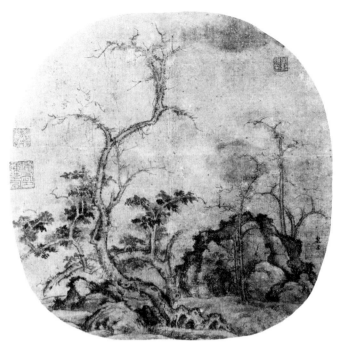

Ts'ao Chih-po (1272–1355)
Trees and Rocks (Shu shih t'u), Yüan Dynasty, ca. 1340
Round fan mounted as a hanging scroll, ink and light color
on silk, 27.0 × 27.4 cm.
Museum purchase, John Maclean Magie
and Gertrude Magie Fund (58-51)

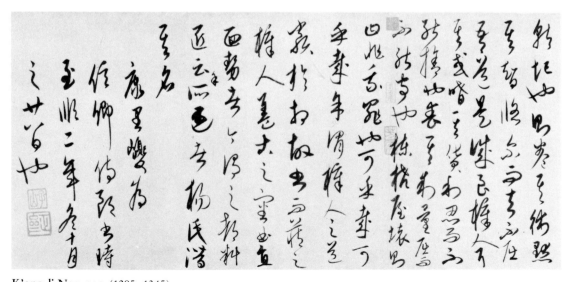

K'ang-li Nao-nao (1295–1345)
Detail of *Biography of a Carpenter (Tzu-jen chuan)*, Yüan Dynasty, dated 1331
Handscroll, ink on paper, 0.3 × 2.8 m.
Gift of John B. Elliott, Class of 1951, in honor of Lucy Lo (85-11)

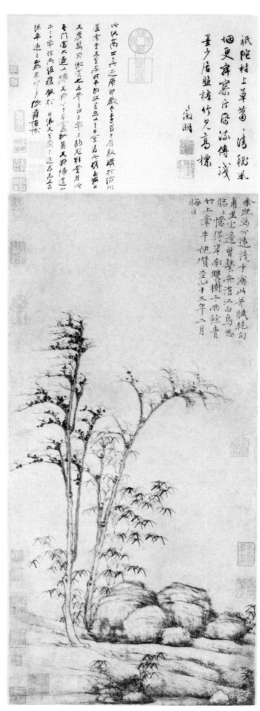

Ni Tsan (1301–1374)
Twin Trees by the South Bank (An nan shuang shu), Yüan Dynasty, dated 1353
Hanging scroll, ink on paper, 56.0 × 27.0 cm.
Gift of Wen C. Fong, Class of 1951, and Mrs. Fong, in honor of Mrs. Edward L. Elliott (75-35)

Wang Fu (1362–1416)
*Remembering Ni Tsan's "Wu-t'ung Tree and Bamboo by a Thatched Pavilion"
(I Ni Yün-lin Wu chu ts'ao-t'ang t'u)*,
Ming Dynasty, dated 1408
Hanging scroll, ink on paper, 74.9 × 29.9 cm.
Gift of Wen C. Fong, Class of 1951, and Mrs. Fong, in honor of John B. Elliott, Class of 1951 (83-43)

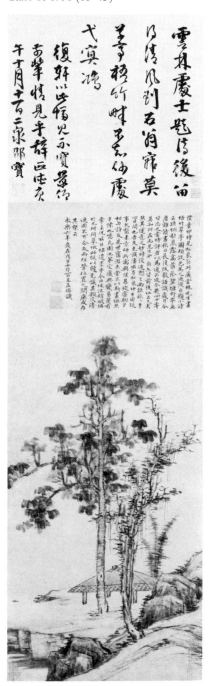

213

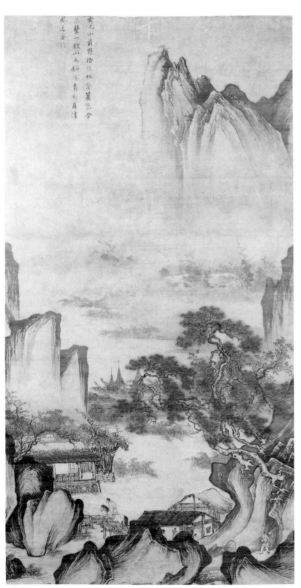

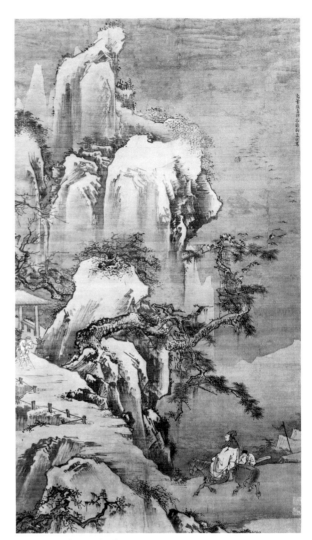

Wang E (flourished ca. 1488–1545)
Winter in the Mountains (Tung ching shan-shui),
Ming Dynasty, after 1510
Hanging scroll, ink on silk, 1.8 × 1.0 m.
DuBois Schanck Morris Collection (47-74)

T'ang Yin (1470–1524)
*Seeing off a Guest on a Mountain Path (Shan lu
sung k'o)*, Ming Dynasty, ca. 1505–1510
Hanging scroll, ink and light color on silk, 1.2 × 0.6 m.
DuBois Schanck Morris Collection (47-245)

214

Ch'en Hung-shou (1599–1652)
Five-character Poem (Wu-yen shih),
Ch'ing Dynasty, after 1644
Hanging scroll, ink on paper, 1.1 × 0.3 m.
Gift of John B. Elliott, Class of 1951 (71-1)

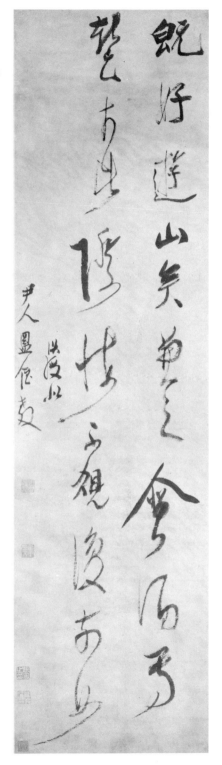

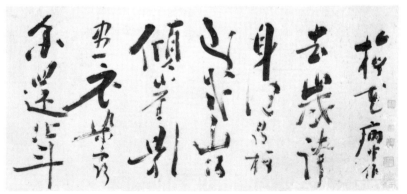

Ch'en Hsien-chang (1428–1500)
Detail of *Poems on Plum Blossoms (Mei-hua ping chung tso)*,
Ming Dynasty, dated 1492
Handscroll, ink on paper, 0.3 × 9.0 m.
Gift of John B. Elliott, Class of 1951 (80-43)

215

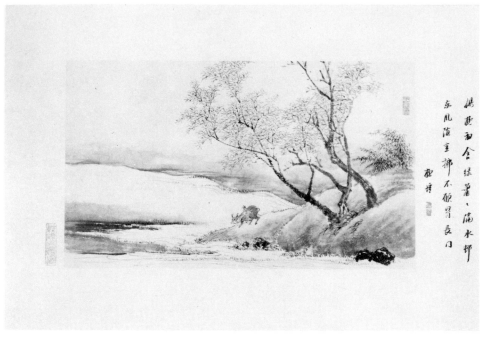

Wang Hui (1632–1717)
Herd Boy (Mu-t'ung), Ch'ing Dynasty, dated 1673
Album leaf C of *In Pursuit of Antiquity (Ch'ü-ku)*, ink and light color on paper,
17.6 × 29.8 cm.
Gift of Mr. and Mrs. Earl Morse (73-67c)

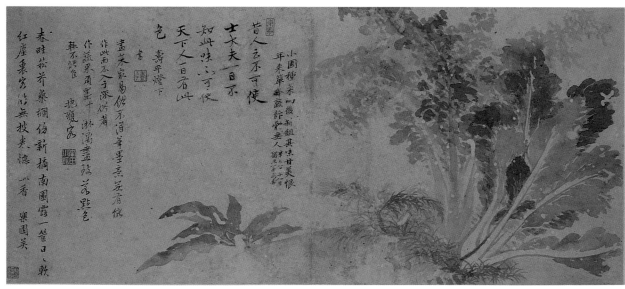

Yün Shou-p'ing (1633–1690)
Cabbages (Pai-ts'ai), Ch'ing Dynasty, dated 1674
Album leaf H of *Flowers, Landscapes, and Vegetables (Hua-hui shan-shui shu-kuo)*,
ink and color on paper, 26.4 × 59.4 cm.
Gift of David L. Elliott (75-29h)

216

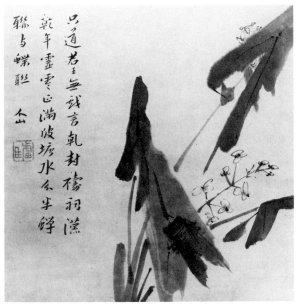

Chu Ta (1626–1705)
Water Weed and Insects (Ts'ao ch'ung),
Ch'ing Dynasty, ca. 1681
Album leaf D of *Flowers and Insects (Hua-hui ts'ao-ch'ung)*,
ink on paper, 30.2 × 30.2 cm.
Gift of Mrs. George Rowley, in memory of George Rowley
(63-39d)

Tao-chi (1642–1707)
Sections of *Letter to Chu Ta (Chih Pa-ta-shan-jen ch'ih-tu)*,
Ch'ing Dynasty, ca. 1699
Album leaves E and F, ink on paper, each 18.7 × 13.0 cm.
Museum purchase with funds given by the Arthur M. Sackler Foundation (68-204e-f)

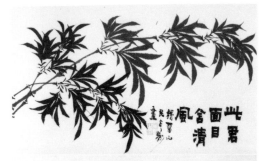

Chin Nung (1687–1764)
Bamboo and Calligraphy (Hua chu t'i-chi),
Ch'ing Dynasty, dated 1750
Hanging scroll, ink on paper, 95.7 × 38.5 cm.
Jeannette Shambaugh Elliott Collection (78-18)

Hua Yen (1682–ca. 1765)
Cloud Sea in the T'ai Mountains (T'ai-tai yün-hai t'u), Ch'ing Dynasty, dated 1730
Hanging scroll, ink on paper, 1.8 × 0.7 m.
Museum purchase with funds given by the Arthur M. Sackler Foundation (69-75)

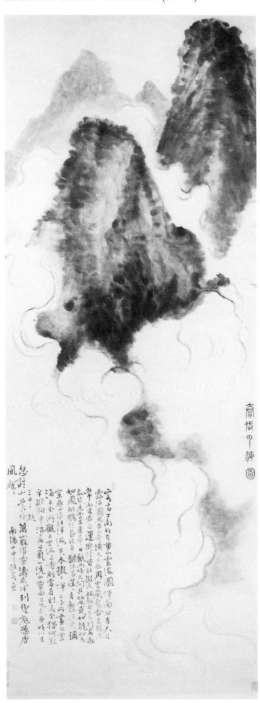

218

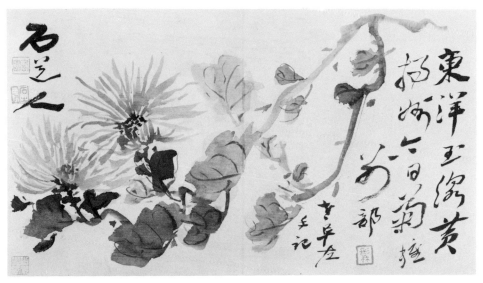

Kao Feng-han (1683–ca. 1747)
Peony (Mu-tan), Ch'ing Dynasty, dated 1738
Album leaf E of *Flowers and Calligraphy (Hua-hui t'i-chi)*,
ink and light color on paper, 30.5 × 48.0 cm.
Jeannette Shambaugh Elliott Collection (77-15e)

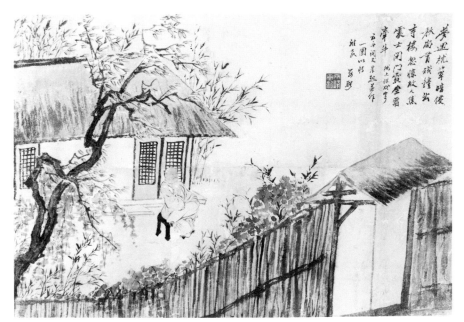

Lo P'ing (1733–1799)
Chiao Wu-tou at His Country Cottage (Chiao Wu-tou ts'un-chü t'u),
Ch'ing Dynasty, ca. 1760s
Hanging scroll, ink and color on paper, 38.0 × 46.0 cm.
Gift of Wen C. Fong, Class of 1951, and Mrs. Fong (78-43)

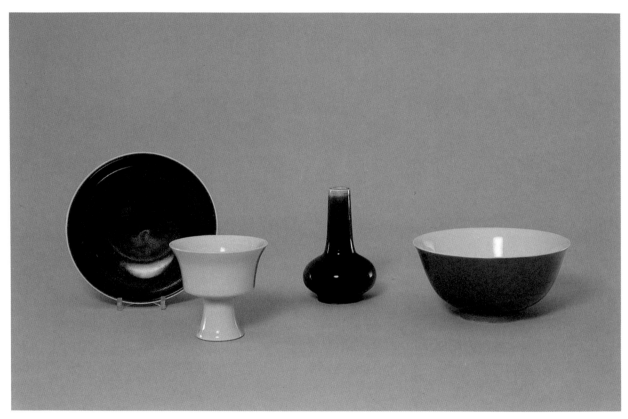

CH'ING DYNASTY CERAMICS

From left:

Dish, Ch'ien-lung period (1736–1795)
Porcelain with *sang-de-boeuf* glaze, height 3.5 cm.
Gift of Mrs. C. Reinold Noyes (64-94)

Stem Cup, Yung-cheng period (1723–1735)
Porcelain with pale celadon glaze, height 9.2 cm.
Gift of Mr. and Mrs. Nathan V. Hammer (59-110)

Vase, Ch'ing Dynasty (1644–1911)
Porcelain with *sang-de-boeuf* glaze, height 12.2 cm.
Gift of J. Lionberger Davis, Class of 1900 (69-36)

Rice Bowl, Yung-cheng period (1723–1735)
Lavender glaze over white porcelain biscuit, height 7.8 cm.
Gift of J. Lionberger Davis, Class of 1900 (66-75)

Carved Spinach-jade Dish, Ch'ing Dynasty, eighteenth century
Green nephrite, 4.5 × 27.0 cm.
Gift of J. Lionberger Davis, Class of 1900 (69-37)

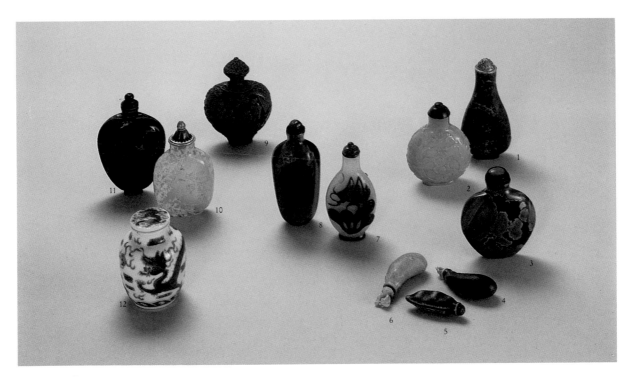

Snuff Bottles, Ch'ien-lung period (1736–1795)
Bequest of Colonel James A. Blair, Class of 1903

1. Lapis lazuli (36-614)
2. Yellow glass with flower medallion decoration (36-670)
3. Turquoise matrix (36-819)
4. Camelia-green porcelain (36-875)
5. Camelia-green porcelain (36-1043-2)
6. Gray porcelain (36-832)
7. Mottled white glass with green insect decoration (36-531)
8. Crystal with painting inside (36-724)
9. Cinnabar lacquer (36-816)
10. Mottled gray and white crystal (36-745)
11. Black lacquer (36-809)
12. White porcelain with green dragon decoration (36-861)

221

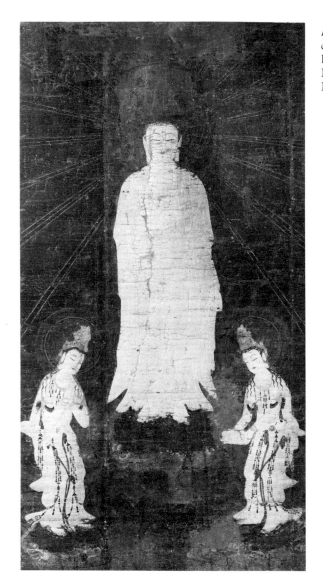

Descent of Amitabha Buddha, Kamakura period, ca. fourteenth century
Hanging scroll, gold and colors on silk, 1.2 × 0.7 m.
Museum purchase, Carl Otto von Kienbusch, Jr., Memorial Collection (52-59)

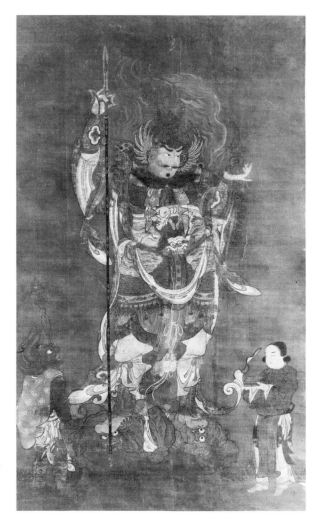

Bishamonten with Zennishi Dōji and a Yaksa, Kamakura period, ca. early fourteenth century
Hanging scroll, colors on silk, 1.1 × 0.7 m.
Gift of McKenzie Lewis, Jr. (64-187)

226

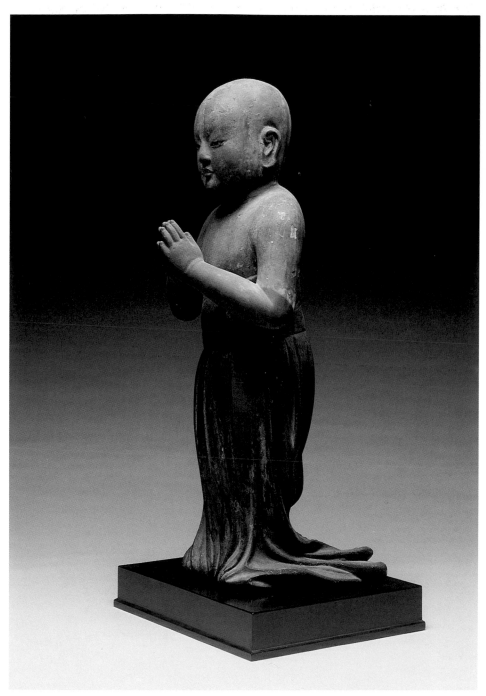

Infant Shōtoku Taishi, Kamakura period, ca. third quarter of the thirteenth century
Wood with traces of polychrome, joint-wood technique, height 50.0 cm.
Museum purchase, Fowler McCormick, Class of 1921, Fund (84-76)

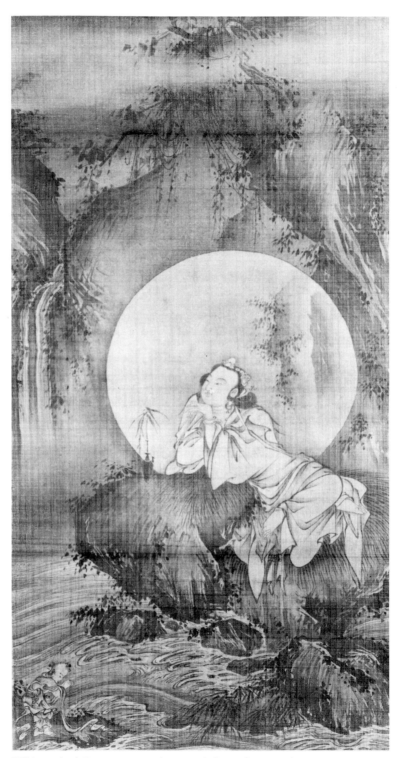

White-robed Kannon, Kamakura period, ca. fourteenth century
Hanging scroll, ink on silk, 96.5 × 49.0 cm.
Promised gift of Duane E. Wilder, Class of 1951 (L17.85)

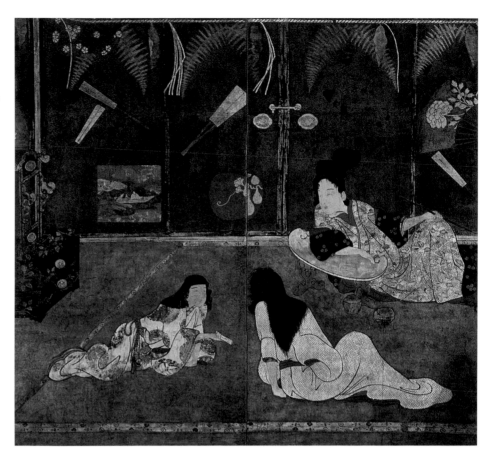

Messenger Delivering a Letter,
Momoyama period, ca. 1590
Two-fold screen, colors on
paper, 1.4 × 1.5 m.
Museum purchase with funds
given by William R. McAlpin,
Class of 1926 (64-50)

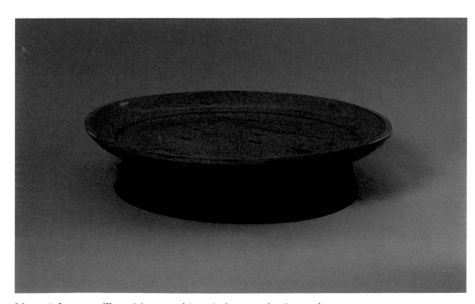

Negorō Lacquer Tray, Muromachi period, ca. early sixteenth century
Lacquer, height 10.5 cm., diameter 45.5 cm.
Museum purchase with funds given by Duane E. Wilder, Class of 1951 (85-77)

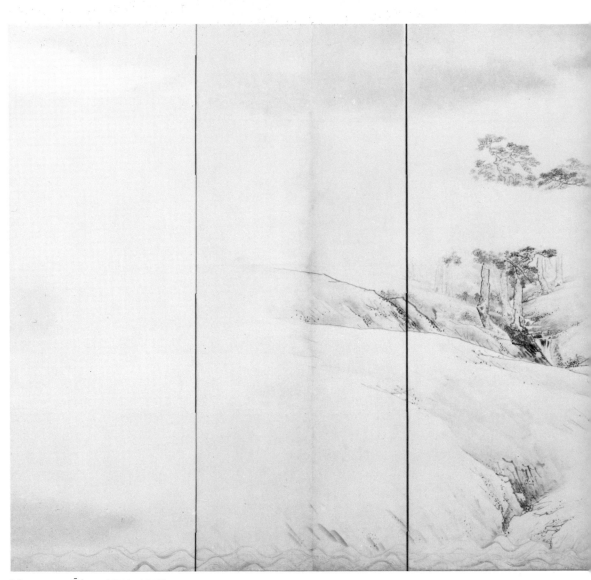

Maruyama Ōkyo (1733–1795)
The Hozu River, Edo period, dated 1772
Six-fold screen, ink, light colors, and gold stipple on paper, 0.3 × 1.6 m.
Museum purchase with funds given by William R. McAlpin, Class of 1926 (68-125)

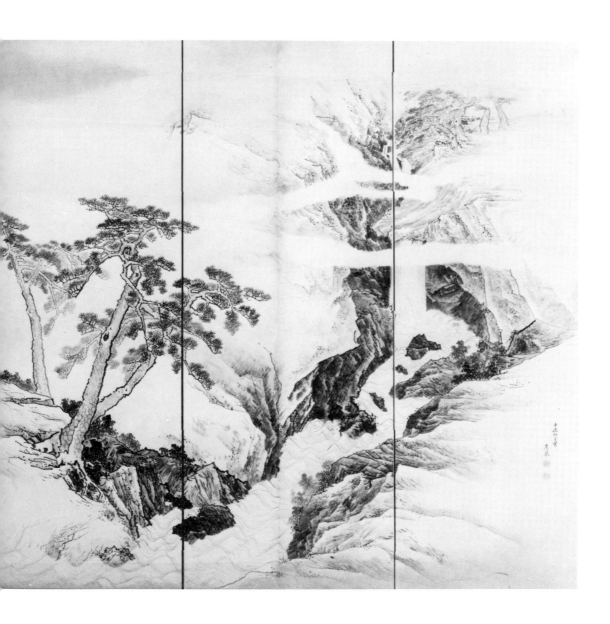

231

INDIAN AND ISLAMIC ART

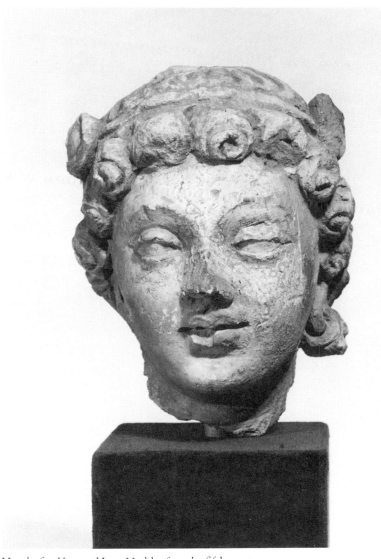

Head of a Young Man, Hadda, fourth–fifth century
Gray-buff stucco, preserved height 15.5 cm.
Gift of J. Lionberger Davis, Class of 1900 (66-42)

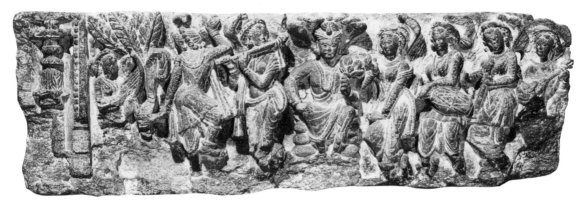

Frieze of Musicians, Gandhara, third century
Gray schist, height 20.0 cm.
Museum purchase (42-73)

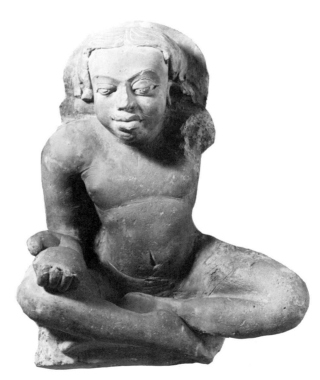

Seated Male Figure, Gupta period (fifth century)
Terracotta, height 31.0 cm.
Museum purchase with funds given by Mrs. Christian H. Aall, through the Port Royal
Foundation, Inc., and Mrs. Patrick J. Kelleher, in memory of Patrick J. Kelleher,
Graduate School Class of 1947 and Director of The Art Museum (1960–1972) (85-58)

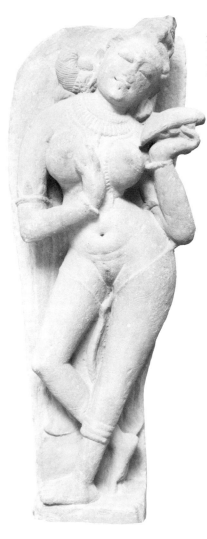

Devata, Pratihava Dynasty (805–1036)
Red sandstone, height 87.0 cm.
Museum purchase, John Maclean Magie and
Gertrude Magie Fund (63-26)

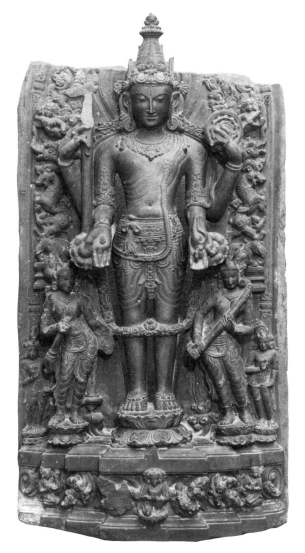

Vishnu and Attendants, Pala Dynasty
(tenth–twelfth century)
Black schist, 75.0 × 44.5 cm. (without tang at bottom)
Museum purchase, John Maclean Magie and Gertrude
Magie Fund (61-47)

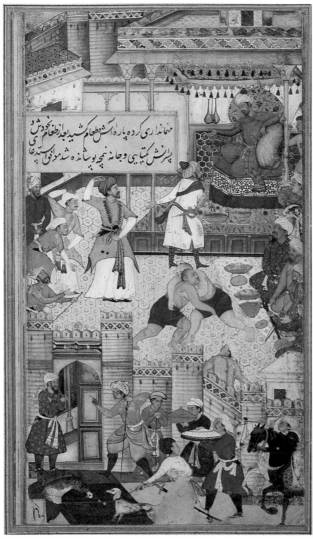

Scene of Entertainment, Mogul (School of Akbar),
ca. 1590; page from historical prose text
Ink, gold colors on paper, 35.5 × 23.3 cm.
Museum purchase, Carl Otto von Kienbusch, Jr.,
Memorial Collection (71-30)

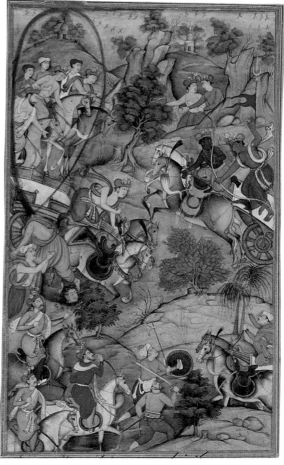

Battle Scene, Mogul, second half of the sixteenth century
Page, 30.6 × 17.0 cm.; miniature within border, 20.5 × 10.5 cm.
Gift of J. Lionberger Davis, Class of 1900 (69-38)

236

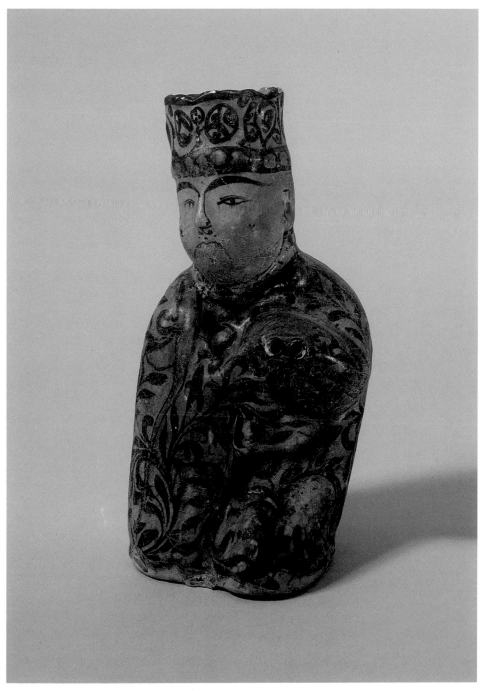

Seated Figure Holding a Wine Bottle, Kashan, Persian, thirteenth century
Clay, height 22.0 cm.
Museum purchase, Trumbull-Prime Fund (31-3)

AFRICAN ART

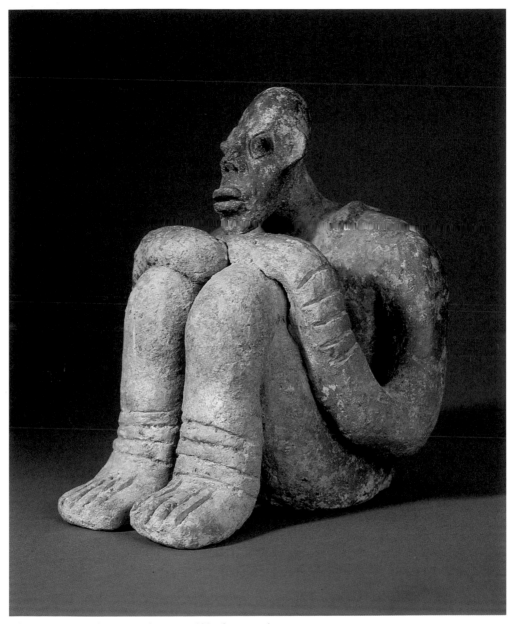

Djenne area, Mali, West Africa, twelfth–fourteenth century
Seated Man
Terracotta, height 21.0 cm.
Museum purchase with funds designated for The Art Museum by the Governor of New Jersey,
The Honorable Thomas Kean, from the proceeds of the Third Annual Governor's Invitational
Tennis Tournament (85-7)

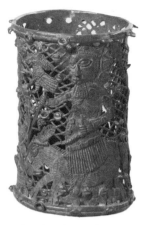

Benin, Nigeria, sixteenth century (?)
Armband
Bronze, brown patina, height 13.5 cm.
Gift of J. Lionberger Davis, Class of 1900 (63-38)

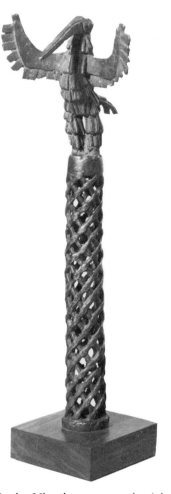

Benin, Nigeria, seventeenth–eighteenth century
Musical Instrument
Bronze, brown patina, height 32.0 cm.
Gift of J. Lionberger Davis,
Class of 1900 (68-33)

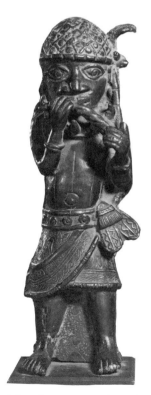

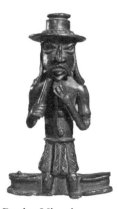

Benin, Nigeria, seventeenth–eighteenth century
Horn Player
Bronze, height 22.0 cm.
Gift of J. Lionberger Davis, Class of 1900 (68-31)

Benin, Nigeria, seventeenth century
Figure of a Portuguese
Bronze, brown patina, height 11.0 cm.
Gift of J. Lionberger Davis, Class of 1900 (68-32)

Akan, Ghana, late nineteenth century
Badge of Honor (*akrafokonmu*)
Metal, gold wire, diameter 7.2 cm.
Museum purchase, Fowler McCormick,
Class of 1921, Fund (82-17)

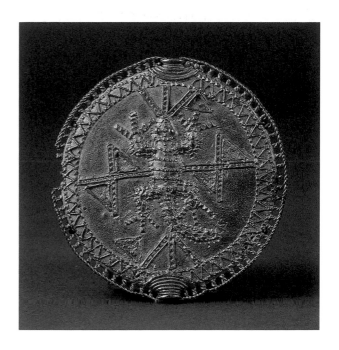

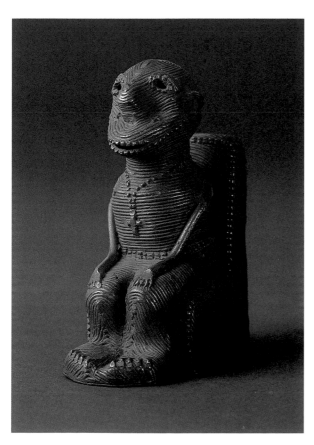

Lagoon Group, Ivory Coast, nineteenth century
Seated Man
Fused gold wire work, height 8.0 cm.
Gift of J. Lionberger Davis, Class of 1900 (68-41)

241

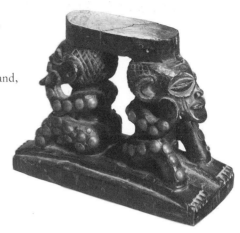

Tshokwe, Zaire and northeastern Angola,
late nineteenth century
Headrest
Dark brown wood, height 13.0 cm.
Gift of Mrs. Doyle in memory of her husband,
Donald B. Doyle, Class of 1905 (53-147)

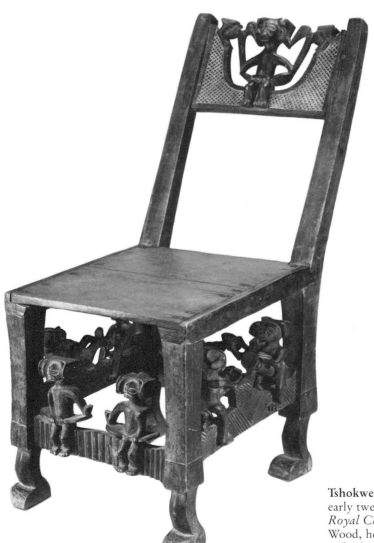

Tshokwe, Tshikapa region, East Angola or Zaire,
early twentieth century
Royal Chair
Wood, height 60.0 cm.
Gift of Perry E. H. Smith, Class of 1957 (80-23)

242

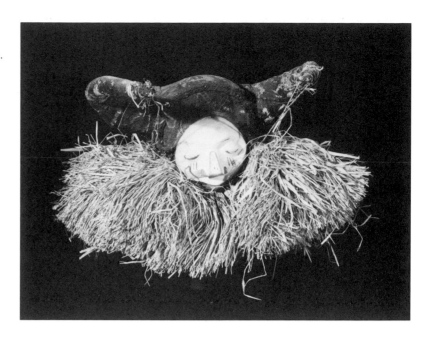

Zaire, twentieth century
Mask
Wood and raffia, height 23.0 cm.
Gift of Perry E. H. Smith,
Class of 1957 (79-79)

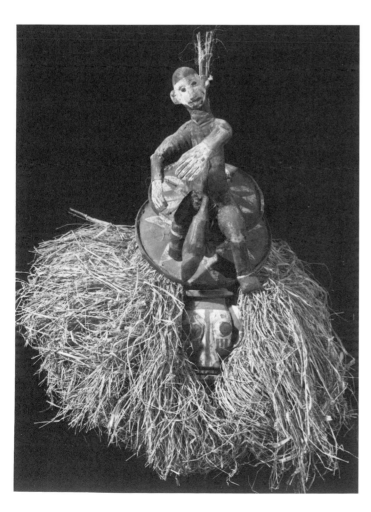

Zaire, twentieth century
Mask
Wood and raffia, height 80.0 cm.
Gift of Perry E. H. Smith, Class of 1957 (79-80)

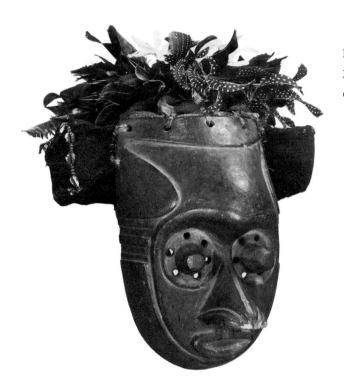

Kuba, Zaire, 1920s
Mask
Wood, height 28.0 cm.
Gift of Dr. and Mrs. Melvin A. Scharfman (80-25)

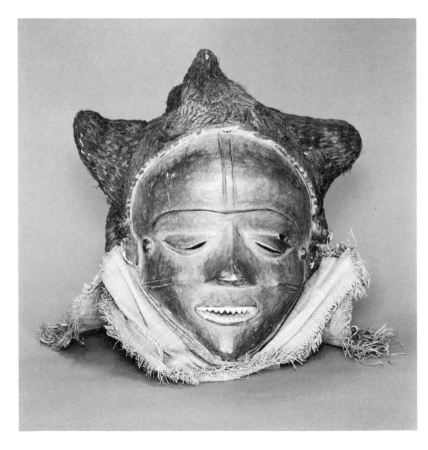

Pende, Zaire, late nineteenth century
Mask
Wood, paint, and tan raffia cloth,
height 39.0 cm.
Gift of Mrs. Doyle in memory of her
husband, Donald B. Doyle, Class
of 1905 (53-140)

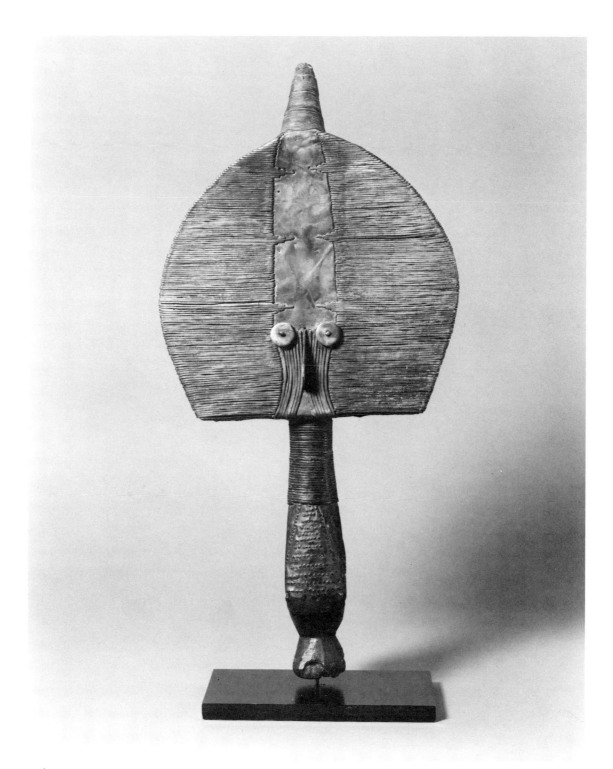

Gabon, MaHongwe, Shake, or BuSamai, late nineteenth century
Reliquary Guardian Figure
Wood, sheathed with copper, height 58.5 cm.
Museum purchase, Henry Strater Fund, and an anonymous donor (72-34)

PRE-COLUMBIAN ART

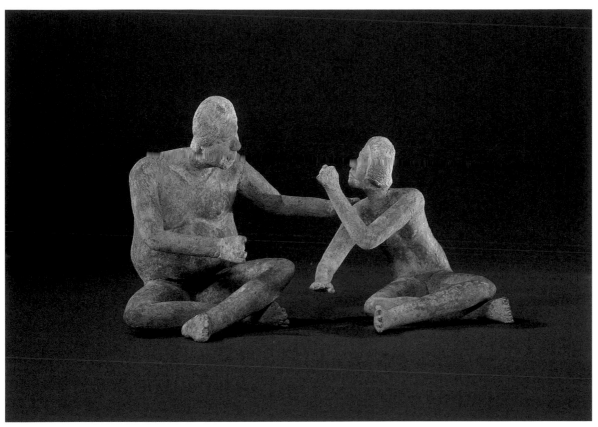

Xochipala, Guerrero, Mexico, before 1500 B.C.
Seated Shaman; *Seated Youth*
Red-brown micaceous clay, height 13.5 cm.; 11.0 cm.
Gift of Gillett G. Griffin, in honor of David W. Steadman (72-38; 72-39)

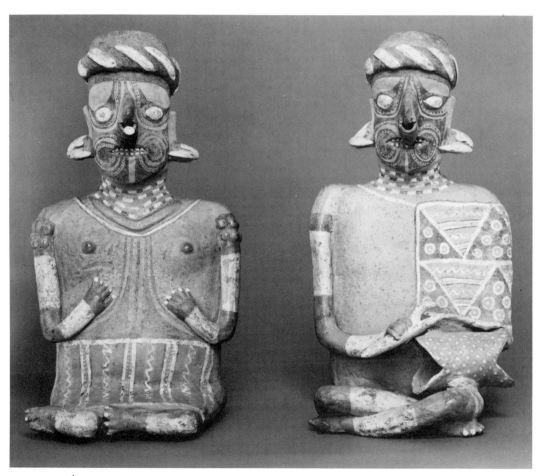

Ixtlán del Río style, Nayarit, Mexico, 200 B.C.–A.D. 100
Shaman; *Female Shaman*
Red clay covered with red slip, height 42.5 cm. each
Gift of Gillett G. Griffin (77-91; 77-92)

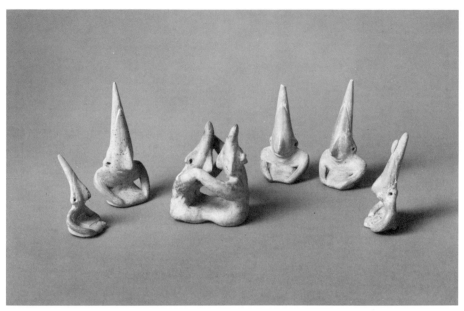

Jalisco, Mexico, 200 B.C.–A.D. 200
Five Single Figures and Two Wrestling Figures
Clay, heights ranging from 7.0 to 11.4 cm.
Gift of J. Lionberger Davis, Class of 1900 (68-63–68-68)

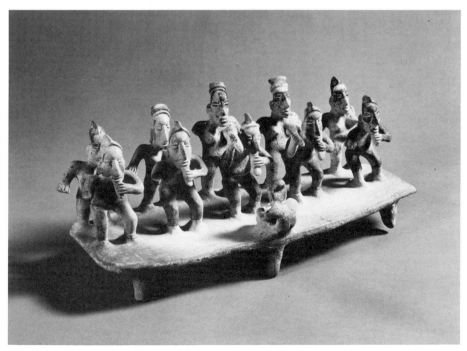

Jalisco, Mexico, 200 B.C.–A.D. 100
Plateau with Eleven Figures: Five Musicians Playing Transverse Flutes or
Whistles, with Chorus of Five Women and a Single Drummer
Clay with traces of polychrome, 15.5 × 36.5 × 15.0 cm.
Gift of Gillett G. Griffin (84-22)

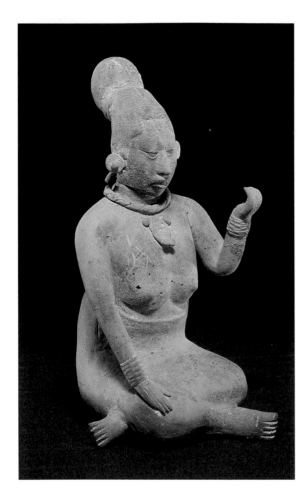

Maya, Jaina, Campeche, Mexico, Late Classic period
(A.D. 600–900)
Whistle in the Form of the Moon Goddess Ixchel
Clay, height 22.5 cm.
Gift of Gillett G. Griffin (79-92)

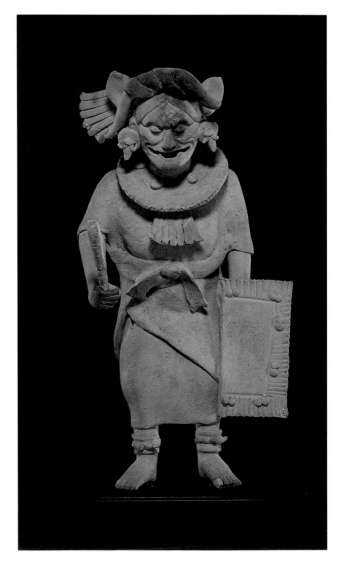

Maya, Jaina, Campeche, Mexico, Classic period
(A.D. 200–900)
Old Jaguar God in Warrior Stance
Clay, height 26.0 cm.
Museum purchase with funds given by
J. Lionberger Davis, Class of 1900 (65-197)

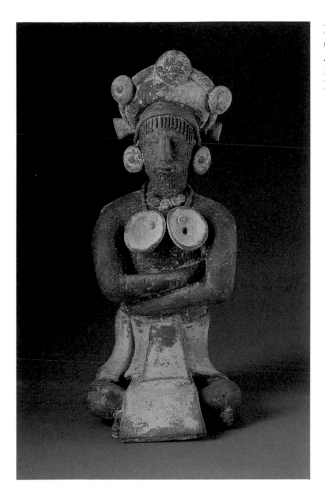

Maya, Jaina, Campeche, Mexico, Late Classic period
(A.D. 600–900)
Seated Man
Fine red clay, white slip, blue paint, height 17.7 cm.
Museum purchase (81-8)

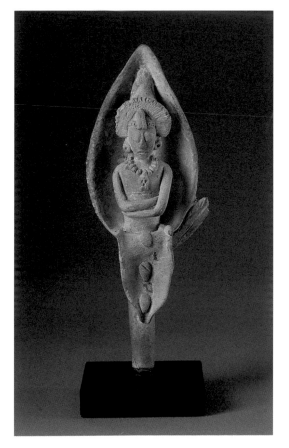

Maya, Jaina, Campeche, Mexico, Late Classic period
(A.D. 600–900)
Young God Emerging from a Flower
Clay, height 15.0 cm.
Museum purchase (83-5)

Maya, Jaina, Campeche, Mexico, Late Classic period (A.D. 600–900)
Head
Shell, height 3.0 cm.
Museum purchase, Robert Wood Johnson 1962 Charitable Trust (79-12)

Maya, Jaina, Campeche, Mexico, Late Classic period (A.D. 600–900)
Pectoral in the Form of the Glyph Ahau
Shell, maximum height 7.7 cm.
Gift of Gillett G. Griffin (83-51)

Maya, Michoacán, Mexico, Late Classic period (A.D. 600–900)
Seated Nobleman
Mottled green and gray jadeite, height 8.2 cm.
Museum purchase with funds given by the Hans and Dorothy Widenmann Fund (Hans A. Widenmann, Class of 1918) (72-35)

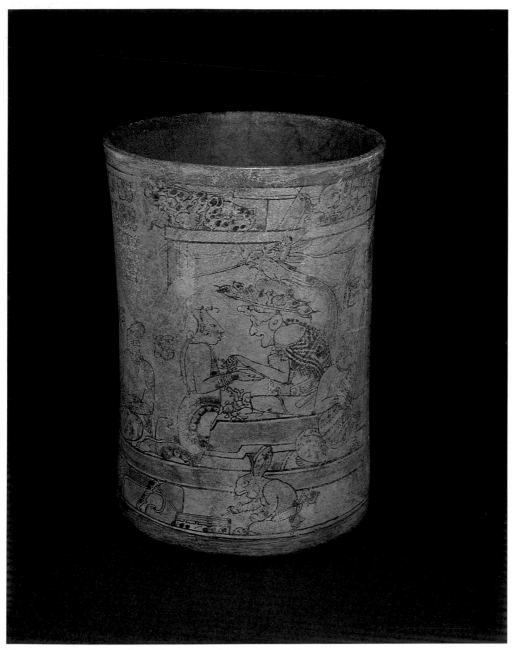

Maya, northern Petén, Late Classic period (A.D. 600–900)
Palace Scene with Beheading, vase in Codex style
Granular gray-buff clay, mineral inclusions, height 21.5 cm., diameter of rim 16.6 cm.
Museum purchase with funds given by the Hans and Dorothy Widenmann Fund
(Hans A. Widenmann, Class of 1918) (75-17)

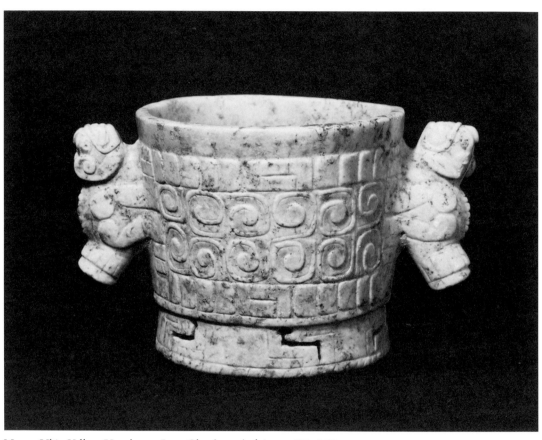

Maya, Ulúa Valley, Honduras, Late Classic period (A.D. 600–900)
Vessel
Marble, height 12.8 cm.
Museum purchase, Robert Wood Johnson, Jr., Charitable Trust (78-2)

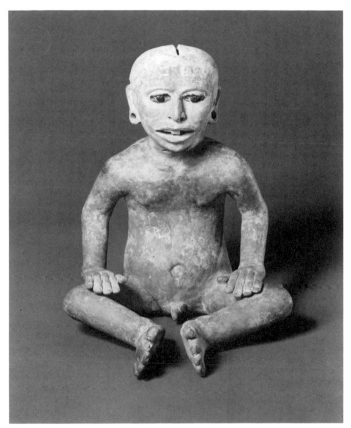

Veracruz, Mexico, ca. 200 B.C.
Red-Painted Seated Man
Clay, height 30.5 cm.
Gift of Gillett G. Griffin (82-87)

Veracruz, Mexico, 200 B.C.–A.D. 500
Hacha in the Form of a Head
Volcanic stone, height 19.0 cm.
Gift of Miles Lourie (84-5)

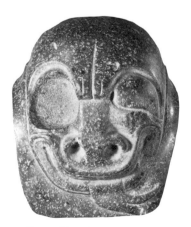

Olmec, first millennium B.C.
Knee-guard (yuguito)
Granite, height 13.0 cm.
Museum purchase with funds given by the Wallace
S. Whittaker Foundation, in memory of Wallace S.
Whittaker, Yale Class of 1914 (83-17)

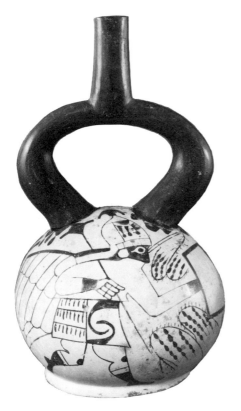

Moche, Peru, ca. fifth century A.D.
Hummingbird Warriors Running Through the Desert,
stirrup-spout vessel
Clay, height 28.0 cm., diameter 15.5 cm.
Gift of Gillett G. Griffin (85-68)

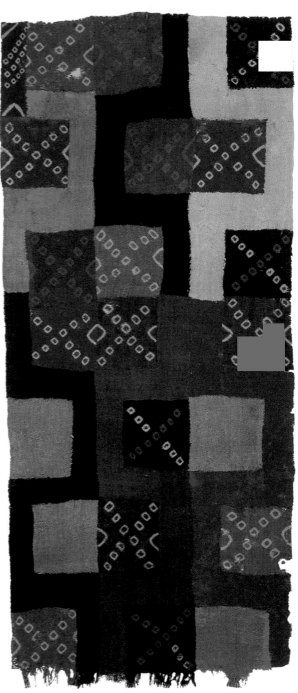

Nazca, Peru, A.D. 400–500
Cloth with Geometric Design
Wool patchwork, 1.43 × 0.6 m.
Gift of Mr. and Mrs. Arnold Glimcher (82-83)

262

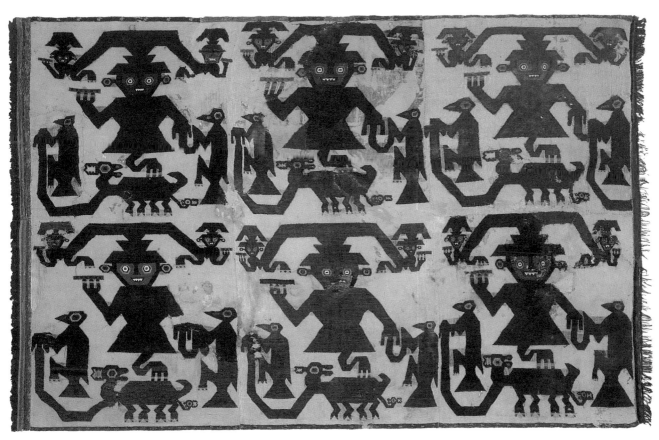

Chimu, Peru, 1000–1400
Brocaded Cloth with Deities
Cotton and wool, 1.6 × 2.5 m.
Museum purchase with funds given by
Herbert L. Lucas, Jr., Class of 1950 (86-2)

AMERICAN ART

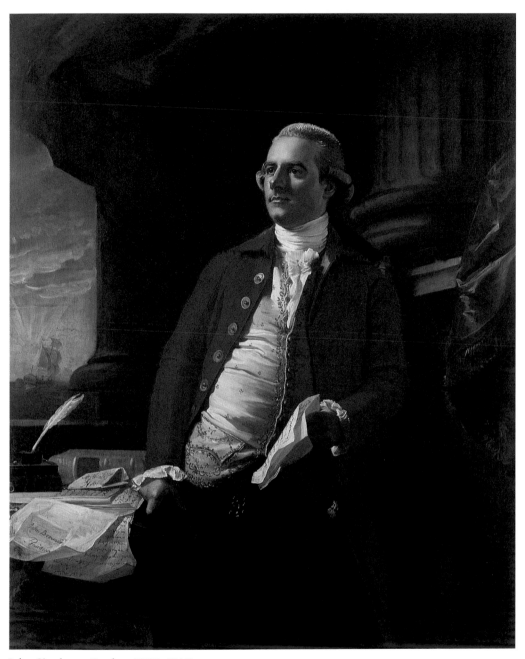

John Singleton Copley (1738–1815)
Portrait of Elkanah Watson, 1782
Oil on canvas, 1.5 × 1.2 m.
Presented by the Estate of Josephine Thomson Swann (64-181)

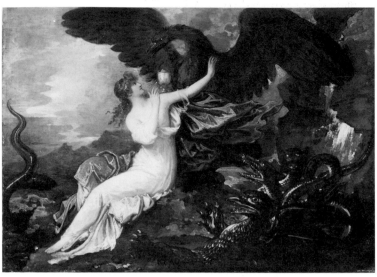

Benjamin West (1738–1820)
Eagle Bringing the Cup to Psyche
Oil on panel, 29.8 × 42.6 cm.
Museum purchase, John Maclean Magie and Gertrude Magie Fund (52-62)

Rembrandt Peale (1778–1860)
George Washington
Oil on canvas, 91.2 × 73.8 cm.
Gift of Mr. and Mrs. Landon K. Thorne for
the Boudinot Collection (66-262)

John Trumbull (1756-1843)
Brigadier General Ebenezer Huntington
Oil on canvas, 63.5 × 52.6 cm.
Gift of Max Adler (76-10)

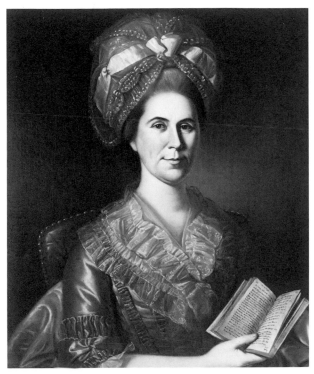

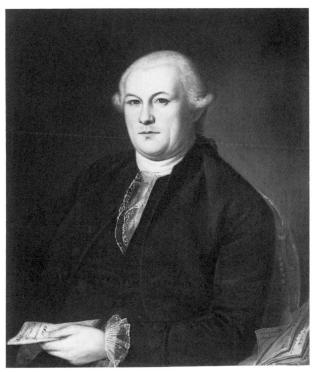

Charles Willson Peale (1741–1827)
Mrs. Elias Boudinot IV
Oil on canvas, 76.0 × 63.5 cm.
Gift of Mr. and Mrs. Landon K. Thorne for
the Boudinot Collection (54-267)

Charles Willson Peale (1741–1827)
Elias Boudinot IV
Oil on canvas, 76.0 × 63.5 cm.
Gift of Mr. and Mrs. Landon K. Thorne for
the Boudinot Collection (54-266)

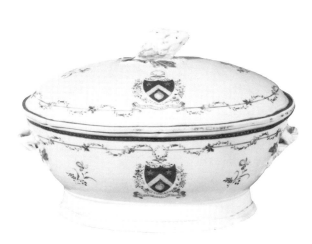

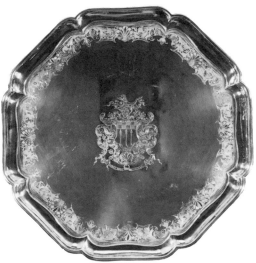

Chinese export ware
Covered Soup Tureen
Porcelain, height with cover, 21.0 cm.; with the
Boudinot coat of arms
Gift of the Thorne Foundation for the Boudinot
Collection (74-21a, b)

Jacob Hurd (Boston, 1703–1758)
Silver Tray
Maximum diameter 32.8 cm.; engraved with the coat of
arms of William Peartree Smith
Gift of Mrs. William Dominick for the Boudinot
Collection (59-47)

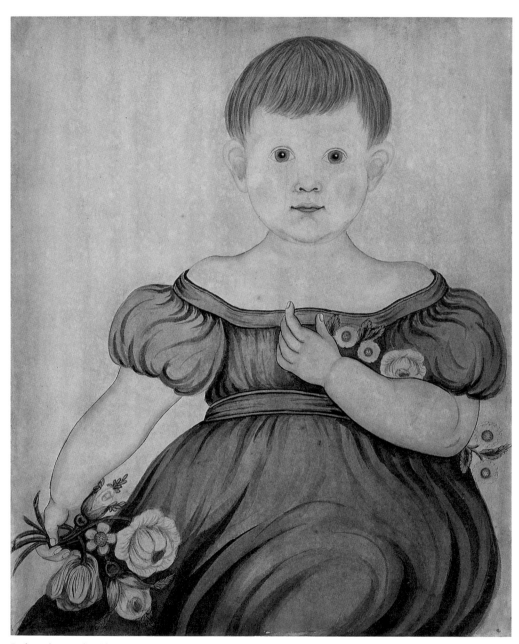

Deborah Smith Taber (1796–1879)
Hetty E. Taber, New Bedford, Massachusetts
Watercolor, 45.5 × 36.6 cm.
Gift of Edward Duff Balken, Class of 1897 (58-86)

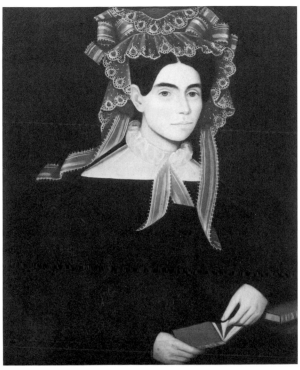

Attributed to Ammi Phillips (1788–1865)
Wife of the Journalist
Oil on canvas, 81.0 × 66.0 cm.
Gift of Edward Duff Balken, Class of 1897 (58-79)

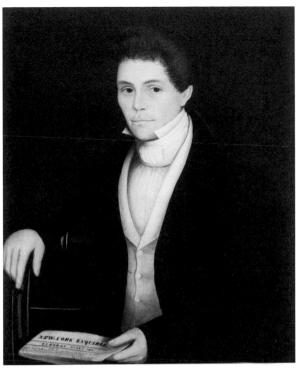

Attributed to Ammi Phillips (1788–1865)
The Journalist
Oil on canvas, 81.3 × 65.5 cm.
Gift of Edward Duff Balken, Class of 1897 (58-78)

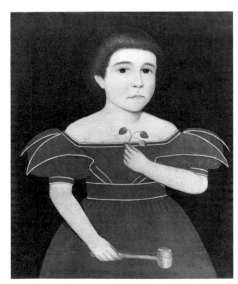

Attributed to Ammi Phillips (1788–1865)
The Boy in Red
Oil on canvas, 53.2 × 49.0 cm.
Gift of Edward Duff Balken, Class of 1897
(58-75)

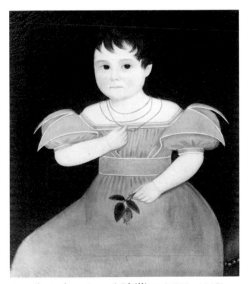

Attributed to Ammi Phillips (1788–1865)
The Girl in Pink
Oil on canvas, 58.0 × 49.0 cm.
Gift of Edward Duff Balken, Class of 1897
(58-74)

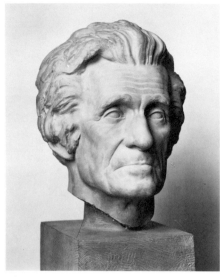

John Frazee (1790–1852)
Andrew Jackson, 1834
Plaster, height 32.0 cm.
Museum purchase, John Maclean Magie
and Gertrude Magie Fund (47-207)

William Rush (1756–1833)
George Washington
Plaster, painted black, height 68.5 cm.
Museum purchase, John Maclean Magie
and Gertrude Magie Fund (46-78)

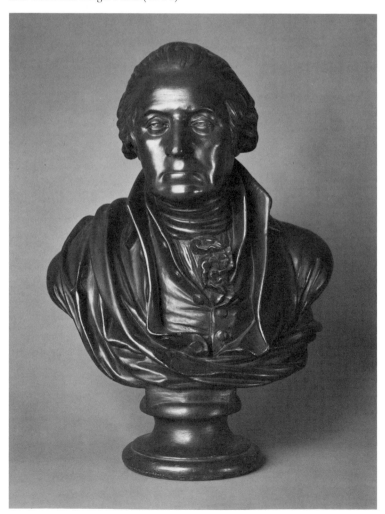

Thomas Sully (1783–1872) ▶
Mrs. Reverdy Johnson, 1840
Oil on canvas, 2.4 × 1.5 m.
Given by twenty-one friends
of the University, aided by the
Caroline G. Mather Fund (49-108)

270

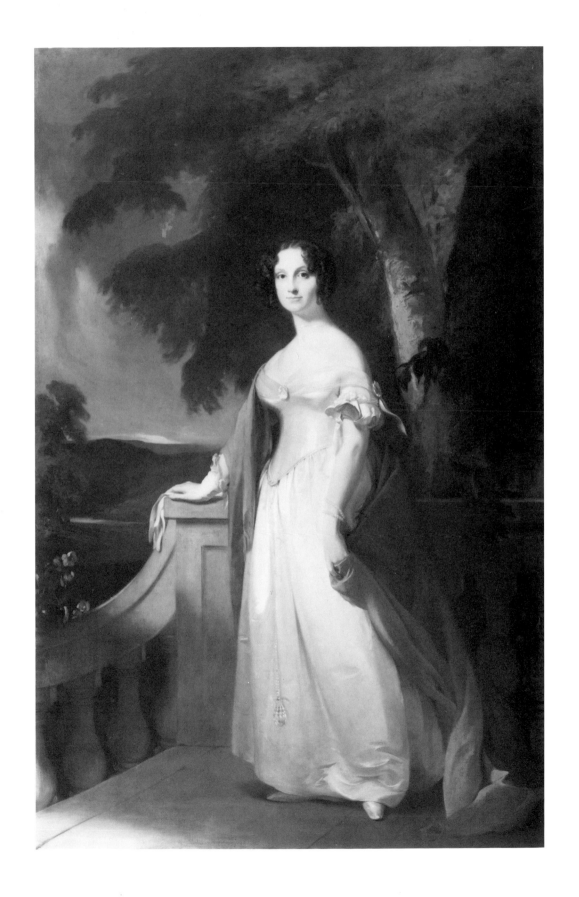

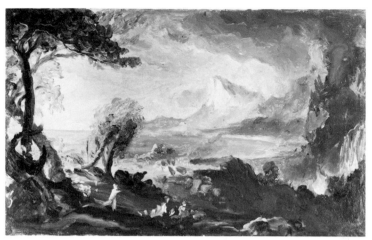

Thomas Cole (1801–1848)
Sketch for *The Course of Empire, Savage State*
Oil on canvas, 16.0 × 26.0 cm.
Gift of Frank Jewett Mather, Jr. (41-51)

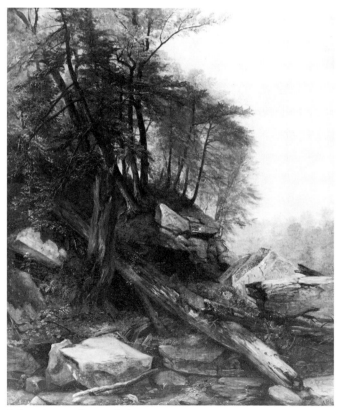

Asher Brown Durand (1796–1886)
Kaaterskill Landscape, 1850
Oil on panel, 52.5 × 42.5 cm.
Museum purchase, John Maclean Magie
and Gertrude Magie Fund (46-104)

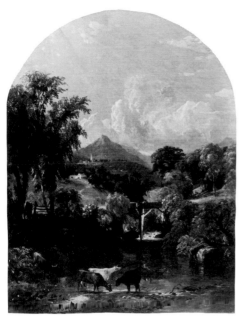

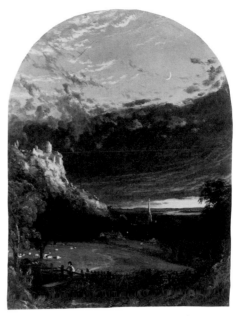

Jasper Francis Cropsey (1823–1900)
Morning, 1854
Oil on canvas, 43.8 × 32.3 cm.
Gift of Stuart P. Feld, Class of 1957,
and Mrs. Feld (84-31)

Jasper Francis Cropsey (1823–1900)
Evening, 1855
Oil on canvas, 44.4 × 33.1 cm.
Gift of Stuart P. Feld, Class of 1957,
and Mrs. Feld (84-32)

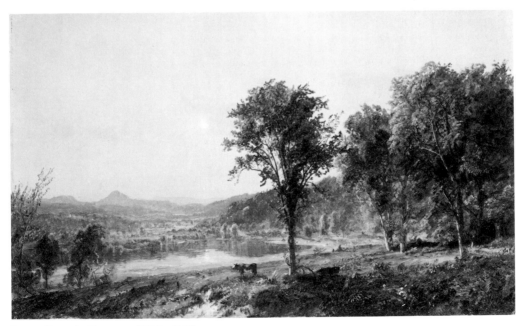

Jasper Francis Cropsey (1823–1900)
Mounts Adam and Eve, 1872
Oil on canvas, 30.6 × 51.3 cm.
Gift of the Newington Cropsey Foundation (83-11)

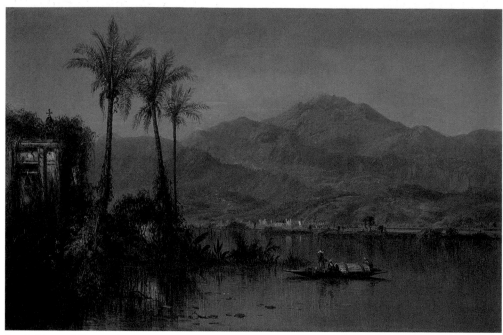

Louis Remy Mignot (1831–1870)
South American Scene, 1862
Oil on canvas, 37.5 × 56.5 cm.
Gift of Stuart P. Feld, Class of 1957, and Mrs. Feld (80-38)

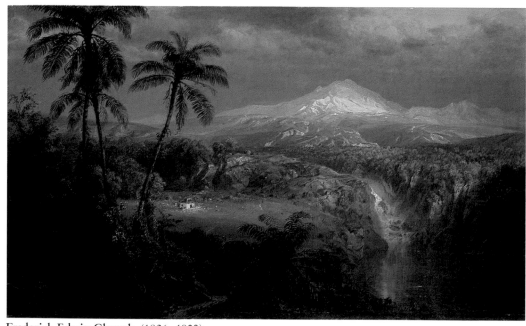

Frederick Edwin Church (1826–1900)
Passing Shower in the Tropics, 1872
Oil on canvas, 31.0 × 51.3 cm.
Museum purchase (45-212)

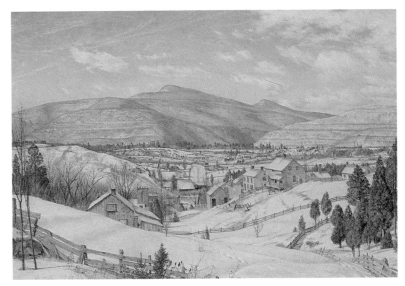

Charles Herbert Moore (1840–1930)
Winter Landscape, Valley of the Catskill, 1866
Oil on canvas, 18.0 × 25.5 cm.
Gift of Frank Jewett Mather, Jr. (53-35)

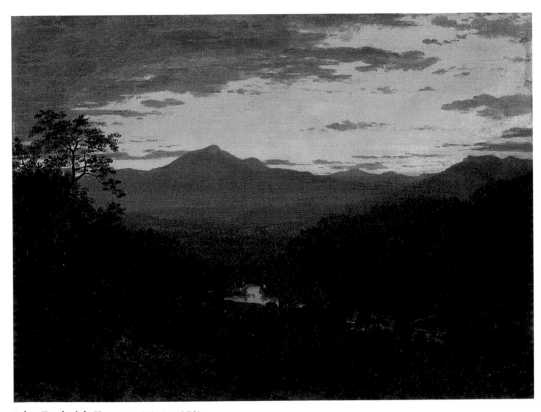

John Frederick Kensett (1816–1872)
Sunset, Camel's Hump, Vermont
Oil on canvas, 30.5 × 41.0 cm.
Gift of the Old Print Shop, New York City (45-199)

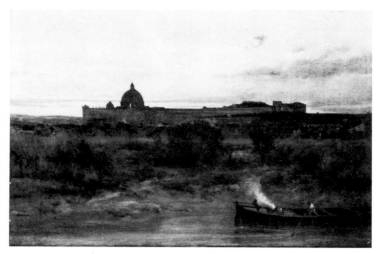

George Inness (1825–1894)
Sunset near St. Peter's, Rome
Oil on canvas, 41.0 × 61.0 cm.
Gift of Hugh Trumbull Adams, Class of 1935 (82-12)

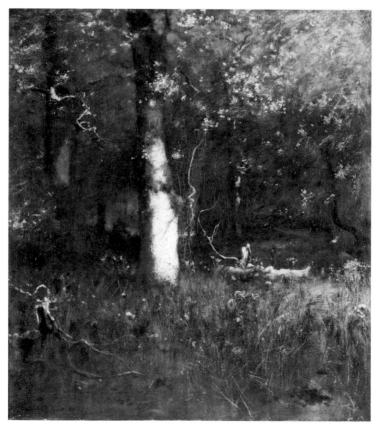

George Inness (1825–1894)
Home of the Heron, 1891
Oil on canvas, 1.1 × 1.0 m.
Gift of Victor Stephen Harris, Class of 1940, and David Harris,
Class of 1944, in memory of their father, Victor Harris (43-93)

Albert Bierstadt (1830–1902)
Undulations: White Mountains, New Hampshire
Oil on paper, 26.0 × 36.0 cm.
Gift of Florence Lewison Glickman in memory
of her husband, Maurice Glickman (82-109)

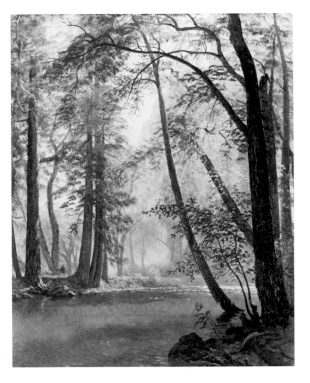

Albert Bierstadt (1830–1902)
Yosemite Valley, California
Oil on paper, 50.0 × 40.0 cm.
Gift of Stuart P. Feld, Class of 1957,
and Mrs. Feld (83-53)

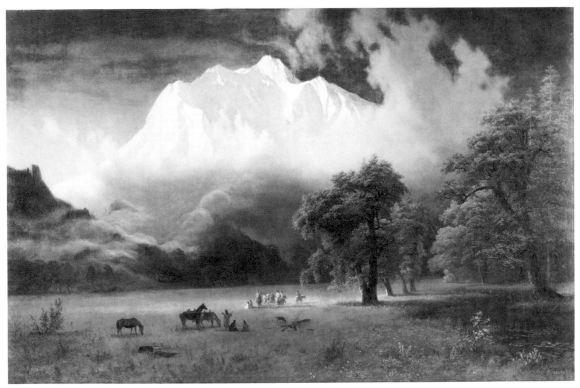

Albert Bierstadt (1830–1902)
Mount Adams, Washington, 1875
Oil on canvas, 1.4 × 2.1 m.
Gift of Mrs. Jacob N. Beam (40-430)

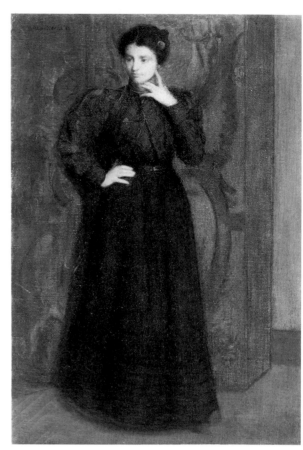

Julian Alden Weir (1852–1919)
The Green Dress, 1898
Oil on canvas, 45.8 × 30.7 cm.
Bequest of Gilbert S. McClintock, Class of 1908 (59-71)

Eastman Johnson (1824–1906)
Grover Cleveland, 1891
Oil on paper, mounted on canvas, 42.5 × 30.5 cm.
Museum purchase (65-202)

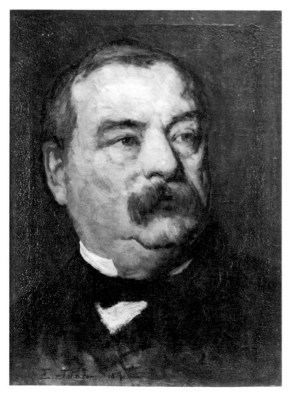

John Singer Sargent (1856–1925) ▶
Elizabeth Allen Marquand
(Mrs. Henry G. Marquand), 1887
Oil on canvas, 1.7 × 1.1 m.
Gift of Eleanor Marquand Delanoy (77-77)

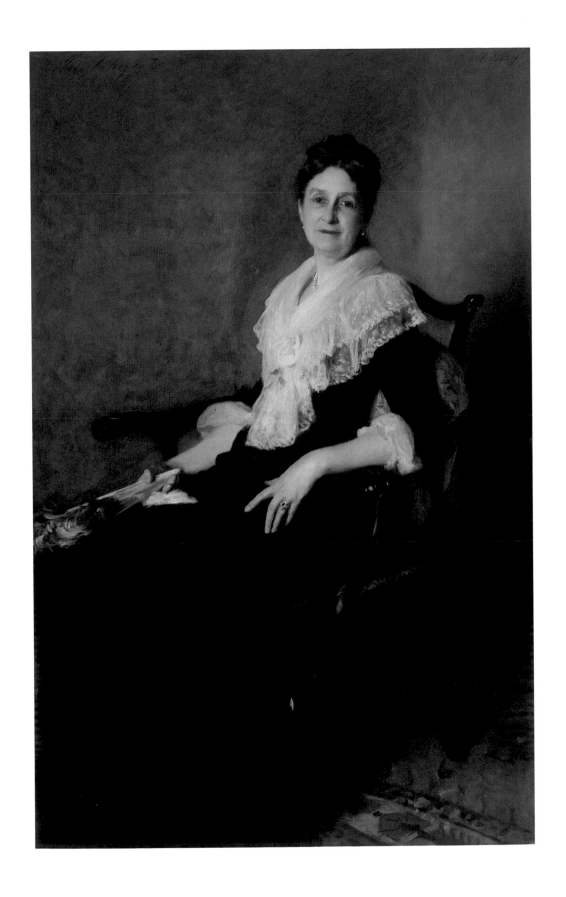

279

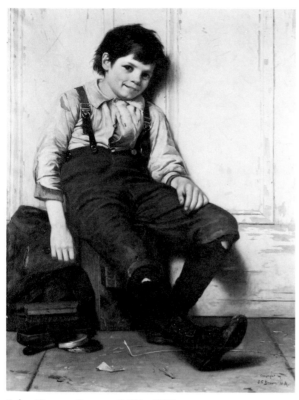

John George Brown (1831–1913)
Lazy Bones
Oil on canvas, 1.1 × 0.8 m.
Gift of Carl Otto von Kienbusch, Class of 1906, for
the Carl Otto von Kienbusch, Jr., Memorial
Collection (51-57)

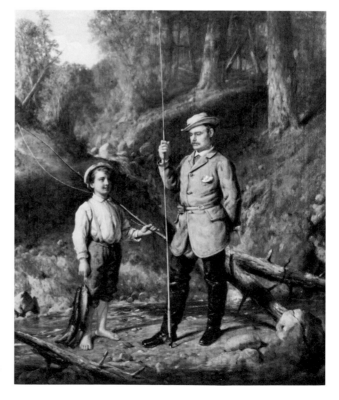

Junius Brutus Stearns (1810–1885)
The Old, Old Story, 1882
Oil on canvas, 61.0 × 51.0 cm.
Gift of Carl Otto von Kienbusch, Class of
1906, for the Carl Otto von Kienbusch, Jr.,
Memorial Collection (64-180)

Kenyon Cox (1856–1919)
Bird Song, 1896
Oil on canvas, mounted on board,
44.3 × 29.5 cm.
Museum purchase, John Maclean Magie
and Gertrude Magie Fund (79-58)

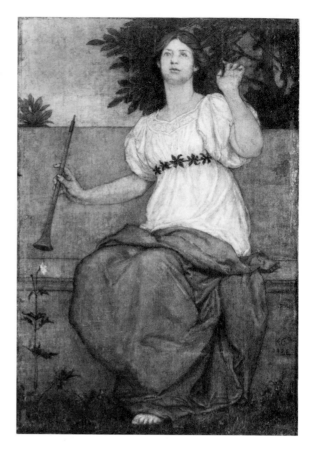

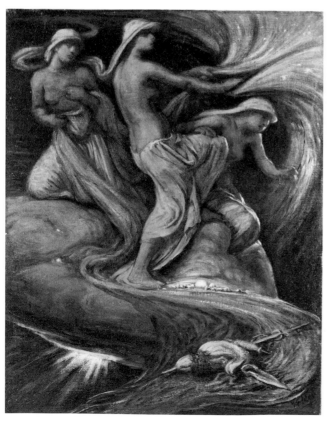

Elihu Vedder (1836–1923)
The Fates Gathering in the Stars
Oil on canvas, 44.0 × 33.8 cm.
Museum purchase, Caroline G. Mather Fund (79-57)

Augustus Saint-Gaudens (1848–1907)
Bastien-Lepage, 1880
Bronze plaque with oak mount, 26.5 × 37.5 cm.
(mount 84.0 × 52.0 cm.)
Gift of Norman Armour, Class of 1909 (49-144)

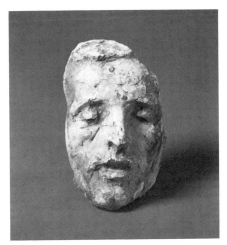

Frederick MacMonnies (1863–1937)
Study for *Nathan Hale*
Plaster (posthumous cast of clay model),
height 50.0 cm.
Museum purchase, John Maclean Magie
and Gertrude Magie Fund (77-72)

Frederick MacMonnies (1863–1937)
Study for the face of *Nathan Hale*
Plaster cast, height 13.0 cm.
Museum purchase, John Maclean Magie
and Gertrude Magie Fund (77-73)

283

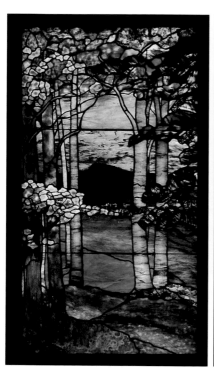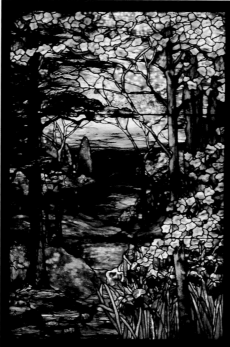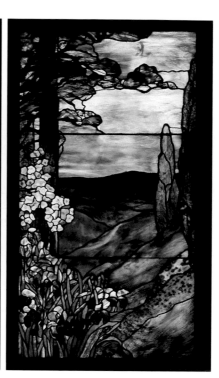

Louis Comfort Tiffany (1848–1933)
Landscape, triptych
Opalescent glass, 1.3 × 2.3 m.
Gift of Norman A. Ballantine, Class of 1935, in memory
of Percy Ballantine, Class of 1902, Peter Ballantine, Class
of 1925, and Peter Stevens Ballantine, Class of 1952 (67-6)

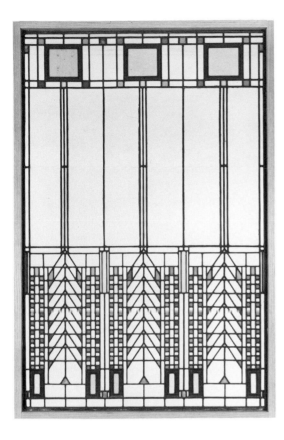

Frank Lloyd Wright (1867–1959)
Window from the Darwin D. Martin House, Buffalo, 1904
Pot-metal glass and white glass, oak frame, 1.1 × 0.7 m.
Museum purchase, Fowler McCormick, Class of 1921, Fund
(81-10)

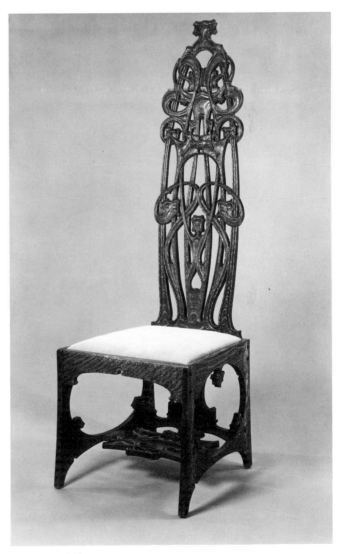

Newcomb College pottery, New Orleans
Three-Handled Mug
Height 16.0 cm.
Museum purchase (72-8).

Charles Rohlfs (1853–1936)
Chair
Oak, height 1.4 m.
Gift of Roland Rohlfs (72-25)

285

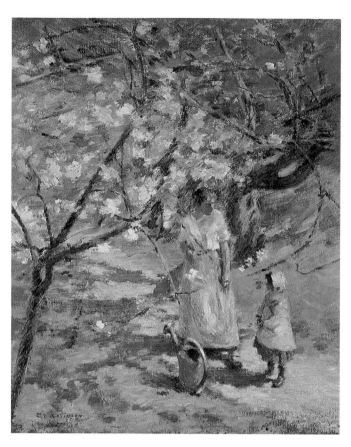

Theodore Robinson (1852–1896)
In the Orchard
Oil on canvas, 51.0 × 41.5 cm.
Gift of Frank Jewett Mather, Jr. (43-96)

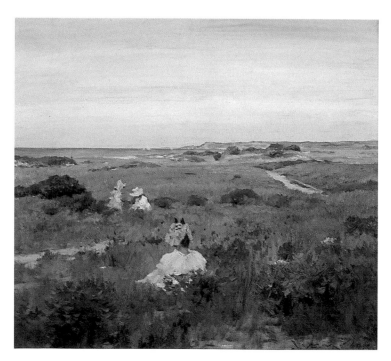

William Merritt Chase (1849–1916)
Landscape: Shinnecock, Long Island
Oil on panel, 36.3 × 40.9 cm.
Gift of Francis A. Comstock,
Class of 1919 (39-35)

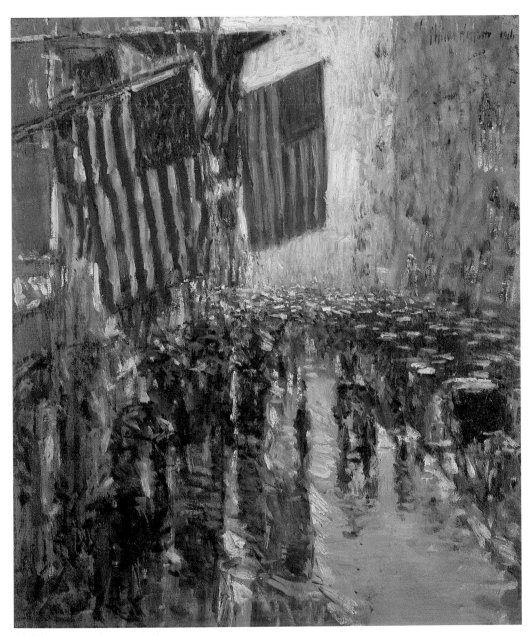

Childe Hassam (1859–1935)
Rainy Day, Fifth Avenue, 1916
Oil on canvas, 46.0 × 38.5 cm.
Gift of Albert E. McVitty, Class of 1898 (42-62)

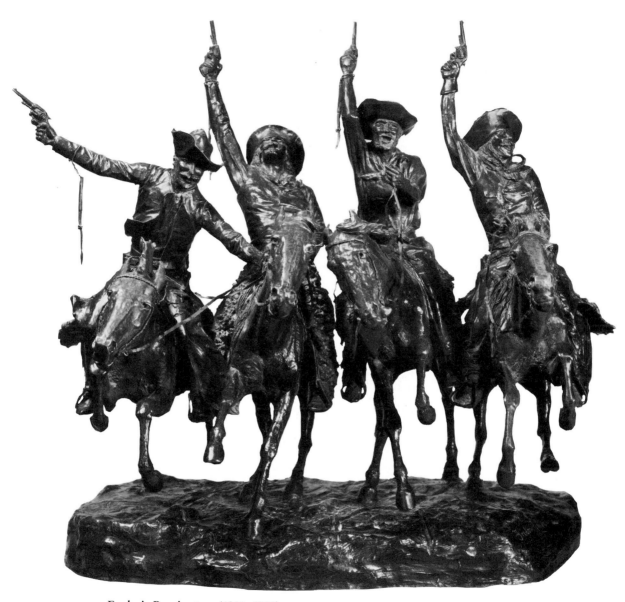

Frederic Remington (1861–1909)
Coming Through the Rye, 1902
Bronze, height 78.4 cm.
Promised gift of Laurance S. Rockefeller, Class of 1932

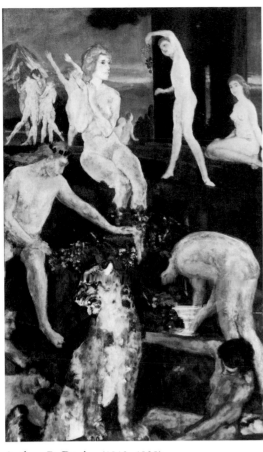

Arthur B. Davies (1862–1928)
Dionysus
Oil on canvas, 76.0 × 45.5 cm.
Gift of Albert E. McVitty, Class of 1898 (45-273)

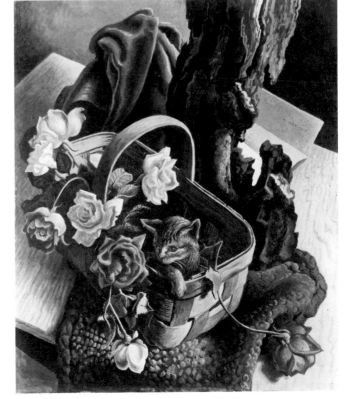

Thomas Hart Benton (1889–1975)
Pussycat and Roses, 1939
Tempera on canvas, 61.0 × 50.0 cm.
Gift of Mr. and Mrs. Morton L. Janklow,
in honor of their daughter, Angela LeRoy
Janklow, Class of 1985 (82-103)

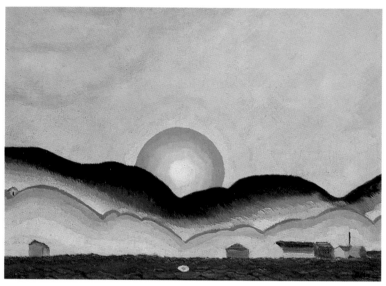

Arthur G. Dove (1880–1946)
Sunrise, Northport Harbor, 1929
Oil on canvas, 38.0 × 51.0 cm.
Gift of John S. McGovern, Class of 1926 (62-44)

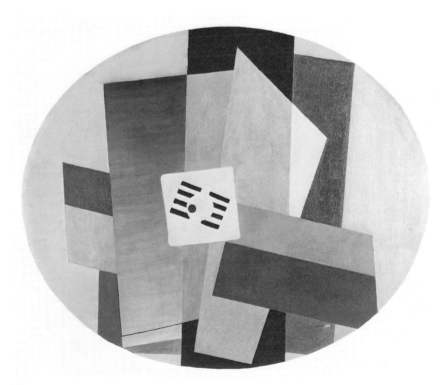

Albert E. Gallatin (1881–1952)
Abstraction, 1944–50
Oil on canvas, 76.5 × 63.5 cm.
Gift of the artist (50-124)

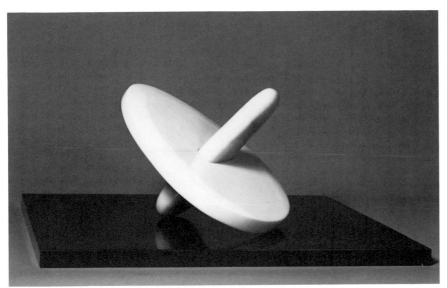

Isamu Noguchi (born 1904)
Funny Face
Marble, height 18.5 cm.
Gift of the artist for the William C. Seitz,
Graduate School Class of 1955,
Memorial Collection (*77-87*)

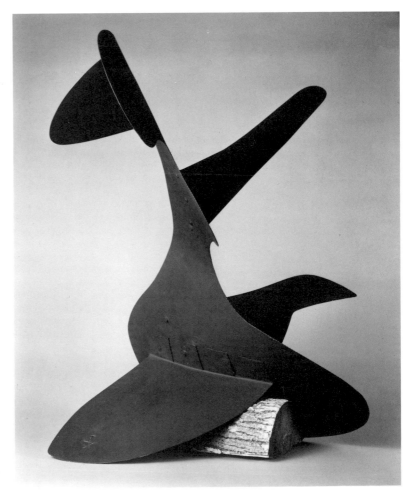

Alexander Calder (1898–1976)
Maquette for *Whale* (1937)
Mild steel, painted black, height 90.0 cm.
Gift of Mrs. Alfred H. Barr, Jr. (79-16)

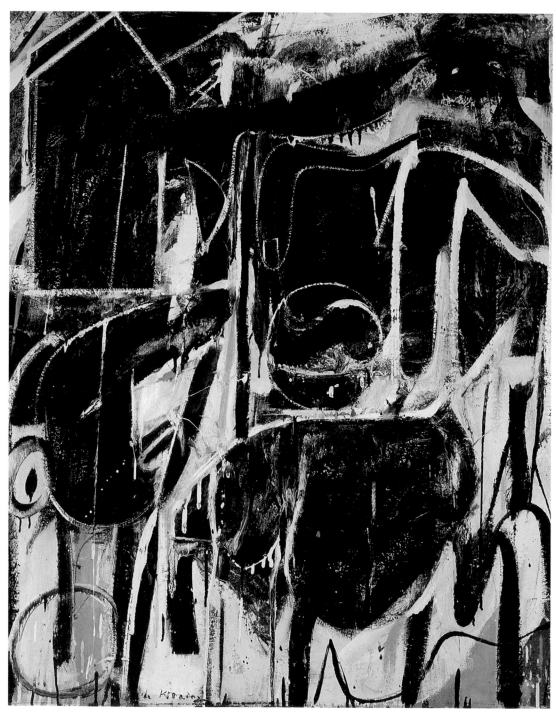

Willem de Kooning (born in the Netherlands, 1904)
Black Friday, 1948
Oil on composition board, 1.3 × 1.0 m.
Partial gift of H. Gates Lloyd, Class of 1923, and Mrs. Lloyd (76-44)

Andy Warhol (born 1930)
Blue Marilyn, 1962
Silkscreen and acrylic on canvas,
50.5 × 40.3 cm.
Gift of Alfred H. Barr, Jr., Class
of 1922, and Mrs. Barr (78-46)

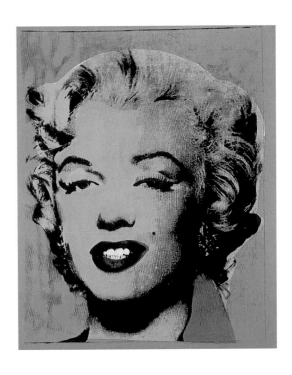

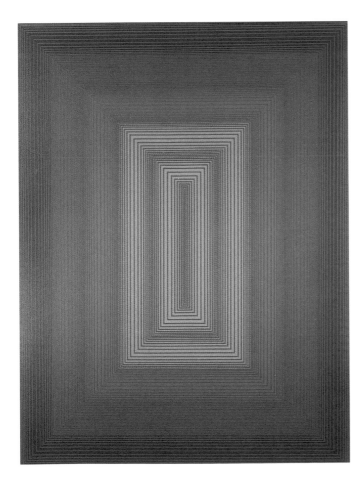

Richard Anuszkiewicz (born 1930)
Light Mauve Tint, 1971
Acrylic on canvas, 1.2 × 0.9 m.
Promised gift of the artist for the William C. Seitz,
Graduate School Class of 1955,
Memorial Collection

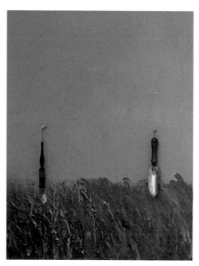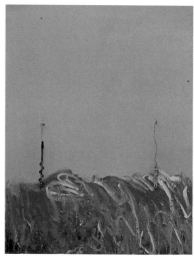

Jim Dine (born 1935)
The Art of Painting No. 2, 1973
Enamel and acrylic on canvas, with objects;
five panels, each 1.2 × 0.9 m.
Presented in memory of Helen B. Seeger on
the date of her birthday by her son, Stanley J. Seeger, Jr.,
Class of 1952, through the Helen B. Seeger Fund (74-1)

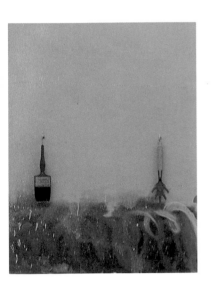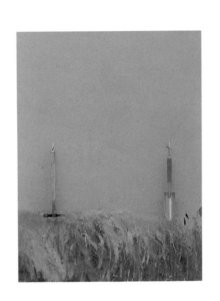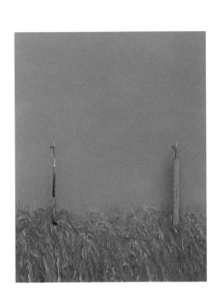

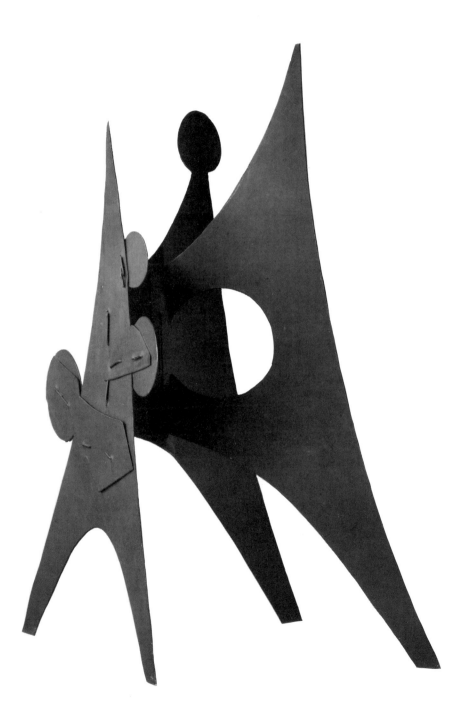

Alexander Calder
(1898–1976)
Maquette for *Five Disks:
One Empty*
Sheet aluminum, painted black,
height 56.2 cm.
Gift of the artist, in honor of
Alfred H. Barr, Jr., Class of
1922 (70-7)
In situ: Executed 1969–1970,
installed 1971
Mild steel, painted black,
height 8.0 m.
Located on plaza between Fine
and Jadwin Halls

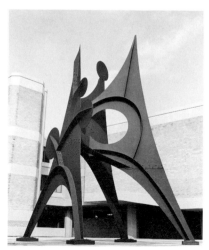

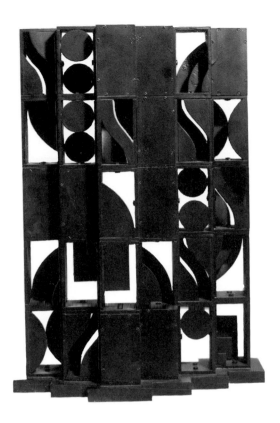

Louise Nevelson (born 1900)
Maquette for *Atmosphere and Environment X*, 1968
Cor-Ten steel, painted black, height 36.3 cm.
Gift of the artist (69-8)
In situ: Executed 1969–1970, installed 1971
Cor-Ten steel, height 6.5 m.
Located between Nassau Street and Firestone Library

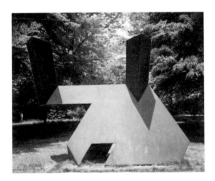

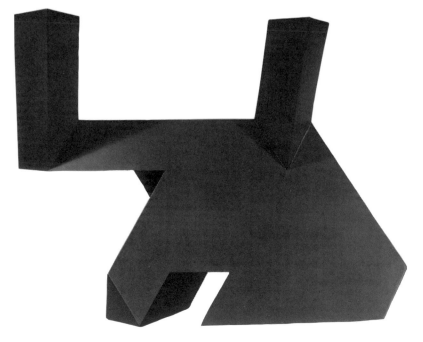

Tony Smith (1912–1980)
Maquette for *Moses*, 1967
Pressed wood, painted black,
height 56.5 cm.
Gift of the artist (69-123)
In situ: Model executed 1967–1968,
fabricated and installed 1969
Mild steel, painted black, height 4.6 m.
Located on grounds in front
of Prospect House

George Segal (born 1924)
Torso, wall relief, 1972
Plaster, height 80.0 cm.
Promised gift of the artist for the
William C. Seitz, Graduate School
Class of 1955, Memorial Collection

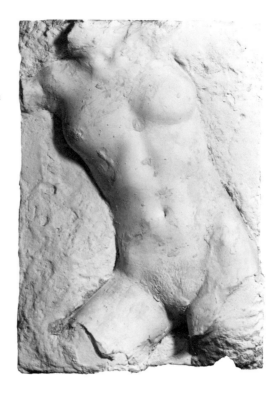

Philip Pearlstein (born 1924)
Female Model on Cast-Iron Bed, 1975
Oil on canvas, 1.2 × 1.5 m.
Anonymous gift (79-75)

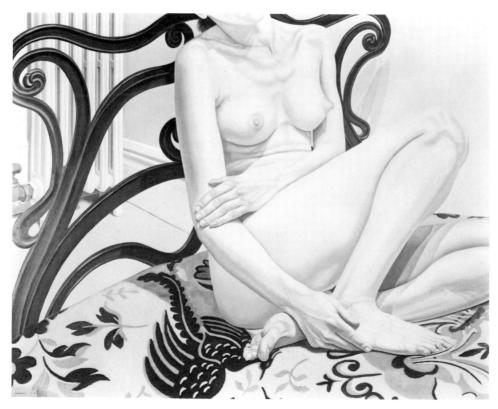

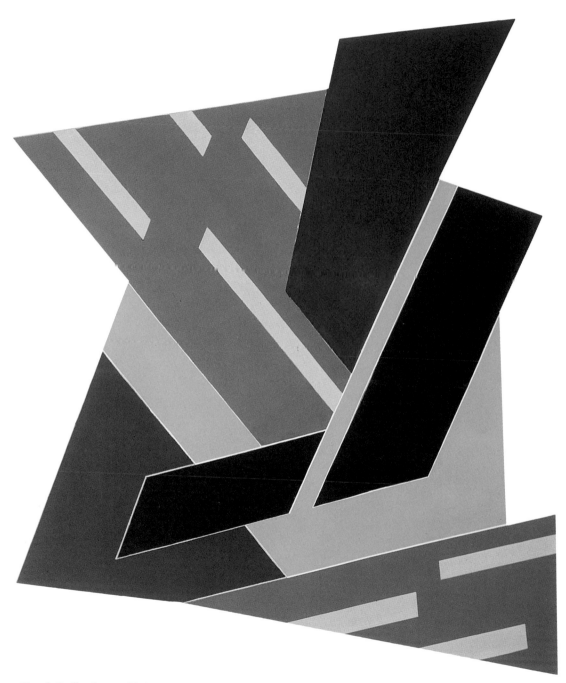

Frank Stella (born 1936)
Felsztyn I, 1971
Acrylic on canvas with felt, 2.8 × 2.2 m.
Gift of the artist, Class of 1958, for the William C. Seitz,
Graduate School Class of 1955, Memorial Collection (76-34)

PHOTOGRAPH CREDITS

Photographs are by Clem Fiori, except for those noted below. Many thanks also to Michael Pirrocco for his assistance in printing photographs.

Feinstein: pages 50 top, 56 top, 103 top left, 224 right.

Reuben Goldberg: pages 21 top, 34 top, 42 bottom, 54 top, 59 top and bottom, 60 bottom, 69 top, 76 top, 111, 143, 198 bottom, 280 top.

Leonard Kane: pages 120 top, 127 top, 150 top, 152 bottom, 156 bottom, 267 bottom right, 278 bottom.

Sol Libsohn: pages 97 bottom, 225 left and right, 226 left and right, 235 top and bottom, 226 bottom left, 267 top right.

Robert P. Matthews: page 284.

Elizabeth C. Menzies: pages 48 bottom, 65 bottom, 136 bottom, 139 bottom, 269 bottom left.

Thomas Mulvey: page 118 bottom.

Otto Nelson: page 219 top.

Taylor and Dull: pages 20 bottom, 30 top, 31 top, 34 bottom, 45 bottom, 54 bottom, 67, 70, 74 bottom, 78 top and bottom, 79 top and bottom, 82 top, 86, 88 bottom, 90 top and bottom, 92 bottom, 93 top and bottom, 95 top, 97 top, 98 bottom, 100 bottom, 103 top right and bottom, 108 bottom, 112 top and bottom, 113 bottom, 116, 124, 125 top and bottom, 126 top and bottom, 130 top, 131 top, 134 top, 135 top, 138 top and bottom, 140 bottom, 145 top and bottom, 151 top, 153 bottom, 154 bottom, 156 top, 162 bottom, 197 bottom, 198 top, 204, 213 left, 214 left, 215 right, 216 top, 217 bottom, 218 left, 219 bottom, 233, 240, 266 bottom right, 267 bottom left, 269 bottom right, 276 bottom, 277 bottom, 278 top, 280 bottom, 300 top, 301. Copy prints: pages 166 top, 168, 172 top, 176 bottom, 177, 182 top.

COPYRIGHT ACKNOWLEDGMENTS

Note: In the captions, all measurements expressed in meters have been rounded off to one decimal place.

MUSEUM STAFF